Swedish Rock Art Series: Volume 6

North Meets South

Theoretical Aspects on the Northern and Southern Rock Art Traditions in Scandinavia

Edited by

Peter Skoglund, Johan Ling & Ulf Bertilsson

OXBOW | books
Oxford & Philadelphia

Published in the United Kingdom in 2017 by
OXBOW BOOKS
The Old Music Hall, 106–108 Cowley Road, Oxford OX4 1JE

and in the United States by
OXBOW BOOKS
1950 Lawrence Road, Havertown, PA 19083

Hardback Edition: ISBN 978-1-78570-820-6
Digital Edition: ISBN 978-1-78570-821-3 (epub)

A CIP record for this book is available from the British Library
and the Library of Congress

Printed in Malta by Melita Press

For a complete list of Oxbow titles, please contact:

UNITED KINGDOM
Oxbow Books
Telephone (01865) 241249
Email: oxbow@oxbowbooks.com
www.oxbowbooks.com

UNITED STATES OF AMERICA
Oxbow Books
Telephone (800) 791-9354, Fax (610) 853-9146
Email: queries@casemateacademic.com
www.casemateacademic.com/oxbow

Oxbow Books is part of the Casemate Group

*Front cover: Rock paintings at Cuttle Lake, Western Ontario, Canada (after G. Rajnovich);
and rock paintings at River Olekma, Eastern Siberia (after P. Okladnikov and A. I. Mazin).*

The printing of this book is financed by the Swedish Foundation of Humanities and Social Sciences (Riksbankens jubileumsfond).

Swedish Rock Art Series

Bronze Age rock art represents a unique Nordic contribution to world culture, and more than 17,000 localities are known in Sweden alone. They constitute one of the World's most complex and well-preserved imageries. Centered in the World Heritage site of Tanum in western Sweden, the Swedish Rock Art Research Archives (Svenskt Hällristnings Forsknings Arkiv – SHFA), at the University of Gothenburg was established in 2006 to further documentation and research on this unique Bronze Age heritage. All original documentation – from large rubbings to photos are being digitized and along with modern digital documentations made continuously accessible for international research on the web portal www.shfa.se. Based on this material Swedish Rock Art Series will present ongoing research and new documentation in the years to come.

Kristian Kristiansen
Series editor

Johan Ling
Director SHFA

Contents

List of contributors

ULF BERTILSSON
Swedish Rock Art Research Archives (SHFA)
University of Gothenburg
Department of Historical Studies,
Archaeology
P.O. Box 100
S-405 30 Gothenburg, Sweden
ulf@shfa.se

JAN MAGNE GJERDE
Department of Archaeology, History,
Religious Studies and Theology
UiT – The Arctic University of Norway
Postboks 6050 Langnes
9037 Tromsø, Norway
jan.magne.gjerde@uit.no

FLEMMING KAUL
The National Museum of Denmark
Ancient Cultures of Denmark and the
Mediterranean
Frederiksholms Kanal 12
DK-1220 Copenhagen K., Denmark
Flemming.Kaul@natmus.dk

ANTTI LAHELMA
Institute of Archaeology
Department of Philosophy,
History, Culture and Art Studies
University of Helsinki
P.O. Box 59
00014 University of Helsinki, Finland
antti.lahelma@helsinki.fi

JOHAN LING
Swedish Rock Art Research Archives (SHFA)
University of Gothenburg
Department of Historical Studies,
Archaeology
P.O. Box 100
S-405 30 Gothenburg, Sweden
johan.ling@archaeology.gu.se

TROND LØDØEN
Section for Cultural Heritage Management
University Museum of Bergen
P.O. Box 7800
5020 Bergen, Norway
trond.lodoen@uib.no

ANNE LENE MELHEIM
Museum of Cultural History, Department
of Archaeology
University of Oslo
P.O. Box 6762
St. Olavs plass
0130 Oslo, Norway
a.l.melheim@khm.uio.no

PETER SKOGLUND
Linnaeus University
Department of Cultural Sciences,
Archaeology
391 82 Kalmar, Sweden
peter.m.skoglund@lnu.se

HEIDRUN STEBERGLØKKEN
NTNU Vitenskapsmuseet
7491 Trondheim, Norway
heidrun.steberglokken@ntnu.no

Introduction

Peter Skoglund and Johan Ling

The Swedish Rock Art Research Archives (SHFA) were established in 2006 as an infrastructure to further documentation and research on Swedish rock art. The archive, which is part of the University of Gothenburg, aims to store and present existing rock art documentation for public and research.

SHFA is also a research institute promoting research on rock art in Scandinavia and beyond. The archive publishes the Swedish Rock Art Series, aiming to present research on Scandinavian rock art to an international audience. An initiative to facilitate and strengthen this process is to arrange international symposia targeting Bronze Age imagery.

The current volume, which is number 6 in the series, is the outcome of the second international symposium under the heading *North meets South* held in Tanum, Sweden, 21–23 October 2014. The title of the volume, *North meets South. Theoretical aspects on the northern and southern rock art traditions in Scandinavia*, was chosen to put a focus on Scandinavian rock art regardless of regions and traditions.

There has been a tendency in rock art research to merely focus on either the Northern Tradition (NT) or the Southern Tradition (ST) of rock art and there is a need to broaden the discussion. Thus, the aim of this symposium was to stimulate different perspectives and themes that focused on the intersection between these traditions.

However, it is important to stress that there are obvious differences in space and time regarding these two traditions. Yet there are also some features and formats in common in time and space, and a significant theme of the conference was to highlight the interaction between these rock art traditions. Various aspects of this theme are reflected in this publication, which gathers nine researchers from four different countries (Norway, Sweden, Denmark and Finland).

The papers presented in this volume fall into two broad categories. There are papers dealing with issues concerning categorization and style – *i.e.* presupposed concepts that shape the way we comprehend data and organize the material in various traditions (Lødøen, Stebergløkken). There are also papers taking their starting point in the images themselves, trying to elucidate possible influences and interaction between different regions and rock art traditions (Bertilsson Kaul, Melheim and Ling, Skoglund, Gerde, Lahelma).

In his paper, *Trond Lødøen* questions the still predominant tendency to categorize Scandinavian rock art into just two traditions, associated with hunting societies on the one hand and farming societies on the other. Using the Norwegian material, Lødøen discusses a number of aspects associated with this categorization. He questions both the background for the separation exclusively into these two traditions and the possible interaction between them, and argues in favour of a much more developed and nuanced classification of the still expanding bulk of rock art. Furthermore, Lødøen argues that the standard categorization into two major traditions has hindered researchers from discussing other possible interconnections such as similarities between rock art in western Norway and rock art in southern Europe reflecting possible interconnections across the Atlantic.

An interesting characteristic of central Norway is the meeting between the Northern and the Southern Traditions. In this region, the different traditions coexist not just in this macro-perspective, but also side by side at the same sites – occasionally even in the same panels. The region is a perfect setting to study the interaction between the two traditions. Based on a thorough definition of style and type, *Heidrunn Stebergløkken* identifies various sub-groups in the material and argues that meetings between various socio-cultural groups actually took place at least at some of the locales in central Norway.

Lene Melheim and *Johan Ling* argue that the strong maritime focus in south Scandinavian Bronze Age rock art could be seen as a fusion of two different maritime legacies. The first legacy relates to the north Scandinavian hunter-gatherer tradition of making rock art at maritime locations in the landscape and the second major impact relates to Bell Beaker influence in southern Scandinavia. By incorporating two different maritime legacies on both a practical and a symbolic level, the societies in southern Scandinavia created new

maritime institutions which enabled them to enter and participate actively in the maritime exchange networks of the Nordic Bronze Age. The authors regard the institutionalization of this particular kind of maritime-ness as a crucial feature, a doxa for the reproduction of the Nordic Bronze Age societies.

Ulf Bertilsson focus on the rock carvings at Nämforsen. Although some researchers have pointed to similarities to the Southern Tradition, the notion that the carvings belong to the Stone Age and the northern hunting and trapping culture is firmly established. A difficulty then rises from the fact that the two adjacent settlements, Ställverket and Råinget, were most intensively settled in the Bronze Age i.e. after the period carvings are considered to have occurred. Moreover, bronze casting was done at Råinget. The coastal burial cairns from the Bronze Age largely contemporary with these settlements may also be connected to the carvings. A special type of manned ships resembling the SN Nag type occurs in 'strategic positions'. The explanation for these phenomena is the advancing Bell Beaker culture that also left its mark in the form of a very typical flint arrowhead at Ställverket, indicating that the area was drawn into a growing network of trade and exchange in the Bronze Age.

Jan Magne Gjerde takes boat typology as a starting point for his essay, which compares boat images from the Northern and Southern Traditions. Traditionally, the history of research on rock art in Scandinavia has a clear division between the (northern) hunter and the (southern) agrarian rock art traditions. In light of new discoveries of boat motifs in northern Scandinavia this paper argues that new data call for a re-evaluation of the strict divisions based on the economy, geography and time of the boat motif. This paper proceeds from the Stone Age boat depictions in northernmost Europe and is an attempt to nuance this strict north-south division and point out some possible relations between the two traditions.

In his paper, *Antti Lahelma* concludes that even though the southern and northern rock art traditions partially overlap in both space and time, and show some evidence of communication and interaction, the scholarly traditions rarely do, but tend to interpret each type of rock art according to models that seem oblivious to each other. This paper examines the 'sun ship' in the context of the northern Scandinavian 'hunter' rock art. Russian and North American scholars have pointed out parallels to the same motif also in the rock art of other regions of the northern circumpolar zone. However,

scholars studying the Southern Tradition have associated this motif with elements of Indo-European mythology, and its roots have been traced to the Mediterranean world and Ancient Egypt. By discussing and comparing these different models Lahelma points out the danger of being too restricted to only one research model or one geographic area.

Flemming Kaul take his starting point in the rich evidence of long-distance exchange and communication between southern Scandinavia and examines the possible influences between southern Scandinavian rock art and the Mediterranean. Kaul's paper asks what kinds of mechanisms made these connections possible. He argues that the ancient Greek (and Homeric) concept of guest-friendship, *xenia*, may give us an idea of those social mechanisms that would make the transportation of people and goods practically feasible. This concept can also be used to understand the long-distance connections, which seem to be reflected by specific shapes or types of ships in Late Bronze Age rock carvings – from Alta in northernmost Norway to Bottna in central Bohuslän – could be understood in terms of the *xenia* concept. Here, well-established guest-friendship connections would make long-distance maritime journeys possible.

Peter Skoglund discusses the occurrence of axe images at Simrishamn in Scania and at Stonehenge in Wessex, all of which can be dated to the Arreton phase/Montelius' period 1, 1750/1700–1500 BC. These two concentrations are the only major clusters of axe images in northern Europe dating to this time, and some of the images demonstrate similarities in style and design. In order to understand this situation, an interpretation is put forward implying that these two areas were linked by a network of people who traded in metal and amber. The function and value of amber and metal was, however, different in the two areas. It is argued that differences in the conceptualization of metal are reflected in the ways axe images are arranged and displayed in Wessex and in Scania.

A major conclusion to be drawn from the symposium is the great complexity and variation of rock art in Scandinavia and the need for a perspective comparing various regions in Europe and beyond. By bringing together scholars from various parts of Scandinavia, and publishing the contributions in this volume, we hope we have been able to demonstrate the potential for further research along these paths.

The Meaning and Use(-fulness) of Traditions in Scandinavian Rock Art Research

Trond Klungseth Lødøen

Abstract: The paper questions the still predominant tendency to categorise Scandinavian prehistoric rock art into just two traditions, associated with hunting societies on the one hand and farming societies on the other. More than a century ago, the iconography from this part of Europe was separated into 'South Scandinavian' and 'North Scandinavian' rock art. Later on, the terms hunters' and agrarian rock art came into use, together with

other variants, before these were reconceptualised into the 'Northern and Southern Traditions' in the 1930s. Despite the fact that hundreds of sites have been rediscovered since the first categorisation, we are still left with just two major groups of rock art in Scandinavia. Researchers have also argued in favour of merging the two traditions and even of interaction between them, but this has often been challenged by the widely-separated dating of the supposed traditions. This paper, which takes its point of departure in the Norwegian material, discusses a number of aspects associated with this categorisation, questions both the background for the separation exclusively into these two traditions as well as the possible interaction between them, and argues in favour of a much more developed and nuanced classification of the still expanding bulk of rock art. This will be thoroughly problematised, as it will be argued that some of the sites normally labelled within the Northern Tradition, at least in Western Norway, share a number of features and elements with rock art of the Atlantic tradition of central and southern Europe, thus indicating a potential interaction between Scandinavia and southern Europe at the end of the Late Mesolithic. This adds to other supposed influences from north-eastern and eastern Europe, thereby challenging the background for both the Southern and the Northern Traditions as clearly defined and consistent traditions.

Key words: Cup and Ring Tradition, Rock art, traditions, dating, contemporaneity, Northern and Southern Tradition, Atlantic and Megalithic art.

Background

The following discussion takes its point of departure in the symposium 'Where North Meets South – Methods and Theory in Interpreting Rock Art Traditions', in which contributors were also encouraged to highlight potential interaction between these traditions. For many years, Scandinavian rock art has been categorised into two basic traditions that are assumed to have northern and a southern geographical backgrounds respectively. Apart from their opposing points of origin, it has been argued that they are the result of different types of cultures and ideologies, although the nature of

the societies behind the imagery is not always fully brought to light when analysing the iconography, something that is often out of reach when only the images are analysed. This has resulted in a considerable amount of relativism in studies of rock art. However, the traditional view has been that the rock art that is claimed to be of northern origin was developed by an indigenous hunter-gather-fisher population, while the other type of tradition, with an assumed southern origin, was produced by a culture with another set of ideas that was introduced to Scandinavia from outside (Sognnes 2001: 13). However, the varied character of the iconography means that it is far from clear what the shared and unifying features within each of the different traditions actually were, and therefore these crude assumptions and categorisations are questioned.

What is the significance of rock art traditions?

What exactly is implied by the idea of 'traditions' when it comes to prehistoric rock art? Is it the similarity between individual figures, or the shared codex represented by the numerous compilations of images, also understood as narratives, spread over a certain geographical area? The societies and ideologies behind the iconography are still of an uncertain nature, and clearly the more or less inaccessible ideas behind the imagery. From the literature, it seems to me on the one hand that a ship equals the 'Southern Tradition', which equals farming societies and their ideology, and so we can immediately question why ship images should be associated with agriculture and farming. On the other hand, naturalistically outlined animals equal the 'Northern Tradition', something which for decades our modern Cartesian world view has tended to equate with subsistence, economy and hunting, and whose mission also seems to be accomplished when it comes to the meaning of the rock art. There have been a number of suggestions as to how to understand the imagery at the hunters' sites, but it is often only the sites that are considered, being interpreted as hunting grounds, aggregation places or assembly sites, as the iconography itself is more difficult to decipher. Analyses of the iconography of the Northern Tradition have tended to focus mainly on the animals, causing interpretations to be associated with hunting, emphasising the reluctance to move beyond the

idea of animals only as game. In the same way as the previous concept, the Northern Tradition is used as a type of all-encompassing description for most rock art from northern Scandinavia, which despite its categorisation, varies considerably in its form and nature within this area, something that causes me a number of problems, and this is why I believe we are far from having a clear understanding of the situation.

Two ruling and contrasting traditions in Scandinavia?

The departure point for our present traditions dates back to the beginning of the nineteenth century, when rock art was first divided into 'South Scandinavian' and 'North Scandinavian' rock art (Sognnes 2001: 13). These two have also been synonymous with 'Arctic' and 'schematic' art respectively, and because of the different datings of these two categories, also with 'Stone Age' rock art on the one hand and 'Bronze Age' rock art on the other. At a later stage, this separation was based more on the assumed subsistence for the societies behind the art, which divided naturalistically outlined animals into 'hunters'' rock art, while sites with geometric motifs such as circles and spirals were classified as 'agrarian' rock art (Hansen 1904: 323–325; Sognnes 2001: 13). This led to highly particularised categorisations, in which individual types of motifs were believed to be either of the hunters' or the agrarian type. Large compilations of rock art at many sites, which we now seem to be more willing to consider as narratives and more closed events, were often understood in the past as the result of the continuous adding of new figures to a rock art panel, and not necessarily by the same culture. A geometrically-shaped image amongst a number of naturalistic animals could therefore be interpreted as either the result of agrarian thoughts and ideologies added to the imagery of hunter-gatherer expressions, perhaps with the aim of altering the meaning or changing the ideological content of expressions left by a former culture, or alternatively, that those which are claimed to be more recent motifs were the result of superimpositions, made at a much later stage, and awkwardly enough without any concern for the earlier iconography the rock panels may have contained, as if the

only purpose for the rock art was to mark the presence or existence of one culture instead of another. For nearly a century, animals that were depicted or at least outlined in a naturalistic manner were categorised as hunters' art. At the other end of the scale, circles or motifs, which could not easily be associated with or identified in the material remains of hunter-gatherers, were ascribed to agriculturalists. Much later, these two groups were modified or reshaped into the Northern and Southern Traditions, and in the following discussion the latter descriptions will be used more or less synonymously with the 'hunters'' and 'agrarian' rock art. Now, more than a century after the first categorisation, we are still left with just two general groups or traditions (Sognnes 2001: 13). These are supposed to categorise iconography produced over several thousand years, all over Scandinavia, into just two branches. Taking into account the number of discoveries made since they were first separated into groups, this is a case of extreme categorisation, and something I find almost counterproductive for acquiring new knowledge. What exactly do sites within the Northern Tradition have in common?

What exactly are the similarities shared by sites within the Southern Tradition, and what are the ruling premises for the different traditions? I see a clear need for more internal analysis of the rock art within these two supposed traditions before we investigate the interaction between them, because I believe that there are a number of possibilities to isolate more groups or traditions within the present number of sites – at least within the Northern Tradition, which concerns me the most. Otherwise, I am not sure if we will be able to understand what is interacting, and we should not forget that it is not the images that are interacting, but instead the societies that were responsible for them. In addition, I believe that there are similarities between the Scandinavian rock art and rock art elsewhere in Europe that should be analysed more thoroughly.

The need for a better framework for rock art categorisations

As I see it, we would benefit from a complete reconsideration of our present traditions, since I believe our goal is to try to approach the meaning behind

the rock art, which can vary considerably when our scope is northern Europe. If we consider that the spread of rock art and the meaning of the imagery is often discussed without including the contemporary context, something that is difficult to identify due to dating issues – at least in the case of the Northern Tradition – then we have a considerable way to go. The latter addresses another fundamental problem with rock art archaeology as such. In this tradition we seem to group together almost incomparable entities, with criteria of the most basic level, where images of red deer, reindeer or elk, or for that matter sea mammals, are all placed in the same group, based on the idea that as long as there are more or less wild species to be identified on the different panels, then they are considered to be from the same group or tradition – the Northern Tradition. But is this sufficient to define a tradition?

Here, these matters will be questioned in greater detail, addressing a number of basic concerns that mainly refer to what is defined as the Northern Tradition, but also going beyond its borders, balanced by a discussion of some of the iconographical features that are left for us to investigate. I will use Western Norway as my point of departure, starting with the traditional interpretation of one of our most debated sites, *Ausevik*, in the municipality of Flora, and also touching on the Vingen site in Bremanger, a little farther to the north, both of which are in the county of Sogn og Fjordane (Fig. 1.1). The nature of these sites will be discussed in light of other sites of the so-called Northern Tradition, and also seen in relation to a few significant rock art complexes elsewhere in Europe.

The significance of the Northern Tradition in Western Norway – or a western Norwegian variant of the Northern Tradition?

Over the last eighty years or so, the dating of the Ausevik site and its association with groups or traditions has varied (Lødøen 2014). When the site first became known to the public in the 1930s, the documented animal images were regarded by Johannes Bøe as being of the same type as those found in Vingen, and so he claimed that the site belonged to the hunters'

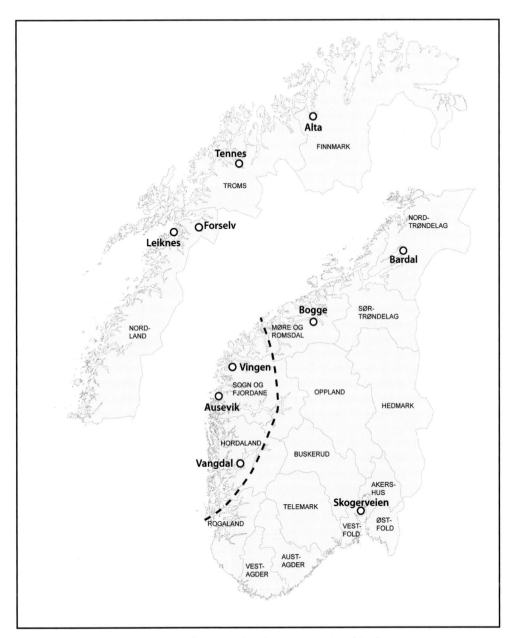

Figure 1.1. Map of Norway showing sites mentioned in the text.

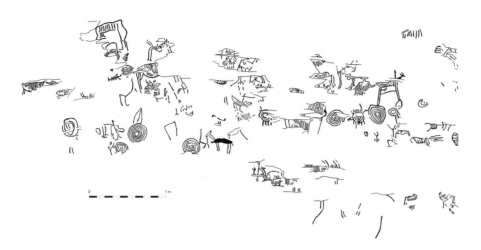

Figure 1.2. One of the many panels in Ausevik with animal images and circular combinations (after A. Hagen 1969).

type of rock art (Bøe 1932: 34–36). Thirty years later, this was questioned by Anders Hagen, who was highly occupied with cultural dualism, and accepted that all the animals depicted in the rock panels were the result of hunting groups and of the hunters' tradition, but claimed that all the geometric images must have been the result of influences from agricultural societies (Hagen 1969: 5, 79) (Fig. 1.2). However, he was not able to fully identify this and track down any provenance or a convincing origin for these motifs, either in terms of geographic areas or cultures and societies (Hagen 1969: 90–95). It is possible to read between the lines in Hagen's work that hunters were not capable of thoughts involving such abstract images as geometric shapes, despite the fact that they are present even in Palaeolithic art (Breuil and Obermaier 1935; Bégouën and Breuil 1958). In the 1970s, on the basis of stylistic similarities with the Vingen rock art, Egil Bakka argued that the site should instead be dated to the Middle Neolithic, and that the images were produced by hunting societies, while still accepting that a single foot symbol could belong to a more recent tradition (Bakka 1973: 178). It is striking to note how these researchers focused on single categories of motifs, and do not seem to have understood the compilations of images as anything more than a continuous process of adding new images to rock panels and not as narratives. This is illustrated by the attention the foot image mentioned above has received in the literature – if indeed it even is a foot image – and is also symptomatic for a number of approaches chosen throughout the history of rock art research. Later on, Eva and Per Fett focused more closely

on the geometric images – also with a strong focus on a single group of images – and introduced a completely new perspective when they tried to see similarities, relationships and a clear influence from the Megalithic art of the British Isles and Ireland at sites in Western Norway (1979: 72). A couple of decades later, in the 1990s, Eva Walderhaug revisited the site and tried to identify a series of known societal changes in the material culture of Western Norway during the Neolithic period, reflected in the imagery (1994: 81). Like the previous researchers, she also argued for an influence from Megalithic art in Ausevik, although she saw a number of challenges with the chronology of the rock art in Scandinavia in relation to the British Isles (1994: 81). Walderhaug's occupation with the Neolithic development also led to a collaboration with Christopher Prescott, as a result of which they claimed to have identified influences from the Nordic Battle Axe culture and later the Bell Beaker culture in the iconography at Ausevik (Precott and Walderhaug 1995: 263) (Fig. 1.3). They concluded that Ausevik was a site where hunters' rock art or the Northern Tradition was under the influence of farming societies, leading to a rock art site that also belonged to the Southern Tradition – a transition site – while Vingen was accepted as a site that was less influenced by Neolithic cultures and where a hunters' ideology, in the form of rock art, was more or less pure and undisturbed (Prescott and Walderhaug 1995). On the one hand it is interesting to note, as a part of these researchers' reasoning, how the addition of a few new symbols would have completely changed the symbolic content and even the association with a tradition (Bakka 1973: 168; Prescott and Walderhaug 1995: 263). It is also interesting to note that many of the images that were considered to be the result of influence by agricultural societies or the Southern Tradition in Ausevik are also present in Vingen (Hagen 1969: 103; Bakka 1973: 157; Lødøen and Mandt 2012), but this site was never questioned as being anything other than of the Northern Tradition (*e.g.* Hagen 1969: 79; Bakka 1973: 166; Prescott and Walderhaug 1995: 268).

Altered chronologies and changed perspectives

The constantly frustrating dating of these two sites, and their attribution by researchers to such vastly different periods as the Iron Age or the

Figure 1.3. Red deer closely associated with a spiral (after A. Hagen 1969).

0 30 cm

Bronze Age (Hagen 1969: 113) on the one hand and the Neolithic (Bakka 1973: 173) or the Mesolithic (Bakka 1979: 118; Ramstad 2000: 58) period on the other, led to a number of excavations being carried out at these sites from the 1990s onwards (Lødøen 2003, 2010, 2013, 2014). The agenda behind this approach was partly to try to bridge the gap between rock art and its contemporary material context, but also to produce new evidence, while being fully aware of the fact that the recovery of archaeological remains at these sites and in the immediate vicinity of the rock art panels could either predate the rock art or be the result of post-depositional processes (Lødøen 2013: 25). However, combined with scientific methods such as palynology and soil science, independent data documenting human impact on the environment has been used together with the archaeological material, which has produced results that support the dating of the rock art sites in question (Hjelle and Lødøen 2010).

These efforts dated the Vingen site to the end of the Late Mesolithic, between 4900 and 4200 cal BC (Lødøen 2013: 29). More surprising were the results of the archaeological excavations in Ausevik, which obtained a dating from the period between 5000 and 4600 cal BC (Lødøen 2014: 61–62), implying that the two sites are more or less contemporary, and that Ausevik could even predate the Vingen site (Lødøen 2014: 60). This once again provided a new chronological framework for the rock art of Ausevik, which at the same time was more logical in order to explain similarities in the iconography as a matter of stronger contemporaneity between Vingen and Ausevik. Even more importantly, it has provided a new point of departure for analysing the iconography within the framework of a Late Mesolithic hunting-fishing society and its ideology, and not a farming community. Both sites also suggest that important cultural changes, which have received less attention at least in these areas, took place at the end of the Late Mesolithic (Lødøen 2014, 2015a).

Sites for mortuary practice and regeneration, but for whom and how frequently?

Together with new studies of the iconography and its local distribution, I will claim that the most essential similarities between the two sites are the nature of the anthropomorphic figures, which have barely been discussed to date, and their association with the animal images. The animals are unquestionably the most recognisable and frequently appearing images, which have always received the greatest attention, while there has been less focus on the presence of anthropomorphic images, their character and location. The latter groups, found on the different rock faces, boulders or stones, are often very simple and highly stylised, although a large number of them clearly show ribs, spinal columns and often a conspicuous pelvis (Fig. 1.4). It therefore seems obvious that these were not meant to express living humans, or dead individuals, but skeletons (Lødøen 2014: 66, 2015a: 85–87). I cannot see any sensible reason why skeletons were depicted other than in association with the handling of dead members of past societies, who are clearly displayed as discarnated bodies (Lødøen 2014: 66, 2015a: 87). This has convinced me that the rock art both at Vingen and at Ausevik is not only

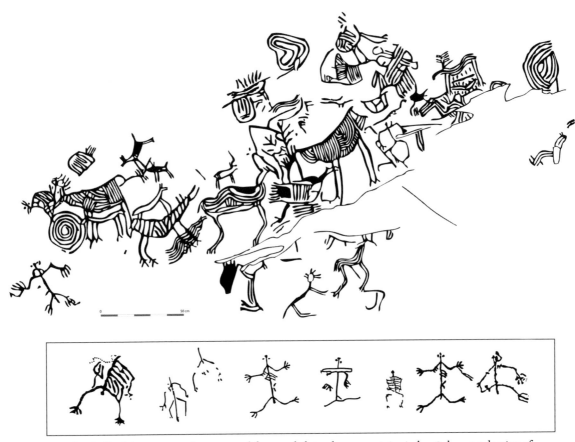

Figure 1.4. A herd of red deer seem to be separated from a skeleton by concentric circles. Below, a selection of skeletons from Ausevik (after A. Hagen 1969).

connected to mortuary rituals (Lødøen 2014, 2015a, 2015b), but has to do with secondary burials and the secondary treatment of corpses, something which is discussed in a number of other papers (Lødøen 2014, 2015a, 2015b). It is therefore interesting that research on mortuary practices in central Europe and southern Scandinavia clearly indicates that excarnation and subsequent disarticulation were the main mortuary processes in most parts of Europe in the Mesolithic and in the Early and Middle Neolithic, which consequently resulted in few burials (Cauwe 1988, 2001; Nilsson Stutz 2003; Grünberg 2000). However, exceptions to this practice seem to have occurred at the end of the Late Mesolithic, when a number of cemeteries appear,

and where some individuals were still being disarticulated, but only to a modest degree (Nilsson Stutz 2003). From this point on large numbers of burials have been documented – often as cemeteries – at sites such as Skateholm I and II, Scania, Sweden (Larsson 1981) and at Vedbæk, Zealand, Denmark (Albrethsen and Brinch Pettersen 1976), most of which are single inhumation graves, although there are examples where more than one individual was buried in the same grave.

The nature of these cemeteries, where none of the graves seem to overlap or interfere with each other, together with the completeness of the skeletons, seem to indicate that towards the end of the Late Mesolithic there was a greater respect for the integrity of the body (Cauwe 1988, 2001: 47; Nilsson Stutz 2003: 349). Altogether this may have been the result of religious changes, or was caused by a new cosmological understanding or potentially as the result of a changed ideology. Burials are almost completely absent in Western Norway, but a few have been found, and interestingly been dated to the Late Mesolithic, where even potential disarticulation has been documented (Jansen 1972:58; Lødøen 2014:65; 2015:93). It is therefore compelling to note that the same awareness of decomposition processes and a focus on the completeness of skeletons in the cemeteries is also reflected in the iconography at the rock art sites dated to corresponding periods at the end of the Late Mesolithic. Another interesting aspect is that red deer are a frequently occurring element in the form of antlers (Larsson 1988; Kannegaard Nielsen and Brinch Pettersen 1993; Grünberg 2000; Nilsson Stutz 2003) or bones in the graves (Griegson and Mellars 1987), which clearly parallels how skeletons are surrounded by red deer on the rock panels, emphasising the importance of this species in death processes. Therefore I consider these as potentially being 'soul animals' that provided the necessary circle of regeneration (Lødøen 2014, 2015a). But as regards the question of traditions, could it be understood that the societies behind the burials in south Scandinavia belonged just as much to the Northern Tradition as the Ausevik rock art, or for that reason the rock art at the Vingen site? The apparent lack of rock outcrops in the vicinity of Skateholm and Vedbæk or in southern Scandinavia may have led them to leave any iconography they considered necessary on other materials. But how does this fit with the rest of the rock art sites claimed to belong to the Northern Tradition? I will return to this question later on in this article.

The narratives at Ausevik and Vingen are also arranged in a way that may indicate death cycles or regeneration, where animals seem to be led to the sites from a western origin and then return and leave the sites towards the west again, often accompanied by skeletons (Lødøen 2014: 70, 2015a: 87–90). As already mentioned, concentric images are a frequently occurring motif in Ausevik and Vingen, as are spirals, which Hagen claimed was a more recent category (1969: 90), but which seem to be as contemporary as the rest of the imagery at the two sites, and clearly of Mesolithic origin. They are often part of narratives where they seem to be approached by animals (Hagen 1969: 20; Lødøen 2014: 54), and which possibly could be understood as entrances into the rock, something to which I will also return.

Altogether, this opens the way for a new understanding of the rock art of the Northern Tradition, which is now more complementary to studies of burial remains, and where the rock art can provide us with a better insight into thoughts about mortuary rituals and the afterlife, something I have argued in favour of elsewhere (Lødøen 2014, 2015a, 2015b). Understanding rock art in this way seems reasonable, as the rock art of the so-called Southern Tradition frequently occurs inside graves (Goldhahn 1999; Linge 2007; Mandt 1991) on bedrock supporting cairns or underneath grave mounds and in other such mortuary environments (Wold 2005), and where the frequently appearing ships could have been present for the purpose of transporting souls, much the same function as I argue that certain animals had in previous periods.

It is still far from clear who used the rock art sites and for whom they were intended. Although burials can be difficult to locate and many rock art sites are yet to be discovered, these two categories seem to share the characteristics of being few and far between, compared to the numerous habitation sites dated to the same timespan. In the first place, these two categories may be perceived as incomparable entities, but since both practises – obviously graves – are related to mortuary rituals, they seem to hold more connotations that may be useful in understanding their meaning, or at least how they relate to habitation sites and to the rest of the contemporary material culture. This is something that should be explored in much greater detail in the future, for the rock art sites.

The narratives found in Vingen and Ausevik seem to be arranged in a very similar way (Lødøen 2014: 67), along with the type of images they contain (Hagen 1969: 112–119; Bakka 1973: 166, 188; Walderhaug 1994: 88).

This said, there are a number of clear differences, which may indicate that the two sites are representative of bands or groups who had their own specific expressions, but who nevertheless shared a number of similar ideas, or perhaps the same basic religion and ideology. To a large extent this is also the case at the much smaller Vangdal site in the Hardangerfjord area, Hordaland, to the south of Ausevik, where at least one skeleton image is associated with several red deer images which for the most are depicted as moving westward, meaning they share features that are typical of Ausevik and Vingen (Fig. 1.5). These three sites seem to share a number of features, which lays the foundations for isolating a potential western Norwegian variant of the Northern Tradition. For the majority of the other sites that are bundled together as the Northern Tradition, the similarities that seem

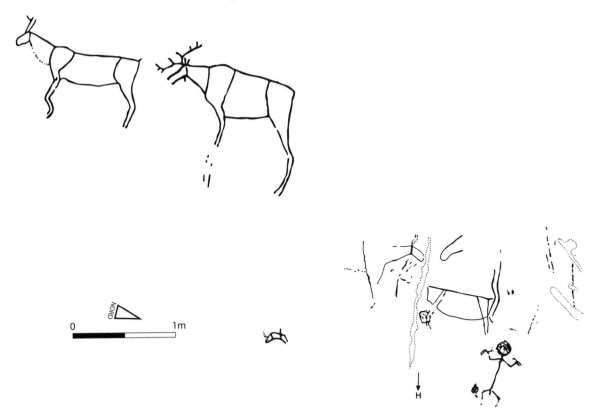

Figure 1.5. A narrative of shared content with Ausevik where animals and skeletons seem to be associated – perhaps soul animals (after G. Mandt 1970).

to be so basic for Western Norway are less apparent, such as the circular movement of red deer and skeletons, or concentric circles associated with animals. Most of the other sites are either represented by single animals, herds of animals, different species or other images that are not comparable to the Vingen and Ausevik sites, but which again are all bundled together as the Northern Tradition, something which will be briefly discussed below.

The character of the Northern Tradition in a wider perspective

To the north of Vingen and Ausevik in the County of Møre og Romsdal, at Bogge, three panels are located above each other (Hallström 1938). Two of them are considered to belong to the Northern Tradition, while one panel with ship images is assumed to be from the Southern Tradition. The two upper panels respectively contain whales and concentrations of animals, possibly red deer. On the latter panel, the individual animal figures have some similarities to the animal images in the iconography at Vingen and Ausevik as regards their form and shape, but have none of the shared features such as skeletons and concentric circles (Fig. 1.6a). One of the animals is depicted upside down with claw-like hooves, which may address some aspects of cosmology or potentially be associated with death, but there is little resemblance to Vingen or Ausevik in terms of the narratives and expressions (Lødøen and Mandt 2010: 118).

Further north, a number of other localities classified as Northern Tradition sites are located in the county of Sør-Trøndelag, such as Bardal, Bøla, Hell, Hammer, Stykket and Holtås (Gjessing 1936; Hallström 1938; Sognnes 1999). Reindeer and elk are the most common species at sites such as Bardal, Stykket and Hammer, but also sea mammals and birds (Fig. 1.6b). There are no concentric circles, but other geometric images can be found at Bardal and Stykket. At Bardal there are representations of anthropomorphs, not as skeletons, but instead they seem to be more vital and probably represent living individuals. Most of these sites have little in common with Ausevik and Vingen. However, the Holtås site (Sognnes 1999), containing a myriad of stylised and schematic animal images, geometric figures and

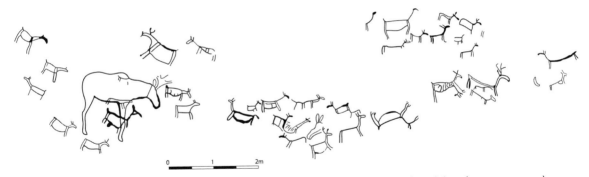

Figure 1.6a. The imagery at Bogge in Møre og Romsdal. Only animals, mainly red deer (G. Gjessing 1936).

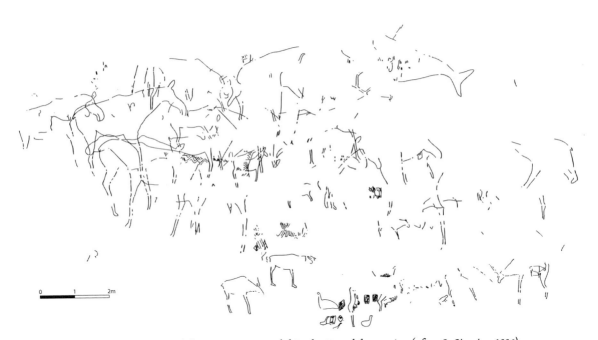

Figure 1.6b. Some of the imagery at Bardal in the Trøndelag region (after G. Gjessing 1936).

chequered patterns, has some similarities to the way in which the motifs are organised in Ausevik, although there are no skeletons, anthropomorphs or concentric circles (Sognnes 1999). It should also be noted that the Bardal site and a few others in this region contain agrarian art superimposed over compilations of the much older hunters' art.

Moving further north to the county of Nordland, a number of sites with polished rock art have been documented at locations such as Valle, Leiknes, Sagelva, Fykan and Klubba (Hallström 1938) where only animal images are found (Fig. 1.6c). They stand out as apparently being from a unique tradition, of uncertain age, although a number of researchers have argued in favour of these being the oldest type of rock art in Scandinavia (Hesjedal 1994; Gjerde 2010), without any of the features that are so typical in Ausevik, but considered to be of the Northern Tradition. Another location of interest is the Forselv site, further north in Nordland, where a highly visible herd of reindeer images are depicted together with halibut and other types of fish, anthropomorphs, more abstract geometric images and at least one boat (Hallström 1938; Gjessing 1932) (Fig. 1.6d). Here there are also a number of geometric images with a very definite shape: squares, and rhombic patterns with a strong resemblance to similar geometrical patterns at the Bardal site, although without any of the features that are so typical in Western Norway, such as circles or skeletons.

Sites of somewhat similar shapes and sizes can also be found in Troms, which again have their own unique elements, such as Tennes, Åsli and Skavberget (Gjessing 1938; Hallström 1938; Simonsen 1958) (Fig. 1.6e). The common dominator with the other sites mentioned above is first and foremost the animal images, and for many of them it is difficult to identify the species – although it is likely that they are reindeer and/or elk. However, at the Tennes site it is also interesting to note that one anthropomorphic image shares some of the features with the images from Ausevik and Vingen, thought to be skeletons.

The largest concentration of images of the Northern Tradition can be found at the head of the Alta fjord in Finnmark. At several locations, such as Hjemmeluft, Kåfjord and Amtmannsnes, large numbers of panels with numerous animal images have been found which are partly associated with anthropomorphs in larger narratives (Helskog 1999). The majority of the animals are reindeer, elk and bears, and a number of other types of mammals, sea mammals, birds and fish. The narratives vary greatly, and some of the variations are argued to be the results of chronology. Some of the narratives are also thought to express changing seasons, although this may also have to do with regeneration, and may therefore be related to the expressions found in Ausevik and Vingen. Special mention should be made

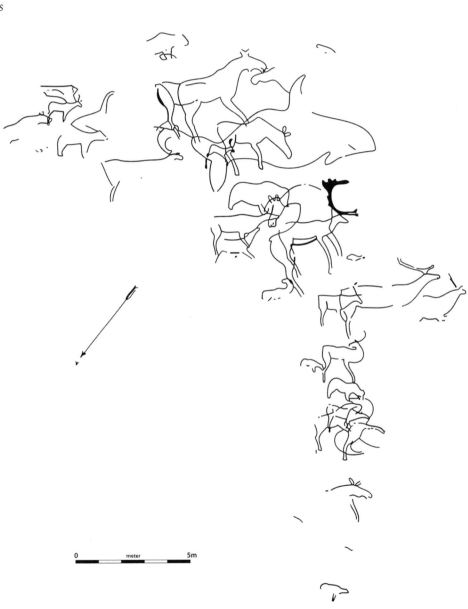

Figure 1.6c. Polished rock art at Leiknes in Nordland, with a number of different land and sea animals (after G. Gjessing 1932).

0 meter 5m

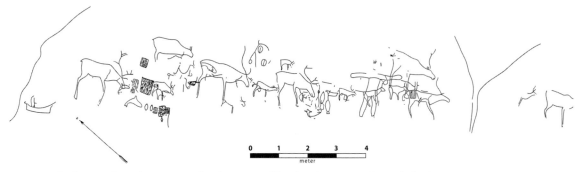

Figure 1.6d. The Forselv rock art in Nordland. Groups of land and sea animals, and also boats and geometric images of a very definite and distinct type. As varied as Ausevik, but of a completely different type (after G. Gjessing 1932).

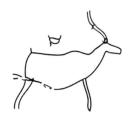

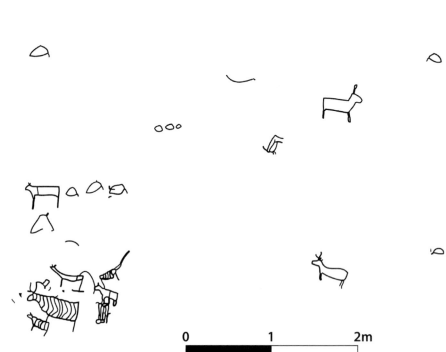

Figure 1.6e. Sea mammals and reindeer or elks associated in what could be a cyclic event, as they are depicted as moving in different directions, with and without body decoration (after P. Simonsen 1958).

Figure 1.6f. Skeleton image from Amtmannsnes with more explicit similarities to Western Norway (T. Lødøen).

of the Amtmannsnes site, which contains images of skeletons and animal-human relationships of a similar kind to those seen in Vingen and Ausevik (Helskog 1999; Berg 2003: 17) (Fig. 1.6f).

Heading to the south of Ausevik, towards the south-eastern part of Norway, a number of smaller sites labelled as belonging to the Northern Tradition can be found at the head of some of the fjords, and from there along corresponding river systems at inland locations (Mikkelsen 1977: 181). None of these sites contain many images (Fig. 1.6g), mainly a few representations of elk and the occasional geometric images of more unknown types, and have few features in common with the hunters' sites in Western Norway.

There are a number of other sites of the so-called Northern Tradition in Norway, but due to limitations of space I cannot discuss all of them here. My main point is to focus on the idea of how it is possible that the varied character of the sites, different animals and contrasting structuring of the iconography fits with belonging to only one tradition. It seems clear that the rock art of the Northern Tradition could be divided into a number of independent groups, as several of the images on the numerous panels found at other sites seem to be arranged quite differently. Some of the locations have sets of images that

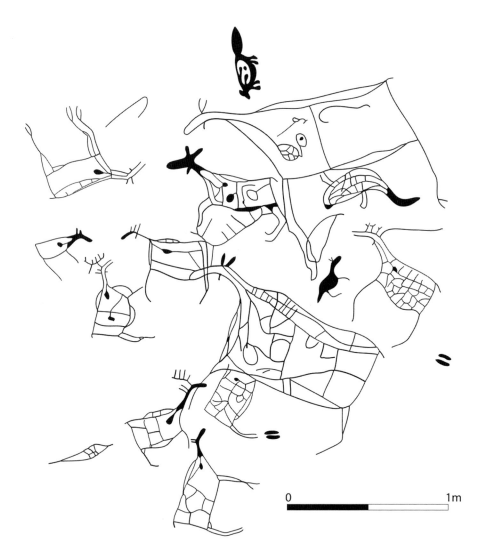

0 ────────────────── 1m

Figure 1.6g. The rock art of Skogerveien, Eastern Norway, with its typical depiction of the 'life-line', from the mouth and leading to the intestine. Possible representations of the heart, stomach, lungs or other organs or elements perceived as highly essential to depict in the past (after E. S. Engelstad 1934).

are virtually incomparable with each other, but are still grouped together as the Northern Tradition. Are we still talking about the same traditions both in the north and in the south of Ausevik and Vingen, which at a number of sites have hardly anything in common other than a vaguely similar pecking technique, and the more or less similar shape of different animals? A number of Northern Tradition sites both north and south of Vingen and Ausevik contain only animals, without any anthropomorphic images. While red deer

are the dominant species at Vingen and Ausevik, the majority of the other sites of the so-called Northern Tradition are represented by different species, such as elk, reindeer, bears and sometimes sea mammals, corresponding to the natural habitat of the different species in the past, but which also seem to follow a different syntax than Vingen and Ausevik. Could these have been mortuary sites that were needed to secure regeneration? There are no concentric circles, or any clear circular movement of animals, but some sites are represented by geometric images, which may be related to the geometric images at Vingen and Ausevik. Neither are skeletons as apparent as they are in Vingen and Ausevik, but should all these different variants be characterised and categorised as the Northern Tradition?

There are a number of other patterns that should be explored more thoroughly. Chronology is still a problematic issue in rock art research: we do not know when it was produced, or how often. It has been argued by several researchers that there seems to have been an upsurge in the Late Mesolithic in the number of rock art sites from what is claimed to be the Northern Tradition (Bjerck 2008; 105; Lødøen and Mandt 2010; Gjerde 2010: 395), something I have attempted to consider as being associated with more sedentary habitation, but the often vague dating of the rock art presents a number of challenges. If the rock art was produced infrequently and the concept of the narratives and iconography had to be borne in mind by the performers for a long time, or even transmitted to subsequent generations, as must have been the case in these oral communities, then it seems reasonable to consider that the expressions may have changed, which to some extent explains the differences found amongst many panels which have corresponding frameworks, but with a fairly wide range of datings. This is in line with the ethnographic record, which has specifically shown how rituals that are less frequently performed tend to change considerably over time in comparable societies, since knowledge of a more esoteric nature had to be transferred orally (*e.g.* Barth 1987).

However, on the one hand it seems that the sites in Western Norway have a number of features that are not shared at the other sites, but then there are similarities with the rock art at the Amtmannsnes site in the form of skeleton images. This means that there could be a connection between the size of the sites and the types of images and narratives they contain, or perhaps it could be that the narratives were following a type of syntax

or structure. Again, this is something that needs to be explored in greater detail, and not only understood as a process of leaving a few images on the rock, which may have been based on conditions we still do not fully understand, where the rest of this potential communication with the underworld or other realms was structured by the use of other material remains or immaterial acts, and where the whole process of making rock art or putting it into its proper cultural form varied between the different individuals or societies who produced the rock art. In addition, we need a more developed and nuanced dating of the rock art – something that could be provided by excavations and independent scientific analysis – once again in order to explain the potential differences. Therefore, societies may have shared a number of elements, such as their religion and mortuary rituals, but not necessarily the structuring of rock images. So the question is: are all of the sites mentioned still within the Northern Tradition?

Nevertheless, many of them do seem to share the same type of location as Ausevik and Vingen, located in the interior and away from tidal currents that stimulated the growth of habitation during the Late Mesolithic (Lødøen 2014, 2015a), and which may therefore correspond to a related cosmological understanding. It is still tempting to suggest that all rock art is connected with regeneration and mortuary practices, but then we are left with the question of why the type and nature of the images and the organisation of the different motifs varies so greatly. Although this generally excludes the skeletons, the same applies to the circular motifs that appear so frequently in Ausevik and Vingen (Hagen 1969: 20), and which seem to be absent elsewhere. Most rock art sites from the Northern Tradition in other parts of Scandinavia seem to have a different structure than the rock art in Western Norway.

New dating evidence prevents the Northern Tradition from ever meeting the Southern Tradition

Until recently, the majority of sites from the Southern Tradition in Norway have been dated to the Early and Late Bronze Age, and even the Late Neolithic. However, recent excavations of associated cultural layers in the vicinity of some of the panels associated with this supposed tradition in

Western Norway have provided radiocarbon datings from the Pre-Roman Iron Age or Late Bronze Age (Lødøen and Mandt 2010: 210). This situation, together with the fact that sites that are normally associated with the Northern Tradition, such as Vingen and Ausevik, are increasingly being dated to the Mesolithic (Lødøen 2003; 2013; 2014; 2015a), implies that the two traditions seem to have been separated by more than two millennia for the western Norwegian sites, and therefore there were less possibilities for interaction.

At some places and sites, the rock art from the two supposed traditions in Scandinavia are found remarkably close to each other, either on the same panel or in the immediate vicinity. However, there are no clear indications of interactions between the different traditions in the use of motifs on the different panels, since rock art of the Southern Tradition is consistently superimposed over rock art of the Northern Tradition. If we take the time difference into account, this could mean that these locations, perhaps because of their often conspicuous character in the landscape, were used regularly and became institutionalised for rituals, which did not necessarily leave rock art, while the societies behind the rituals gradually shifted from a hunter-type ideology towards an agrarian way of thinking. Consequently, this would have resulted in Northern Tradition rock art being left at an initial stage, later culminating in rock art of the Southern Tradition.

Where traditions meet: Western Norway, the British Isles, Iberia and the Atlantic Tradition

With the aim of adding more information into the mixture, allowing for a more nuanced understanding of Scandinavian rock art, it is interesting to investigate potential influences in Western Norway, namely, the presence of geometric images, a topic that occupied earlier researchers. It has previously been argued that these images, both in Ausevik and elsewhere in Western Norway, share a number of features with Megalithic art (Marstrander 1972: 63–64; Fett and Fett 1979: 72; Twohig 1981: 134–140; Walderhaug 1994; Vevatne 1996), or 'Passage Grave Art', as it is often referred to today, found in the British Isles, in western France and western Iberia.

I still consider that the links between Western Norway and the British Isles and Iberia are worthy of investigation, and it should also be mentioned that a number of studies have been carried out in the latter areas in recent years which have provided a great deal of information about rock art chronology and distribution (*e.g.* Johnson 1993; Bradley 1997: 190–192; Waddington 2007). Taking the new dating evidence of Vingen and Ausevik into account, it probably excludes the Megalithic art, although new evidence from Galicia argues in favour of a much older dating for this tradition (Bueno *et al.* 2016:

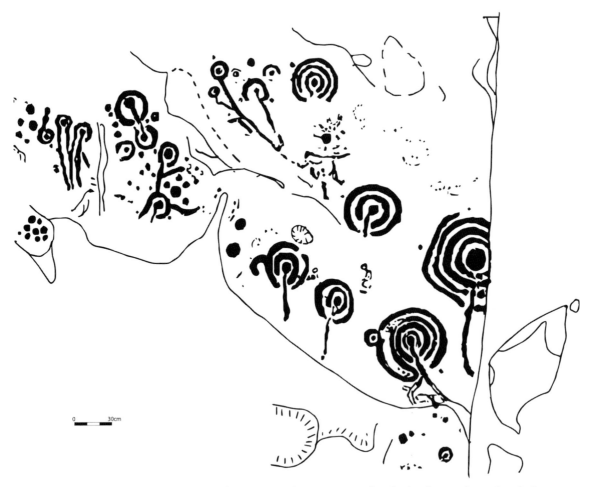

Figure 1.7. Rock art of the Cup and Ring Tradition at Roughting Linn, Northumberland, United Kingdom (redrawn from Beckensall 2001:25).

12–13). However, associations with the older Cup and Ring Tradition of the Atlantic art (Waddington 2007), seems more relevant to include in this debate, and perhaps also reconsiderations in terms of how ideas did not spread towards Western Norway, but instead, from it. Johnson (1993) and Waddington (2007) have both compared Passage Grave art with Atlantic art of the Cup and Ring Tradition in Ireland and Britain respectively, concluding that they belong to very distinct traditions. Although very occasional 'dot and ring' motifs occur in Irish passage grave art, there is otherwise no clear correspondence in terms of the form, context, distribution, age or treatment of the rock surfaces between the two traditions in the British Isles (Waddington 2007). It has also been argued that the Atlantic art or the Cup and Ring Tradition predates the fourth millennium cal BC, meaning that it is much older than the Megalithic art, which also implies that the datings of the rock art in Ausevik and Vingen are more or less contemporary and chronologically comparable to this tradition.

Within the context of the Cup and Ring Tradition, animals do not form a part of the imagery, but may have formed a central part of their religion and cosmology. Therefore, circles, or the very occasional spiral found within this tradition could have had a similar meaning to many circular motifs in Ausevik, and may have represented entrances for potential 'soul animals' that ensured the necessary regeneration. It is therefore interesting that within the Galician Atlantic style – which is closely related to the Cup and Ring Tradition and documented in the Iberian Peninsula – concentric circles and red deer are amongst the most frequent images (Twowig 1981: 135; Peña Santos and Rey Garcia 2001), and where the presence of anthropomorphs, in a simple form, may represent stylised skeletons. However, the dating of the latter type of imagery or narratives has been frequently discussed and questioned (*e.g.* Bradley 2013: 291), but in more than one sense it seems reasonable to consider that the thoughts behind these images were the same as in Ausevik. Recent archaeological investigations in the vicinity of panels in Campo Lameiro, in the Pontevedra region of Galicia in Spain, have added to this debate. On the one hand it has been concluded that the imagery should be dated to the end of the Bronze Age and the beginning of the Iron Age (Santos-Estévez 2013: 107–123), but scientific analysis has also provided data that may indicate that the human activity in the area could be dated as far back as the end of the fifth millennium cal BC (Martínez-Cortizas *et al.* 2013: 239–253), which

in addition to other arguments has suggested a much earlier dating of Galician rock art to the fourth millennium BC (Fábregas, 2009:71). The latter dating is much more in line with the dating of the Cup and Ring Tradition, considering the similarity and correspondence between geometric images in Galicia and the British Isles. Altogether, this could mean that the dating of sites in southern Europe and Western Norway is barely separated in time, or otherwise by only a few hundred years; thereby indicating potentially shared thoughts and related ideologies between Western Norway and Iberia, or between northern and southern Europe. It is therefore interesting to note that several of the narratives that are found in Ausevik have more shared features with panels in the Iberian Peninsula than with other sites in Scandinavia, some of which have been mentioned above (Fig. 1.8). This opens the way for a new chain of reasoning that may suggest that the sedentary hunter-fishermen of Western Norway shared a number of related ideas with sedentary hunter-fisher-farmers further south along the Atlantic coast, in the Iberian Peninsula. This may also have included the ideology behind the related Cup and Ring Tradition of Brittany and the British Isles, despite the lack of figurative rock art, thereby connecting the Northern Tradition in Western Norway to the Atlantic tradition.

As a result, this raises questions regarding the accepted traditions in Scandinavia. At first glance, some of the images may have another character that could just as easily have been caused by different rock types (in which metamorphosed sandstone and the indirect technique were frequently used in the north, while the direct technique used on granite was the southern equivalent, leading to different appearances), although the thought process behind the imagery – the religion, the cosmology and the ideology – could have been of a much more unified and shared character in these distant parts of Europe. Previous studies conducted by Eva and Per Fett at the end of the 1970s concluded that some of the iconography in Ausevik was the result of an influence from the Megalithic cultures of the British Isles, and so they dated at least the geometric images to the Late Neolithic (Fett and Fett 1979: 72–79). Despite a number of controversies associated with the rock art in Ausevik regarding whether it should be dated to the Late Neolithic or the Bronze Age, most researchers have argued that the appearance of spirals and concentric circles was a result of influences from central or southern Europe. Taking into account the new dating evidence from recent excavations which

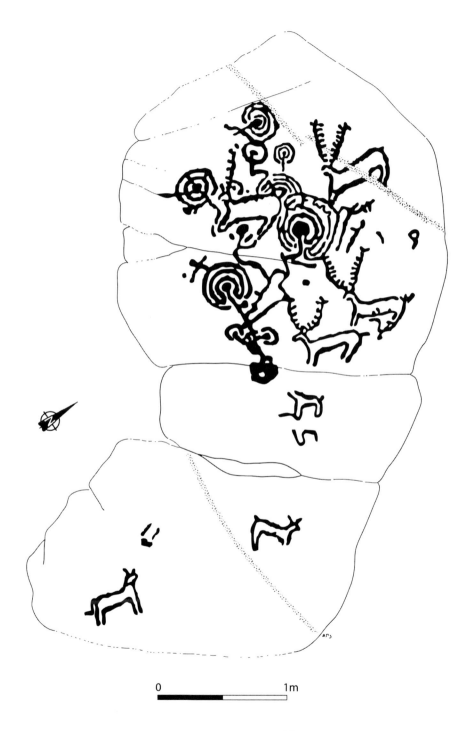

Figure 1.8. Red deer and concentric circles that are strikingly similar to the narratives in Ausevik: compare with Figures 1.3 and 1.4 above. Laxe dos Cebros, Cotobade. Galicia, Spain (after Peña and Rey 1993).

0 1m

indicate that the rock art was produced in the Late Mesolithic, and a number of recent studies of the British and Iberian rock art, this has now altered the perspectives and created a new point of departure. It seems at least plausible to consider that these ideas may have spread from an opposite point of origin. Since Scandinavia seems to have a much longer tradition of creating rock art at open-air sites, the religious or ideological practice of depicting images in rock may have been adopted by cultures further south during processes of contact between groups in northern and southern Europe. This does not necessarily include the thoughts behind the imagery, which may have been more omnipresent for a number of groups or cultures both in the north and in the south, or the result of cultural contact between these past cultures, but instead the physical process of pecking or carving images in solid rock. Much of the material presented above suggests that the ideas behind this imagery may have equally had a more Nordic origin, and that these ideas and the iconography originated in the north. In much the same way as we can discuss influences from the Onega and Kola area in Alta, Finnmark, where the dates do not correspond to the same degree (Gjerde 2010), there should be potential for comparisons of rock art between Western Norway and Iberia, which seems to be even more contemporary and have similarly structured narratives.

Conclusion

And so, in conclusion, I would like to end where I started, expressing the need to reconsider our Northern and Southern Traditions, as I feel I am incapable of understanding what these traditions represent, and whether they correspond to hunting societies on the one hand and farming societies on the other. Nor is it clear whether these types of motifs or the thoughts behind them correspond to my normal understanding of traditions dealing with other cultural remains, where the shared similarities of tools and structures are much more obvious. It is not always easy to define what separates the Southern Tradition rock art from that of the Northern Tradition, and in much the same way it is complicated to define what connects the sites within the different traditions. Is this simple system of categories beneficial, or are they meaningless distinctions that group together things that should be separated, and separate shared thoughts and ideas? The separation into two general groups, something that is clearly a modern categorisation, has provided perspectives in which

the societies responsible for the rock art are seen as being much more closely related to and associated with each other, due to the categorisation, than may have actually been the case in prehistory. On the contrary, as most rock art sites have their own individual character, appearance and iconography that is fairly unique for the different sites, I find it difficult to see the shared similarities for a number of sites within these two basic groups. If we are to accept that the rock art is the result of such contrasting cultures, then how is it possible that they have such a similar practice of depicting images on solid rock, and sometimes even on the same panel? Another issue is that if I were encouraged to maintain the idea of tradition, I wonder if there are openings for a 'Western Tradition' or a 'South-western Tradition' which could bring the Cup and Ring Tradition or Atlantic art into the mix. By widening the scope and evaluating the earliest open-air rock art in Europe, the emerging picture provides a number of nuances that should be further explored in the future. What happened to the once supported eastern influence in Western Norway, supported by previous researchers (Bakka 1975)? Researchers have argued in favour of an eastern influence from the Kola Peninsula at sites of the Northern Tradition in northern Sweden and northern Norway, despite its rather wide dating framework (Gjerde 2010: 393), but these influences are not so clear further south in Norway. There also seems to have been an eastern influence in the spread of rock paintings to Sweden and potentially to the Telemark area of Norway (Lahelma 2008; Slinning 2002). Researchers have also argued that there are similarities between Finnish paintings and carvings at Nämforsen (Gjerde 2010), but are paintings and carvings necessarily comparable? Whatever the case, there is a need to explore in much greater detail the cultural ideas that are shared within areas with sites containing hunters' rock art or rock art from the Northern Tradition, and at what point we introduce the contemporary cultural material context, as this is something that has largely been overlooked, and is a classic problem when associating rock art studies and studies of material culture in archaeological research.

References

Albrethsen, S. E. and E. Brinch Petersen 1976. Excavation of a Mesolithic Cemetery at Vedbæk, Denmark. *Acta Archaeologica* 47: 1–28.
Bakka, E. 1973. Om alderen på veideristningane. *Viking* 37: 151–187.

Bakka, E. 1979. On Shoreline Dating of Arctic Rock Carvings in Vingen, Western Norway. *Norwegian Archaeological Review* 12(2): 115–122.

Barth, F. 1987. *Cosmologies in the Making: A Generative Approach to Cultural Variation in Inner New Guinea.* Cambridge University Press. Cambridge.

Beckensall, S. 2001. *Prehistoric Rock Art in Northumberland.* Tempus. Stroud.

Bégouën, H. and H. Breuil 1958. *Les Cavernes du Volp: Trois-Frères, Tuc d'Audobert, à Montesquieu-Avantès (Ariège).* Arts et métiers graphiques. Paris.

Berg, B. 2003. Bergkunst på Amtmannsnes II. Unpublished Cand Philol thesis. University of Tromsø. Tromsø.

Bjerck, H. B. 2008. Norwegian Mesolithic Trends: A Review. *Mesolithic Europe* (G. Bailey and P. Spilkins, eds): 60–106. Cambridge University Press. Cambridge.

Bøe, J. 1932. Felszeichnungen im westlichen Norwegen I. Vingen und Hennøya. *Bergens Museums Skrifter* 15. A.S. John Griegs Boktrykkeri. Bergen.

Bradley, R. 1997. *Rock Art and the Prehistory of Atlantic Europe: Signing the Land.* Routledge. London.

Bradley, R. 2013. Perspectives from Outside. 1. Twenty Questions about Campo Lameiro. *Petroglifos, paleoambiente y paisaje: Estudios interdisciplinares del arte rupestre de Campo Lameiro (Pontevedra).* (F. Criado-Boado, A. Martínez-Cortizas and M.-V. García Quitela, eds). *Tapa* 42. Instituto de Ciencias del Patrimonio (Incipit). Madrid.

Breuil, H. and H. Obermaier 1935. *The Cave of Altamira at Santillana del Mar, Spain, Madrid, Junta de las Cuevas de AltaMira.* The Hispanic Society of America. Madrid.

Bueno, P. R., Carrera, F. R., Balbín R. B., Barroso, R. B., Darriba, X. and Paz. A. 2016. Stones before Stones. *Reused stelae and menhirs in Galician megaliths. Public Images, Private Readings: Multi-Perspective Approaches to the Post-Palaeolithic Rock Art* (R. V. Fábregas and C. Rodríguez-Rellán) Vol 5: 1–16. Archaeopress Archaeology.

Cauwe, N. 1988. Sépultures collectives du Mésolithique au Néolithique. *Sépultures d'Occident et genèses des mégalithismes, 9000–3500 avant notre ère. Séminaires du Collège de France* (J. Guilaine, ed.): 11–24. Editions Errance. Arles.

Cauwe, N. 2001. Skeletons in Motion, Ancestors in Action: Early Mesolithic Collective Tombs in Southern Belgium. *Cambridge Archaeological Journal* 11(2): 147–63.

Fábregas, R. V. 2009. A Context for the Galician Rock Art. *Rock Carvings of the European and African Atlantic Facade.* (R. de Balbin Behrmann, P. Bueno Ramirez, R Gonzalez Anton, C del Arco Aguilar, eds) BAR 2009 Series 2043: 69–84.

Fett, E. N and P. Fett 1979. Relations West Norway – Western Europe Documented in Petroglyphs. *Norwegian Archaeological Review* 12(2): 65–107.

Gjerde, J. M. 2010. Rock Art and Landscapes: Studies of Stone Age Rock Art from Northern Fennoscandia. PhD dissertation. University of Tromsø. Tromsø.

Gjessing, G. 1932. *Arktiske helleristninger i Nord-Norge.* Instituttet for sammenlignende kulturforskning. Oslo.

Gjessing, G. 1936. *Nordenfjeldske ristninger og malinger av den arktiske gruppe.* Instituttet for sammenlignende kulturforskning. Oslo.

Goldhahn, J. 1999. *Sagaholm - Hällristningar och gravritual.* Umeå universitet. Umeå.

Grigson, C. and P. Mellars 1987. The Mammalian Remains from the Middens. *Excavations on Oronsay. Prehistoric Human Ecology on a Small Island* (P. Mellars, ed): 243–289. Edinburgh University Press. Edinburgh.

Grünberg, J. 2000. Mesolithische Bestattungen in Europa: Eine Beitrag zur vergleichenden Gräberkunde. *Internationale Archäologie* 40. Verlag Marie Leidorf GmbH. Rahden.

Hagen, A. 1969. Studier i vestnorsk bergkunst: Ausevik i Flora. *Årbok for Universitetet i Bergen. Humanistisk series 3*. Norwegian Universities Press. Bergen.

Hallström, G. 1938. *Monumental Art of Northern Europe from the Stone Age. I. The Norwegian Localities*. Thule. Stockholm.

Hansen, A. M. 1904. *Landnåm i Norge: En utsigt over bosætningens historie*. Fabritius. Oslo.

Helskog, K. 1999. The Shore Connection: Cognitive Landscapes and Communication with Rock Carvings in Northernmost Europe. *Archaeological Review* 32: 73–94.

Hesjedal, A. 1994. Helleristninger som tegn og tekst: En analyse av veideristningene i Nordland og Troms. MA thesis. University of Tromsø. Tromsø.

Jansen, K. 1972. Grønehelleren, en kystboplass. Unpublished Mag. Art thesis, University of Bergen. Bergen.

Johnson, S. A. 1993. The Relationship between Prehistoric Irish Rock Art and Irish Passage Tomb Art. *Oxford Journal of Archaeology* 12(3): 257–279.

Lahelma, A. 2008. A Touch of Red: Archaeological and Ethnographic Approaches to interpreting Finnish rock paintings. PhD dissertation. University of Helsinki. Helsinki.

Larsson, L. 1988 Dödshus, djurkäkar och stenyxor: Några reflektioner kring senmesolitiskt gravskick. *Gravskick och gravdata* (E. Iregren, K. Jennbert and L. Larsson, eds): 63–72. Lunds Universitet. Lund.

Linge, T. E. 2007. *Mjeltehaugen: Fragment av gravritual*. UBAS 3. Hovedfag/master. University of Bergen. Bergen.

Lødøen, T. 2003. Late Mesolithic Rock Art and Expressions of Ideology. *Mesolithic on the Move* (L. Larsson, H. Kindgren, D. Loeffler and A. Åkerlund, eds). Papers presented at the Sixth International Conference on the Mesolithic in Europe: 511–520. Stockholm, 2000. Oxbow Books. Oxford.

Lødøen, T. 2010 Concepts of Rock in Late Mesolithic Western Norway. *Changing Pictures* (J. Goldhahn, I. Fuglestvedt and A. Jones, eds): 35–47. Oxbow Books. Oxford.

Lødøen, T. K. 2010b (ed.). The Rock Art Project – Securing and Protecting Rock Art – University of Bergen 1996–2005. *Rock Art Reports from the University of Bergen*. University of Bergen. Bergen.

Lødøen, T. K. 2013. Om alderen til Vingen-ristningene. *Viking* 76: 7–34.

Lødøen, T. K. 2014. På sporet av senmesolittiske døderiter – Fornyet innsikt i alderen and betydningen av bergkunsten i Ausevik, Flora, Sogn & Fjordane. *Primitive Tider* 16: 51–75.

Lødøen, T. K. 2015a. Treatment of Corpses, Consumption of the Soul and Production of Rock Art: Approaching Late Mesolithic Mortuary Practices Reflected in the Rock Art from Western Norway. *Fennoscandia Archaeologia* XXXII: 79–99.

Lødøen, T. K. 2015b. Rock Art as Mortuary Practice in the Late Mesolithic of Western Norway. *Rock Art: When, Why and to Whom* (E. Anati, ed.): 122–126. Atelier. Capo di Ponte, Brescia, Italy.

Lødøen, T. K. and G. Mandt 2010. *The Rock Art of Norway*. Windgather Press. Oxford.

Lødøen, T. K. and G. Mandt 2012. Vingen – et naturens kolossalmuseum for helleristninger. *Instituttet for sammenlignende kulturforskning, Serie B Skrifter 146*. Akademika. Trondheim.

Mandt, G. 1972. Bergbilder i Hordaland: En undersøkelse av bildenes sammensetning deres naturmiljø og kulturmiljø. Årbok *for Universitetet i Bergen. Humanistisk serie* 1970:2. Norwegian University Press. Bergen.

Mandt, G. 1991 Vestnorske ristninger i tid og rom: Kronologiske og korologiske studier. Volumes 1–2. Unpublished PhD thesis. University of Bergen. Bergen.

Marstrander, S. 1972. The Problem of European Impulses in the Nordic Area of Agrarian Rock Art. *Acts of the International Symposium on Rock Art* (S. Marstrander, ed): 45–67. Universitetsforlaget. Oslo.

Martínez-Cortizas, A., M Costa-Casias, J. Kaal, C. F. Vázquez, X. Pontevedra-Pombal and W. Viveen. 2013. De la Geoquímica al Paisaje: Composición Elemental de los Suelos. *Petroglifos, paleoambiente y paisaje: Estudios interdisciplinares del arte rupestre de Campo Lameiro (Pontevedra).* (F. Criado-Boado, A. Martínez-Cortizas and M.-V. Garcia Quitela, eds). *Tapa* 42: 239–253. Instituto de Ciencias del Patrimonio (Incipit). Madrid.

Mikkelsen, E. 1977. Østnorske veideristninger – kronologi og kulturelt miljø. *Viking* 40: 147–201.

Nilsson Stutz, L. 2003. *Embodied Rituals & Ritualized Bodies: Tracing Ritual Practices in Late Mesolithic Burials.* Lunds Universitet. Lund.

Peña Santos, A. and J. M. Rey García 2001. *Petroglifos de Galicia.* Via Láctea. A Coruña.

Prescott, C. and E. Walderhaug 1995. The Last Frontier? Processes of Indo-Europeanization in Northern Europe: The Norwegian Case. *The Journal of Indo-European Studies* 23 (3/4): 257–280.

Ramstad, M. 2000. Veideristningene på Møre: Teori, kronologi og dateringsmetoder. *Viking* 63: 51–86.

Santos-Estéves, M. 2013. Excavaciones arqueológicas en el entorno de los petroglifos. *Petroglifos, paleoambiente y paisaje: Estudios interdisciplinares del arte rupestre de Campo Lameiro (Pontevedra)* (F. Criado-Boado, A. Martínez-Cortizas and M.-V. García Quitela eds). *Tapa* 42: 107–123. Instituto de Ciencias del Patrimonio (Incipit). Madrid.

Simonsen, P. 1958. *Arktiske helleristninger i Nord-Norge* II. Institutt for sammenlignende kulturforskning; B 49. Oslo.

Slinning, T. 2002. Bergmalingene i Telemark: Kultstedenes tidfesting og sosiale sammenheng, Bergen. MA dissertation. University of Bergen. Bergen.

Sognnes, K. 1999. *Det levende berget.* Tapir. Trondheim.

Sognnes, K. 2001. Prehistoric Imagery and Landscapes: Rock Art in Stjørdal, Trøndelag. *BAR International Series.* Archaeopress. Oxford.

Twohig, E. S. 1981. *The Megalithic Art of Western Europe.* Oxford University Press. Oxford.

Vevatne, K. 2006. Ristningar i Etne: Ein analyse av tid og rom. Unpublished Cand Philol thesis. University of Bergen. Bergen.

Waddington, C. 2007. Cup and Rings and Passage Grave Art: Insular and Imported Traditions. *Beyond Stonehenge: Essays in Honour of Colin Burgess* (C. Burgess, P. Topping and F. Lynch, eds). Oxbow Books. Oxford.

Walderhaug, E. 1994. Ansiktet er av stein: Ausevik i Flora – en analyse av bergkunst & kontekst. Unpublished Cand Philol thesis. University of Bergen. Bergen.

Wold, M. 2002. Bergkunst som levninger etter ritualer: Motivbaserte tolkningsforsøk av lokaliteter i Hordaland. Unpublished Cand Philol thesis, University of Bergen. Bergen.

Chapter 2

Where Styles Meet – What Does it Mean?

Heidrun Stebergløkken

Abstract: This chapter focuses on the concept of style in rock art. As in other parts of the world, style has primarily been used as a dating method in Norwegian rock art research. In combination with shoreline dating researchers developed a stylistic sequence of the rock art belonging to the Northern Tradition, which has been used to a greater or lesser extent for almost a century. An interesting characteristic of central Norway is the meeting between the Northern and the Southern Traditions. In this region, the different traditions coexist not just in this macro-perspective, but also side by side at the same sites – occasionally even at the same panels. The region is a perfect place to study the interaction between the two traditions. The rock art also shows enormous variation in style and drawing methods. What can this encounter tell us? And why does this area show such stylistic variation?

Key words: Style, dating, type, Northern Tradition, central Norway, documentation, tracing, interpretation.

Style and dating

One of the challenges of rock art style studies in Norway is that the concept of style has seldom been defined. I was introduced to this problem when I wrote my master's thesis (Stebergløkken, 2008). When I started to discuss the concept of style, it quickly outgrew the framework of the master's thesis, but the topic never left my attention. My PhD project gave me the opportunity to go deeper into this question and to problematise the concept and its usage in Norwegian rock art research.

In this chapter, I use the concepts of 'Northern' and 'Southern' Traditions, the Northern representing the oldest tradition, often connected to the Stone Age hunting tradition. In central Norway, the Southern Tradition is often located in cultivated land, and interpreted in an agrarian context. The borders between the two, however, are not meant to be seen as absolute. There are several examples of coexistence that I will discuss here.

Johan Ling has in recent years made some new discoveries of the rock art belonging to the Southern Tradition in Bohuslän and Uppland, Sweden (Ling, 2004, 2008, 2013). Ling's work shows that the material has a strong maritime connection and could be linked to the coast. The material is dominated by ship figures and there is an absence of motifs that could be linked to agriculture. Because of this, he does not place this tradition in an agrarian context. Instead, Ling sees the maritime aspect as an important factor in localisation. He sees the sites as meeting places between groups or social gatherings associated perhaps with rites of passage, war, travel, transfer of power, launching boats or death (Ling 2013: 89). This is important and pioneering work that opens up new interpretations.

The Southern Tradition material in central Norway shows similarities to Bohuslän when it comes to the motifs represented. That being said, to assume that these interpretations can be transferred directly to the material from central Norway is not necessarily correct. The rock art (Southern Tradition) from central Norway seems to be located very differently from the rock art in Bohuslän. The fjords appear to be important to the Bronze Age society when it comes to other cultural monuments. The burial mounds were located in strategic places on the

coast as visible markers that could be seen from the sea. The rock art, however, seems to be located by the settlements further inland, out of sight of the strangers travelling by sea (Sognnes 1998: 157, 2012: 238; Stebergløkken 2016: 259–260). In contrast to the situation described by Ling (2008) for rock art in Bohuslän, it seems as if something different was happening in central Norway. Although ship motifs dominate, they seem to have a different contact with the landscape. If the ship motifs should be interpreted in an agrarian context, this could be seen in relation to ships as important means of transport for the first imports of livestock and grain (Stebergløkken 2016: 260).

My research has focused on material from the Northern Tradition in central Norway. In particular, five motifs dominate the material: cervids, marine birds, whales, boats and fish. They represent a total of 552 figures divided among 67 panels. Of the 552 figures, 260 are cervids. The cervids therefore stand out as the largest group of motifs.

In Norwegian rock art research the concept of style is closely linked to dating, where style has primary been used as a dating method. This originates from the evolutionary ideas of the 1920–1930s. Haakon Shetelig (1921, 1922), Gustaf Hallström (1938) and Gutorm Gjessing (1936) were the first to see style as an indication of age. Gjessing further developed Shetelig's theories of the evolution of style, from the oldest naturalistic style to a more schematic style at the transition to the Bronze Age. Style in combination with studies of land uplift (maximum date) resulted in three styles and chronological phases:

Style I – Large naturalistic animals, often just contour-drawn;
Style II – Smaller but still contour-drawn animals, less naturalistic and sometimes with internal lines (lifelines);
Style III – Small schematic animals with internal pattern (Gjessing 1936: 168).

The problem lies in the fact that there is no further description of the styles or definition of what style is. Gjessing simply placed the sites known until then within these three style phases. At first this appears non-problematic and we see a clear difference between the naturalistic style of Bøla (Style I) and the schematic style of Holtås (Style III) (Fig. 2.1). The challenge is identifying style II. If we compare the sites that Gjessing categorised in terms of the three styles with the sites discovered in recent decades,

style II emerges as large category containing almost 80% of the material belonging to the Northern Tradition in central Norway. It includes all the material that is

Figure 2.1. A: Style I represented by Bøla I. Tracing: Sognnes 1981. B: Style III represented by Holtås I (tracing: Møllenhus 1968).

not in the purest naturalistic or schematic form. This is because the figures with style II often have elements that are both naturalistic and schematic. Style I is represented by 12% of the material and style III only 9%. Gjessing (1936) supported Style III on the evolutionary idea of style development. He thought that the style represented at Bardal III (Lamtrøa) was completely different from Bardal I and that it had to be much later (Gjessing 1936: 171). The fact that Bardal III is located 11 metres higher than Bardal I does not seem to matter in this case.

The other problem lies in the fact that this style sequence was made almost a hundred years ago. Gjessing himself also said the sequence could be changed with future findings. He also believed that style could be seen in a geographic perspective and that style could be linked to local variations (Gjessing 1936: 159).

The material has increased since this stylistic sequence was made during the 1930s and now shows even greater variation. As a consequence, the style sequence has become inaccurate and in some cases incorrect. The famous reindeer from Bøla (naturalistic) is stylistically dated older than the cervid from Holtås (schematic). However, the shoreline dating tells another story. If we apply the land uplift program developed at the University of Tromsø (Holmeslet 2002), the picture changes. The cervid representing Style I (Bøla) is located at 44 m above sea level, which dates it at 5400 BP. The cervid representing Style III (Holtås) is located at 54 m above sea level, which equals 6500 BP. According to land uplift and shoreline dating, the cervid with the youngest style is the oldest. There is a possibility, of course, of the younger styles appearing at higher shorelines, but not the other way around.

This example could just be an exception to the rule, but my review of the material in central Norway shows that stylistic dating and shoreline dating do not match. Firstly, the Style I sites are not found at the highest shorelines, nor is Style III represented at the lowest shorelines. This indicates that the style sequence is inaccurate and maybe outdated as a method, and

that style associated with shorelines does not give the meaning previously thought. We are left with two choices, either to continue using the style sequence but to further develop it while attempting to uncover the sources of chronological error. The alternative is not to use the style sequence at all. I have chosen to leave the style sequence, as I believe the inadequacy of this material shows the shortcomings of the dating method. Ideally, we would be able to date material from the central Norway by combining style with shoreline dating. At the moment, however, shoreline dating does not support a sequence where naturalistic Style I is the oldest and the schematic Style III represents the youngest phase (Lindgaard 2014: 65; Stebergløkken 2016: 108–109).

What is style?

This is an important question, but no easy answer exists. Part of the problem may be that the style concept is so well known to us today. We are surrounded by this concept throughout our lives. But style comes in many forms and in many contexts. If we are going to use the concept as the methodological basis for rock art research, we need to have a clear and unequivocal definition of the concept. A review of previous work in Norwegian and Scandinavian rock art research shows that this does not seem to have been the case. One of the main problems is the mixing of the concepts of style and type. These concepts are often used interchangeably. Both style and type have been used for classifying rock art.

Gustaf Hallström (1907) focused on the aesthetic qualities of the rock art and built his classification on these aesthetic elements, but he does not use the term style until later. Shetelig (1922) and Gjessing (1936) continued this tradition and the style of the rock art is seen in an evolutionary linear sequence. In the 1930s, Hallström (1938) started to use the term style as well, but he had a different approach. He saw the style as an expression of different phases, but he also tied style to geographic areas (Hallström 1938: 315–355). This reminds us of the approach some American researchers take when they connect style to certain geographic regions (Plog 2009). Povl Simonsen (1979) also made this association and saw style in a time

perspective but also connected style to geographic areas. Egil Bakka (1973) uses both style and type, as did Egil Mikkelsen (1977) when he classified his material. This can be a little confusing and can result in misunderstandings when it comes to separating the two concepts and identifying the differences between them. This is especially a problem when style is used in classification and typology.

Because these concepts are seldom defined, rock art researchers use the concepts in different ways. Some will use style while others would use type instead. One also realises that style and type are connected, but they also represent something different.

Polly Wiessner (2009) writes that style can represent different things, and she distinguishes between 'assertive' and 'emblemic' style. While assertive style is to be seen as an expression of individuality and individual identity, emblemic style is seen as an expression of group identity and borders between different groups (Wiessner 2009: 107–108). In this way style can contain information on many levels, on both a personal and a social level.

Benjamin Smith (1998) describes a dichotomy within the rock art research. On one hand, you find researchers who believe that style chronology is meaningful and that style is a relevant analysis of rock art. On the other hand, you find those who find the concept of style problematic. Smith describes style as a very elusive concept. Style will be affected by both time and space. New styles will take over; some will be adopted and perhaps developed. In some cases, style may also stay more or less unchanged (Smith 1998: 218–219). Because of this, linking style to a specific date is problematic.

Eva Lindgaard (2014) has problematised both style dating and shoreline dating. She discards the idea of style dating because she finds different styles overlapping at same sea level. Shoreline dating should only be used as an indication of maximum age. Her solution to the dating problem is to build a dating framework consisting of radiocarbon dating and shoreline dating (Lindgaard 2014: 65). As a result, she leaves the style concept and the implications of style variation altogether. Instead she focuses on more reliable methods to date the rock art.

Researchers using shoreline dating see rock art as belonging to the Northern Tradition within the context of prehistoric beaches, and interpret the rock art as shore-bound. The material from central Norway shows that it is not necessarily so. Shoreline dating in combination with style dating

has led us to an impasse, as pointed out with the example above (Fig. 2.1). This is only one of many examples showing that style and shoreline dating is difficult in central Norway. As I will come back to, there are similarities between the rock art sites Hammer, Bardal and Evenhus, which may indicate a connection between these sites. These sites, though, are located at very different sea levels, which could be interpreted to mean that the sites were not necessarily shore-bound. In my doctoral thesis, I also argue that the variation in the creation of the motifs could possibly be a result of several visits. If that is the case, one site could have several different time contexts, and then shoreline dating becomes very difficult (Stebergløkken 2016: 263 265). This may be why style and shoreline dating have not been able to bring any new aspects to the research in central Norway in recent years, as has also been pointed out by Kalle Sognnes (2007, 2012a, 2017). Sognnes (2012b) argues that style can be interpreted in two different ways, either as a chronological aspect or as an expression of different group activity (Sognnes 2012b: 241). I believe there are too many arguments against the first. As a result, I have chosen to abandon both methods, but I do not want to discard the concept of style, which I believe still gives meaning, but in another context. My intention is to further investigate what style could mean. Style can be an expression of so much more than just an indicator of time. I believe it is important to keep the two concepts, style and type, separate because they are the foundations of different analyses. I have defined these two concepts for my thesis based on research done both in Norway and in Scandinavia, but also internationally:

- *Style* should be seen as an element of the figure that is created by the artist. Style is a part of the figure, and could have been influenced by the period, group, technique, the place and/or the artist, the creator of the specific image. It is something that already exists, and it is up to the researcher to explore what it could mean.
- *Type*, on the other hand, is something fabricated by the researcher. It serves as a tool to generalise the material, for example before a classification.

In my definition of style and type, figures can be sorted in the same type categories in a typology, but these figures do not necessarily need to share the same style. In other words, there can be style variation within the same type.

From a northern point of view

As the title of this volume – *North meets South* – implies, there appears to be an encounter between two different traditions. There also seems to be an overlap between these two traditions. In central Norway, this overlap is very distinct. The different traditions coexist in this region not just in a macro-perspective, but sometimes also side by side at the same sites, occasionally even on the same panels. This region is a perfect place to study the interaction or non-interaction between these two traditions.

I will approach this topic using material from the Northern Tradition, based on the research I undertook during the course of my PhD. The Northern material shows enormous variation. When I first tried to group the Northern material, I was struck by the complexity of it. The details of the figures and the different drawing methods have almost more differences than similarities.

For my typology, I have identified gestalts based on how the figures have been constructed. The gestalts represent the intuitive types and are so distinctive that they immediately seem to stand out. Gestalts should be so distinctly different from each other that we do not need to analyse the difference to understand what separates them. These gestalts will constitute the foundation blocks and will function as a natural starting point for the typology. Adams and Adams (1991) write that one will be left with a fairly large residual material when the gestalts are identified. This rest cannot be classified as easily. Then starts a completely different process; making types (Adams and Adams 1991: 54–56). In my typology, my overall goal is to find out whether there are any similarities in the drawing method of the material, and whether I can see similarities between the figures in the way they are constructed (Fig. 2.2). Chronology, technique, geography and shorelines are not factors in my typology. The typology also needs to be well described and the description should be on a comprehensible level with not too much focus on the details of the figure. This is because there could be sources of error on a micro-level. This may have been caused as a result of interpreting the documentation or differences in documentation techniques. The important argument is that the types should be verifiable. Other researchers should be able to understand the type definitions and it should also be possible to use the same classification system on another

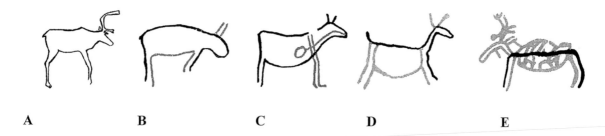

A B C D E

Figure 2.2. The cervids' five gestalts, the black lines illustrate the different framework (tracings, from left: Sognnes 1981, Gjessing 1936, Gjessing 1936, Gjessing 1936, Møllenhus 1968; illustration: Stebergløkken 2016: 141).

material. Types obviously need to be adjusted or cut/added because typology is not static, and it will change with access to new material.

Too much focus on the details in the classification can also create another problem. If two or more figures fit the same gestalt and even the same type description, they can still show dissimilarities in detail or the design of the figure. This could imply style differences. The similarities between the frameworks could mean that they were created by people belonging to the same tradition who had the same teacher/schooling, but the different style could imply different artists with the same teaching passed down or across generations.

Michael Polanyi (1962) considers it impossible for art forms to continue to the next generation with a manual. He believes that various forms of art could only be transferred through a master-apprentice relationship (Polanyi 1962: 53). Is it possible to see rock art in this context where the young are trained by masters? How to construct the figures, which framework should be used or even which elements/attributes were important for that particular group, could be seen as learned constants? This way of thinking relates to what Polly Wiessner (2009) describes as emblemic style (as mentioned initially). I chose to use the concept of style exclusively at an individual level, to clarify the meaning and distinguish style from gestalt and type.

The five gestalts (Fig. 2.2) could represent different schools and the type variation different group traditions within the same gestalt. How the lines and attributes are carried out may vary, representing style variation on an individual level.

The close connection

Approximately 25% of all the rock art in Norway is located in central Norway. My material consists of 67 panels divided between 37 sites, and over half of the sites are located in Nord-Trøndelag county. Kalle Sognnes (2008) estimates that the material is divided 20–80% between the two traditions. The Southern Tradition is clearly over-represented in this area, particularly in the Stjørdal municipality (Sognnes 2008: 230). Nord-Trøndelag county seems to be in a unique position with a concentration of rock art from both traditions. There are ten sites in total with rock art from both traditions. Four of the sites consists of rock art belonging to both traditions, but the different traditions occur on different panels: Berg, Lånke, Skjevik and Bogge. There are six further sites that stand out from the rest of the material – Bardal, Homnes, Revlan, Holtås, Hammer and Evenhus – where both traditions are represented on the same panels (Fig. 2.3).

Bardal is the most famous of them and distinguishes itself by the large amount of rock art and superimpositions. No other panel in central Norway has superimpositions to the same extent. Usually the panels are much smaller and have a small number of figures. Bardal does not represent the norm but is still an interesting and important deviation, which raises a number of questions. One of these questions has been asked by Kalle Sognnes (2008): why was the rock art made at this particular panel, not just on one occasion but on repeated visits? As pointed out by Sognnes, there are hundreds of other rocks suitable for rock art in the area. Still the people belonging to the Southern Tradition chose to hammer their images on top of the already existing Northern rock art. This cannot have happened randomly, and the superimpositions imply a deliberate act (Sognnes 2008: 239–241). It also gives us the impression of aggression (Fig. 2.4). The rock art from the Northern Tradition was visible when the Southern rock art was made; it still is today (even before the conservation and maintenance began at Bardal in 2005).

Instead of deciding that they wanted to add their own art to this panel and build on the existing rock art, they decided to cover the existing rock art with the figures from their own world of symbols. Why wasn't it necessary to cover the Northern Tradition at the other sites?

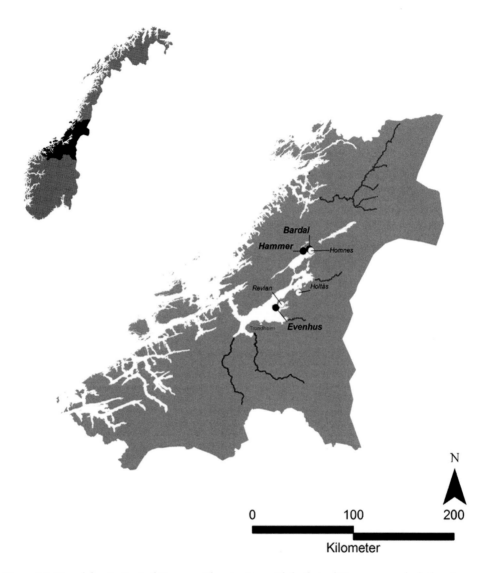

Figure 2.3. Trøndelag in Central Norway. The six sites with both traditions are marked, the sites highlighted and marked with black dots represent the three examples from the text; Bardal, Hammer and Evenhus (illustration: Raymond Sauvage, NTNU, The Museum of Natural and Cultural History 2014).

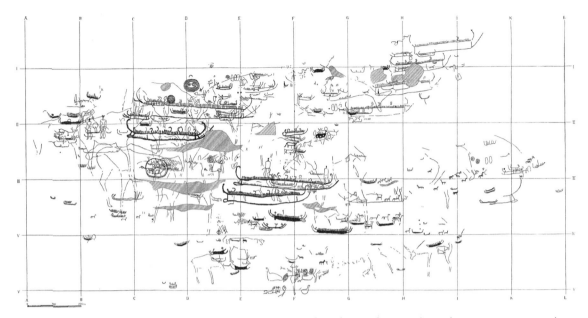

Figure 2.4. Bardal I. The Southern tradition is superimposed on the Northern tradition (tracing: Gjessing 1936).

At other sites the people from the Southern Tradition chose a different panel or placed the figures beside the existing figures belonging to the older traditions, as the examples from Evenhus and Hammer show (Figs 2.5 and 2.6).

Sadly, some of the figures at Evenhus I (Fig. 2.5) have been damaged by exfoliation, and cervid number 4 has lost the back part of its body. Figure 2.3 is interpreted as a boat belonging to the Southern Tradition. Gjessing (1936) also interprets Figure 2.6 as lines belonging to a boat of the Southern Tradition. What is really interesting about this example from Evenhus is that the boats from the Southern Tradition seem to be more weathered than the figures belonging to the Northern Tradition. Gjessing believed that the differences in weathering could mean that the figures belonging to the oldest tradition were pecked deeper and with a better technique, and are therefore more visible today. He also thought that this example shows us that we should be careful about judging chronological orders based on the degree of weathering (Gjessing 1936: 85). This may also indicate that the images belonging to the Southern Tradition were made first

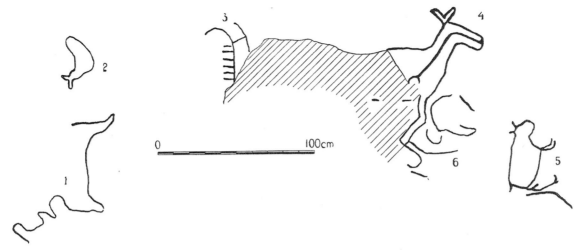

Figure 2.5. Tracing of Evenhus (Gjessing 1936).

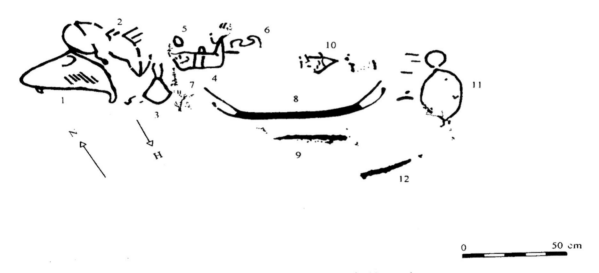

Figure 2.6. Tracing of Hammer IX (Bakka 1988).

at this particular panel and could be a confirmation of the coexistence of the two traditions and that there could have been coexistence over a long period.

Hammer IX (Fig. 2.6) also shows figures belonging to both traditions. The boat figures numbered 4 and 6 belong to the Northern Tradition and

resemble the boats at Evenhus. Boat figure number 8 is of a completely different nature and belongs to the Southern Tradition. Bakka (1988) describes the boat as Hjortspring type with the hull fully pecked. He describes the technique as almost perfect, made by someone with an unusually steady hand, with almost no errors (Bakka 1988: 34).

These three examples from Bardal, Hammer and Evenhus all show the coexistence of both traditions on the same panels. But they differ in the way they coexist, from superimpositions to incorporation and integration with the already existing compositions. These three sites could be starting points to study this meeting between two traditions in central Norway, and perhaps they tell different stories about the nature of this meeting. I would like to go further into this matter, and look more closely at these examples. I will also try to find out whether the figures belonging to the Northern Tradition show differences in gestalts, types or style in their encounter with the Southern Tradition.

Bardal

As mentioned, Bardal I represents a contradiction to the rest of the material with the large amount of superimpositions. It is impossible to say how much later the new tradition took over and placed its rock art on top of the old art. This might indicate the coexistence of different groups at some form of meeting place. However, another alternative is that the new tradition took over the place when the people of the old tradition were long gone, and that the superimpositions are a way of making the site their place.

The Bardal site actually consists of five panels located at different heights belonging to the same property boundary today. Bardal II, VI and V are located at 111–116 m above sea level and belong to a totally different context. These are located in an uncultivated area of the farm and consist of rock art belonging to the Southern Tradition. Bardal III consists exclusively of rock art of the Northern Tradition, depicting cervids and a fringed figure which shows a remarkable resemblance to another site called Holtås I in the same county. These two figures A and B (Fig. 2.7) share both the same

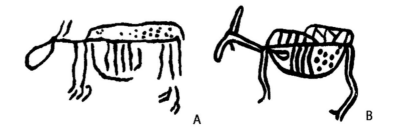

Figure 2.7. Cervids from A: Bardal III and B: Holtås I (tracings, from left: Gjessing 1936, Møllenhus 1968).

A

B

gestalt and the same type. Both figures are constructed in the same way; they have a straight back-line connecting the head and the feet. They both have bodies constructed above and underneath this back-line and they show resemblance in internal pattern (dots and lines). At the same time, there is something that separates them. The legs are slightly different, the shape of the head is different and the lines and mixing of internal pattern clearly separate these two figures. This difference, however, has nothing to do with the typology of the figure. Instead, it is what I define as 'style difference'.

This is a perfect example to illustrate that similarities in the construction of the figure and attributes do not necessarily mean same style. I interpret these two figures as a result of a mutual tradition made by artists who had the same teacher/schooling, but the difference in style implies different artists. This could mean concurrency in time but it could also be a result of teaching passed down through generations.

However, this particular gestalt does not appear on the main panel at Bardal I where the two traditions meet. All figures belonging to the Northern Tradition – the cervids, birds and whales – show similarities at Bardal I. They are constructed with an outline and appear quite naturalistic. They are depicted in correct profile, except the big whale figure in the upper part of the panel. This whale is depicted in twisted perspective (Deregowski, 2005); the tail is twisted so both characteristic tail fins are visible. This can be seen as a perceptive element, which makes it easier to recognise the motif (Deregowski 2005: 131–139). As Figure 2.4 shows, the Southern Tradition completely covers the old tradition's rock art on both the upper and the lower part of the panel. The similarities of the gestalt and the types used by the people belonging to the old tradition could mean that the panel was used by a limited number of people/groups on their first visits to the

panel. Even though the figures show similarities in gestalt and type, there are differences and variations in style. This indicates that the rock art was made by different people with their own individual style, but could belong to the same group tradition with the same schooling.

The younger tradition shows more variation which could indicate the opposite. This could mean that the Southern Tradition started to use Bardal I because the panel was only used for a limited amount of time by the Northern Tradition, and that they had already left the area years before. It could also mean that the people of the younger tradition outnumbered the old one and squeezed them out of the territory, hence the aggressive superimposition. Another theory could be that this panel represents a transition to another lifestyle (agriculture or husbandry) and/or religious beliefs, not necessarily a different group of people. The superimpositions could have been made by the same people and same groups living in the area who had adopted a new way of living. This does not necessarily express aggression between different people belonging to different traditions. My purpose with this is to leave open the possibility that regional groups were capable of adopting and adapting new ideas/rituals/religion that were presented to them. It does not have to be interpreted as an external force that repressed the old tradition.

Hammer

Hammer is located approximately 7 km west of Bardal (Fig. 2.4). Though the rock art here represents both traditions, the context is different. Hammer consists of many small panels scattered in the area surrounding the farm, to a total amount of 17 panels in all. Eight of these are panels containing rock art belonging exclusively to the Northern Tradition and six belong to the Southern Tradition. In addition, there are three panels containing both traditions: Hammer I, V and IX (Fig. 2.6). In these three cases, boats belonging to the Southern Tradition (and footprints at Hammer V) meet the Northern Tradition on these panels (Bakka, 1988). The tendency is that the two traditions occur separately with the exception of these three panels.

This indicates that people from both traditions used this area, with a slightly higher proportion of panels belonging to the Northern Tradition.

So what happens when the two traditions meet at panels I, V and IX, and how do the figures relate to each other?

The obvious difference compared to Bardal I is that there are no monumental panels at Hammer. The panels at Hammer are most likely located on the old shoreline and the prehistoric beach. A huge part of the material belonging to the Northern Tradition in central Norway is located here at Hammer. The motifs that dominate at Hammer are whales and birds; some cervids and boats are also found, but they are in the minority. The gestalts and types vary a lot and show the whole spectrum from naturalistic outlined figure, to small stylistic figures with internal pattern. While a number of the figures are classified as the same type originating from the same gestalts, they also show variation in style. Variation in gestalts and type can mean that people in this area belonged to several different group traditions. Sharing the same gestalts and types may indicate the same group activity. The different styles indicate that many people were involved in making the rock art. The variation of gestalt/type/style on the same panel may also indicate that the same panel was used not exclusively by the same artist or group of people. The panels therefore seem to represent repetitive activities, perhaps performed over many generations.

The boats belonging to the Southern Tradition which we find at Hammer I and IX seem to be incorporated with the rest of the composition of the panel. The panels do not show any superimpositions as shown in Figure 2.6. They seem to build on the already existing figures, and naturally blend with the rest of the composition. If the figures belonging to the Northern Tradition at Bardal I could originate from a very few visits that took place over a limited amount of years, the variations at Hammer may indicate the opposite. The fact that the different traditions seem to prefer their own space could also mean that both traditions seem to overlap in time. Superimpositions would probably have been viewed as a provocative act when the people from the other tradition were still using the territory. The enormous variation in gestalts/type/style of the Northern Tradition could mean that Hammer was used for rock art rituals for a longer time than Bardal. It could also mean that a greater number of people visited Hammer, and that these people represented additional group traditions. There is also the possibility that Hammer was preferred because the people belonging to the Southern Tradition had completely taken over Bardal.

This cannot be said for certain but it is clear that the rock art at Hammer shows a degree of coexistence which stands in contrast to the situation at Bardal.

The shoreline dating of Bardal I is *c.* 6000 BP and Hammer IX relates to *c.* 4400 BP. This undermines the theory of Bardal and Hammer being used at the same time by the people belonging to the Northern Tradition, or for an overlapping period. But the shoreline dating only gives a maximum date and the rock art at Bardal did not have to been made when the panel was shore-bound. The same applies to Hammer. I believe that the similarities of gestalts and types are good indicators of group traditions with possible relations in time. This does not mean they were being used at exactly the same time, but it could mean that the rock art was made by people with the same schooling or tradition. The reason I would not write off the connection between Hammer and Bardal and the possibility of an overlap in time is the clear similarities between the gestalts and types from Hammer, Bardal and Evenhus. Evenhus is located considerably lower in the terrain, giving a shoreline dating of approximately 3300 BP, which equates to the early Bronze Age. The similarities between the gestalts/types from Evenhus, Hammer and Bardal could mean a younger dating of Hammer and Bardal than the shoreline appears to indicate.

Evenhus

Evenhus is located at the tip of the peninsula of Frosta (Fig. 2.3) 22 m above sea level (*c.* 3300 BP) The shoreline dating makes Evenhus the youngest site with rock art from the Northern Tradition located by Trondheimsfjorden. If the rock art was made when the panels were shore-bound, the sea level would have separated the site from the peninsula. Evenhus would then have been situated on a little island in the middle of the fjord. There are six panels at Evenhus, five of which belong to the Northern Tradition. There is only one panel that belongs exclusively to the Southern Tradition (Evenhus IV), which consists only of cup marks. As shown in Figure 2.5, you can see rock art belonging to the Southern Tradition at Evenhus I. An interesting aspect of this site is that the Northern Tradition clearly dominates. This is from a

period of time when agriculture had existed in central Norway for several hundred years, perhaps even for a thousand years.

Frank Asprem (2013) has written about the earliest signs of agriculture in central Norway. A diagram from Vassaunet shows pollen from *Rumex, Ranunculus, Cichoiraceae* and *Urtica* dating from *c.* 3370–3100 cal BC. These species are found in open landscape and in combination with grazing, which may indicate clearing of fields and grazing livestock. The earliest proof of domesticated animals in central Norway has been found approximately midway between Bardal and Hammer, at Hammersvolden. An ox tooth was found during an excavation of a kitchen midden during the years from 1910–1911 and has recently been dated to *c.* 2460–2290 cal BC. In addition to this, other archaeological material (boat-axe, thick-butted flint axe, double-edged hatchet) supports a dating to the Middle and Late Neolithic. The ox tooth is an interesting find, showing us that domestication of cattle took place in this area during the early to middle part of the third millennium BC (Asprem 2013: 177–180).

If we want to rely on the shoreline dating and the maximum age of the rock art at Hammer and Evenhus, these early signs of agriculture might correspond to the time when these panels were used. The shoreline dating of Bardal is slightly older. The similarities in certain gestalts and types between Hammer and Bardal could indicate that Bardal was not shore-bound when the first images were made. We cannot say this for certain and we do not know whether there was any overlap in time between the two traditions at Bardal. But this may be one of many examples which shows that shoreline dating of the rock art in central Norway is complicated.

The rock art at Evenhus shows great variation: both the styles and the gestalts/types display variation as well. This is an indication that these panels were used on several occasions and that the site was important to many different people. The fact that one likely needed a boat to visit the site shows that people knew this place and that this reflects a special place in the middle of the fjord. The obvious assumption is that this place played an important role for the people who travelled by boat. The resemblance to Hammer could also mean that the same groups of people had travelled from Evenhus and up the fjord to Hammer, or the other way around.

Another aspect that connects these two sites is the whale motif. Kalle Sognnes (2002) has also connected these two sites and how the

majority of the whale images are mainly concentrated here. He does not necessarily link the images to whaling, but points out what could possibly be a hunting scene at Evenhus, where what could be interpreted as small whales are found in two boats. There is only one more example of this in central Norway at the Vasstrand site in Åfjord. Apart from these two exceptions, the figures seem to depict live animals, jumping whales as they may have been viewed by Stone Age people from the shores or boats. Sognnes also comments on the whales being mystical species; that they live in water but breathe air; they are mammals and frequently leave the sea by jumping in the air (Sognnes 2002: 203–206). The concentration of whales depicted in the rock art in this area does not necessarily reflect extensive whaling; our fascination with whales can still be seen at modern whale safaris.

The whale concentration also stands out in a larger perspective. Paul Bahn (2013) has carried out a study of rock art containing whale images from all over the world. It is estimated that maybe as much as 80% of all cetacean figures in Europe are located in central Norway. This could probably represent the greatest collection of whale images in rock art anywhere in the world (Bahn 2013: 55). This area clearly stands out not only on the national level. The whale must have been important to those groups of people who made their rock art at Evenhus and Hammer. Of a total of 84 whale figures in my material from the central part of Norway, 37 are situated at Hammer, which represents 44% of the total material, and 17% of the whale figures are located at Evenhus. This means that 61% of all the whale figures are found at Hammer and Evenhus. The whale figures may show importance in a functional (food source) respect or in a spiritual respect (cosmology, religion, rites etc.) or maybe both, the one does not necessarily exclude the other.

Boat images from the Northern Tradition are another motif group that seems to dominate these two sites. Fourteen of the total of 65 boat figures in the material from central Norway are situated at Hammer, which represents 22% of the total material. But as much as 52% of the total amount of boat images in central Norway is found at Evenhus. This means that these two sites represent 74% of all the boat images in this region. This indicates a maritime adaptation in this particular area and that both the whales and boats were important elements at these sites.

Summary and conclusion

This chapter draws attention to some of the methodical challenges we are dealing with in this part of Norway, particularly shoreline dating and style dating. It is important to focus our attention and problematise how different concepts have been used in the classification and systematisation of the rock art, particularly the mixing of style and type. This chapter outlines some other approaches to the material and demonstrates how style and type concepts can be used. A lot of the initial work has been devoted to mapping the usage of the concepts and trying to see whether there is some mutual understanding of the concepts. The aim of this has been to clarify the concepts and define them in such a way that the work can be verified by others.

The old methodical approach of using shoreline dating in combination with style dating in central Norway has been inaccurate and even misleading. Therefore, I wanted to approach the material from a different angle. I chose to separate the concepts of style and type and see them as foundations for different analyses. Gestalts are identified and types are created by the researchers to classify and systematise the material and do not necessarily relate to the aspect of time and dating. The creation of types is only done to organise the material and to find out whether there are certain frameworks or elements that recur in the material. This kind of analysis tells us whether there are different traditions in making rock art. Style, on the other hand, has to do with individuality and the creativity of the artist, and this tells us something else about the material through other analysis. This can tell us whether we can isolate one or more artists on the same panel, or if the rock art was made on one occasion or by more than one artist on repeated visits.

The analysis can show whether types or styles recur across geographical distances. The interaction between the Northern and the Southern Traditions is also an interesting aspect in central Norway which I have explored in this article. The three examples from my material – Bardal, Evenhus and Hammer – show both similarities and differences in the way the two traditions meet and interact. I will not repeat the alternative theories except to summarise briefly: the great variation in both gestalts/types and styles shows that all three sites were used by different groups of people and perhaps revisited on several occasions. Bardal shows perhaps fewer

visits by the Northern Tradition before the Southern Tradition took over the place. The differences in gestalts and types indicate different traditions and schooling in how to make rock art; this may imply different groups. The three sites also show us that there was a meeting between the two traditions and that there was an overlap between them, at least at one if not all three sites. The three sites also show resemblance in gestalt/type and style. This can mean that the people here interacted and that group traditions existed for a long period of time.

Another interesting aspect is the different motif domination of the three sites. Elks dominate at Bardal I, birds and whales dominate at Hammer and boats at Evenhus. Could this be seen as territorial different group traditions, or do the different motifs perhaps have to be interpreted in different topographic contexts? In spite of the differences, there are motifs/gestalts/types that show some sort of interaction of the three sites.

Seeing the material from this angle and choosing not to see style only in a time perspective opens the opportunity to see the material from the perspectives of group traditions and group contact. But it also opens for a more detailed study of style and isolating the individual and the artists' individual preferences. This can show us that the people that made rock art had artistic freedom within a certain framework, which can be traced on different sites.

Acknowledgements

Thanks to Kalle Sognnes, Gunnar Iversen, Martin Eugene Callanan and Ragnhild Berge for reading and commenting on the manuscript.

References

Adams, W. Y., and E. W. Adams 1991. *Archaeological Typology and Practical Reality: A Dialectical Approach to Artifact Classification and Sorting.* Cambridge University Press. Cambridge.

Asprem, F. 2013. The Earliest Agriculture in Central Norway – an Overview of Indications from the Steinkjer Area in North Trøndelag. *The Border of Farming Shetland and*

Scandinavia. Neolithic and Bronze Age Farming. Papers from the Symposium in Copenhagen September 19th to the 21st 2012 (Mahler, D. L. ed.): 177–181. The National Museum of Denmark. Copenhagen.

Bahn, P. 2013. The Bangudae Whales in the Context of World Rock Art. *Bangudae: Petroglyph Panels in Ulsan, Korea, in the Context of World Rock Art.* Vol. 1 (H.-T. Jeon, ed.): 37–66. Hollym International. New Jersey.

Bakka, E. 1973. Om alderen på veideristningane. *Viking,* 37: 151–187.

Bakka, E. 1988. *Helleristningane på Hammer i Beitstad, Steinkjer, Nord-Trøndelag: Granskingar i 1977 og 1981.* Rapport arkeologisk serie 1988 (7), Universitetet i Trondheim. Vitenskapsmuseet.

Deregowski, J. 2005. Perception and the Ways of Drawing: Why Animals are Easier to Draw than People. *Aesthetics and Rock Art* (T. Heyd and J. Clegg, eds): 131–142). Ashgate Publishing. London.

Gjessing, G. 1936. *Nordenfjelske ristninger og malinger av den arktiske gruppe.* Instituttet for sammenlignende kulturforskning, Serie B. Aschehoug. Oslo.

Hallström, G. 1907. Hällristningar i norra Skandinavien. *Ymer,* 27: 211–227.

Hallström, G. 1938. *Monumental Art of Northern Europe from the Stone Age: The Norwegian Localities.* Thule. Stockholm.

Holmeslet, J. M. B. H. 2002. *Havets historie i Fennoskandia og NV Russland.* Last visited 15 May 2013, at http://geo.phys.uit.no/sealev/index.html.

Lindgaard, E. 2014. Style: A Strait Jacket on Hunters' Rock Art Research? *Adoranten. Tanumshede: Scandinavian Society for Prehistoric Art,* 2013: 57–68.

Ling, J. 2004. Beyond Transgressive Lands and Forgotten Seas – Towards a Maritime Understanding of Rock Art in Bohuslän. *Current Swedish Archaeology,* 12: 121–140.

Ling, J. 2008. Elevated Rock Art: Towards a Maritime Understanding of Rock Art in Northern Bohuslän, Sweden. Doctoral thesis. Gothenburg University. Gothenburg.

Ling, J. 2013. *Rock Art and Seascapes in Uppland.* Oxbow Books. Oxbow.

Mikkelsen, E. 1977. Østnorske veideristninger: Kronologi og økokulturelt miljø. *Viking* 40: 147–201.

Møllenhus, K. R. 1968. *Helleristningene på Holtås i Skogn.* Det Kongelige Norske Videnskapers Selskabs skrifter 1968 (3). Tapir Akademisk Forlag. Trondheim.

Plog, S. 2009. Sociopolitical Implications of Stylistic Variation in the American Southwest. *The Uses of Style in Archaeology* 4th edition (M. W. Conkey and C. A. Hastorf, eds): 61–72. Cambridge University Press. Cambridge.

Polanyi, M. 1962. *Personal Knowledge: Towards a Post-Critical Philosophy.* The University of Chicago. Chicago.

Shetelig, H. 1921. *Steinalders-kunst i Noreg.* Norsk aarbok. Bergen.

Shetelig, H. 1922. *Primitive tider i Norge: En oversigt over stenalderen.* John Griegs Forlag. Bergen.

Simonsen, P. 1979. *Veidemenn på Nordkalotten 3. Yngre steinalder og overgang til metalltid.* Institutt for samfunnsvitenskap, Universitetet i Tromsø, stensilserie B, historie 17: 363–547. Universitetet i Tromsø. Tromsø.

Smith, B. (Ed.). 1998. *The Tale of the Chameleon and the Platypus.* Cambridge University Press. Cambridge.

Sognnes, K. 1981. *Helleristningsundersøkelser i Trøndelag 1979 og 1980.* Rapport arkeologisk serie 1981 (2). Vitenskapsmuseet. Universitetet i Trondheim.

Sognnes, K. 2002. Land of Elks – Sea of Whales. *European Landscapes of Rock-art* (G. Nash and C. Chippindale, eds): 195–212. Routledge. London.

Sognnes, K. 2007. Danser med elger: Omkring stil og tegnemåte i den arktiske bergkunsten i Midt-Norge. *Mittnordiska arkeologidagar Saarijärvi 14.-16. juni 2007,* IV: 43–55. Keski-Suomen Museoyhdistys. Jyväskylä.

Sognnes, K. 2008. Stability & Change In Scandinavian Rock-Art. *Acta Archaeologica,* 79(1): 230–245.

Sognnes, K. 2012a. Rock Art Studies in the Nordic Countries, 2005–2009. *Rock Art Studies News of the World IV* (P. Bahn, N. Franklin and M. Strecker, eds): 18–30. Oxbow Books. Oxford.

Sognnes, K. 2012b. Visuell kultur i en overgangsfase – Bergkunst og neolitisering i Trøndelag. *Agrarsamfundenes ekspansion i nord: Symposium på Tanums Hällristningsmuseum, Underslös, Bohuslän, 25.-29. maj 2011.* (F. K. L. Sørensen, ed.): 233–243. Nationalmuseet. Copenhagen.

Sognnes, K. 2017. *The Northern Rock Art Traditon in Central Norway.* BAR International Series 2837. BAR Publishing. Oxford.

Stebergløkken, H. 2008. Et stille møte mellom sjø og land: En stilistisk analyse av de marine veideristningenes motiver, sammenheng og tolkninger. Unpublished Master's thesis. Tapir. Trondheim.

Stebergløkken, H. 2016. *Bergkunstens gestalter, typer og stiler: En metodisk og empirisk tilnærming til veidekunstens konstruksjonsmåter i et midtnorsk perspektiv.* Doctoral thesis, 2016: 38. NTNU Grafisk senter. Trondheim.

Wiessner, P. 2009. Is There a Unity to Style? *The Uses of Style in Archaeology,* 4th edition (M. W. Conkey and C. A. Hastorf, eds): 105–112. Cambridge University Press. Cambridge.

Taking the Stranger on Board – The Two Maritime Legacies of Bronze Age Rock Art

Lene Melheim and Johan Ling

Abstract: In this chapter, we argue that the strong maritime focus in South Scandinavian Bronze Age rock art could be seen as the result of a fusion of two different maritime legacies. The first legacy relates to the North Scandinavian hunter-gatherer tradition of making rock art at maritime locations in the landscape, in connection with seasonal gatherings, and with an emphasis on transformative animistic features and boats. The second major maritime

impact relates to Bell Beaker influence in southern Scandinavia, prior to the Nordic Bronze Age, and is associated with regular overseas sailing, intensified interaction across the North Sea, and trade in raw materials and exotica. By incorporating two different maritime legacies both on a practical and a symbolic level, the societies in southern Scandinavia created new maritime institutions which enabled them to enter and participate actively in the maritime exchange networks of the Nordic Bronze Age. We regard the institutionalisation of this particular kind of maritime-ness as a crucial feature, a *doxa* for the reproduction of the Nordic Bronze Age societies.

Key words: Bronze Age rock art, animism, fusion of two legacies, boat imagery, plank-built boats, maritime-ness, aggregation sites, overseas exchange.

Introduction

The focus on boats in South Scandinavian Bronze Age rock art has been a perpetual headache for archaeologists trying to force them into explanatory models biased towards terrestrial and agricultural practices (Almgren 1927; Malmer 1963; Vogt 2011). The recent turn to maritime perspectives in rock art studies (Østmo 1997; Kristiansen 2004; Nordenborg Myhre 2004; Kvalø 2007; Ling 2008) has overcome this by taking the boat images at face value, as depictions made by maritime-oriented groups heavily reliant on boats and seafaring skills. This new position enables us to explicate the regional differences within the Nordic Bronze Age not as a result of a clash of two cultures/economies, but as a new form of maritime practice, or, maritime culture in its own right that grew out of two initially different legacies. One of the advantages of this maritime practice was the capacity to enter into and partake in international exchange networks.

Our discussion is based on three premises: (1) The South Scandinavian rock art tradition (ST) evolved from the older North Scandinavian rock art tradition (NT). (2) The tradition of carving boat images spread from the north to the south at the transition to the Late Neolithic, and was quite likely accompanied and boosted by a transmission of innovative boatbuilding know-how and seafaring skills. (3) The animistic merging of boats and

animals that evolved among hunter-gatherers in the north was adopted and maintained by maritime Bronze Age groups on the Scandinavian Peninsula.

Neither of these premises is new, and both the north–south evolution and the animistic principles of the ST have been discussed by a number of authors, and most recently by Mike Rowlands and Johan Ling (2015). They argue that Bronze Age rock art could be seen as:

(1) A legacy of the North Scandinavian rock art tradition in terms of the emphasis of animistic feature and the general need to aggregate or interact on a seasonal basis;
(2) southern Scandinavia's entanglement in metals during the Bronze Age, which in fact triggered the entire process of creating rock art during this epoch; as an outcome of this process;
(3) the formation of new maritime institutions; and
(4) a general need to enter and maintain 'international' networks and alliances that inspired the rock art tradition with a pan European code of warriorhood and cosmology.

In this chapter, we intend to deepen these strands by focusing more concretely on archaeological examples showing the merging of the two different maritime traditions, and on how Bronze Age groups in the south adapted and transformed the two legacies, and thereby created the particular maritime institution that is typical of the Nordic Bronze Age, and which is reflected in the ST. Rather than seeing the groups populating the coastline of the Scandinavian Peninsula as primarily stationary agriculturalists, we see them as inherently mobile and maritime-oriented, building on and developing a form of coastal adaptation that had been established millennia earlier. It is striking, however, that boat images are not found in the Stone Age proper in southern Scandinavia, but seem to be a phenomenon that spread from the north to the south in the Late Neolithic–Early Bronze Age.

Around the transition to the Nordic Late Neolithic, and quite possibly as a side-effect of the adoption of functional metal axes, plank-built boats allowed for the crossing of open waters on a regular basis (Østmo 2005, 2009; Prescott 2009). While the use of dug-out canoes continued in the Nordic Bronze Age, the Bronze Age maritime institutions that we describe here sprang from the invention of new seagoing vessels. In the UK, a similar development is argued to be related to the Beaker phenomenon (Van de Noort 2012). The

role played by the maritime Bell Beaker culture (mBBC) when it comes to the development of such boats and the accompanying skills in southern Scandinavia is not well understood, although often taken for granted as one of the factors that strongly shaped the Scandinavian Late Neolithic. Some consider an indigenous technological evolution of seagoing plank-built vessels in northern Scandinavia to be likely (Klem 2010; *cf.* Carrasco 2009: 78), but as for now this builds mainly on an interpretation of the boat images themselves, for lack of any evidence of boat wrecks. In the UK, where a number of plank-sewn boat finds have been dated to the Bronze Age, the oldest to *c.* 2030–1780 cal BC, a development from hide or skin boats into more seaworthy craft with greater carrying capacity is assumed (Van de Noort 2012: 68). It is far from clear from which of the two legacies described here the plank-built seagoing vessel and the necessary nautical skills were adopted in South Scandinavia. Our discussion is not aimed at settling this question, but rather at showing the complex interplay of internal and external factors, and the potential for cross-pollination between them in a period of profound change. First, we will concentrate on the connection between the NT and the ST in terms of animal forms, boats and the location of rock art in the landscape/seascape. In the section that follows, we will focus on the maritime impact of the mBBC.

Taking the animal on board

Today, most scholars agree that the structure of making rock art 'as format' was transmitted from the north to the south (Fig. 3.1), although it developed in a very different way in the south (Gjessing 1936: 130; Fett and Fett 1941: 116; Marstrander 1963: 72; Helskog 1999; Sognnes 2001; Nordenborg Myhre 2004:172; Wrigglesworth 2006: 150; Bradley 2006; Engedal 2006: 178; Goldhahn 2010; Cornell and Ling 2010; Gjerde 2010). Scholars also seem to agree that the transmission of the NT format to southern Scandinavia happened during the Late Neolithic–Early Bronze Age (Goldhahn and Ling 2013). On the Scandinavian Peninsula, this was a period of dramatic change, often considered to relate to the BBC. The fact that it was not until the Late Neolithic–Early Bronze Age that boats became the predominant motif in rock art (Bradley 2006 with refs.) implies that the role and importance of boats changed with the ST (Fig. 3.2). While the iconographic and technological traditions of the

Figure 3.1. *The maritime legacies of Bronze Age rock art. The first legacy relates to the North Scandinavian hunter-gatherer tradition. The second major maritime impact relates to the impact of (maritime) Bell Beaker culture in southern Scandinavia. Map from Goldhahn et al. (2010), showing the distribution of the two rock art traditions in Scandinavia. The blue area denotes the Northern tradition (NT) whereas the red area marks the Southern tradition (ST). Grey areas denote where these traditions overlap (reprinted with the permission of the author).*

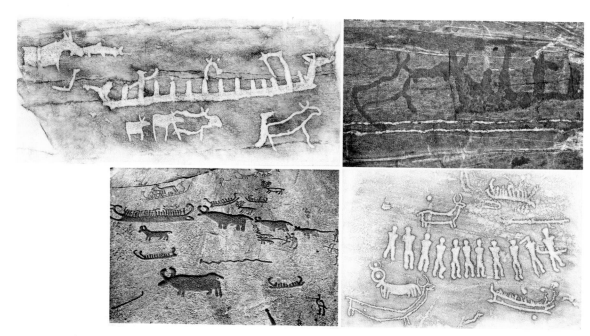

Figure 3.2. The ST 1700–500 BC: A legacy of the NT in terms of transformative animistic features between animals and boats and the general need to aggregate or interact on a seasonal basis. Examples taken from Nämforsen (top) and Tanum (bottom). Top right: Nämforsen, Lillforshällan G (after Dietrich Evers, source: SHFA); top left: Nämforsen, Ådalsliden (after Oscar Almgren, source: SHFA); bottom left: Tanum 12 (after Claes Claesson, source: SHFA); bottom right: Tanum 25 (after Dietrich Evers, source: SHFA).

north may be seen as a *longue durée*, potentially available for the coastal groups further south, the impact from southern Europe with the BBC was, on the other hand, more temporally restricted. We suggest, therefore, that it was the mBBC that triggered the potential of the NT legacy in the south.

In line with Rowlands and Ling (2015) we argue that the interchangeability of species seen in the ST and Nordic Bronze Age iconography rests on an animistic principle or world-view that resembles the more northerly rock art. The basic principle of animism is the transfer of properties from one being to another (Ingold 2006; Willerslev 2007; Dowson 2009; Zedeño 2009). The ability to be the same and different remains possible because of the animist principle of a common essence or soul, which is what actually constitutes the transformation from one side of the alterity divide to the other (Rowlands and Ling 2015).

Figure 3.3. Transformations between boats and bulls from Bohuslän dated to 1600–1300 BC. Left: Tanum 351 (documentation by Tanums hällristningsmuseum Underslös, source: SHFA); right: Kville 159 (after Åke Fredsjö, source: SHFA).

Transformations between animals (elk, reindeer, seals and ducks) and boats are a common theme for the NT (Fig. 3.2). Typical also for the ST are transformations between animals (bulls, horses and ducks) and boats. In the region of Bohuslän, there are sites with bull representations on rock art panels, in close association with boats (Figs 3.3 and 3.4). Ling and Rowlands (2015) highlighted this matter and argued that these scenes narrated ritual transformations between bulls and boats. Bull-boat scenes occur on several panels in the parishes of Tanum and Kville that show boats from Early Bronze Age period Ib–II, or 1600–1300 BC (Fredsjö 1981; Fredell 2003; Ling 2008). These panels faced a seascape during the Bronze Age; some were located at the water's edge, others on elevated outcrops just at the shore (Ling 2008).

In the following we shall exemplify this phenomenon with reference to sites in Tanum. The rock art panel Tanum 12 has a scene with bulls and boats of different sizes that appears to illustrate a sequence of growing and moving bulls (Fig. 3.2), which seemingly enter or transform into a boat. This, in our opinion, clearly illustrates the close ontological connection between bulls and boats in the ST. Another panel, Tanum 25, located on

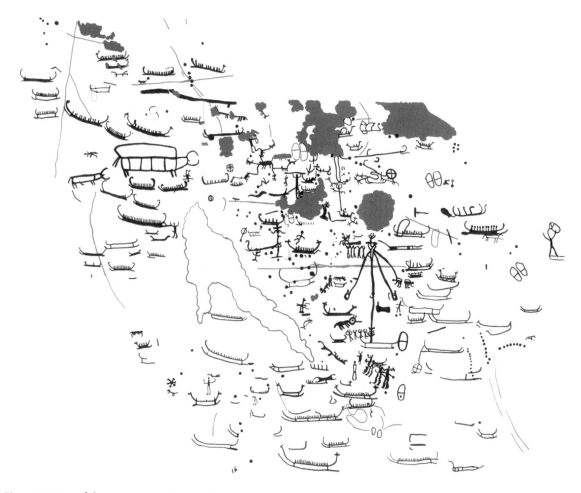

Figure 3.4. One of the most outstanding rock art panels in the Tanum area, Tanum 311. Note the spectacular combinations of bulls and boats (documentation by Tanums hällristningsmuseum Underslös, remade by Fredell 2003, source: SHFA).

the same hill, displays a cluster of boats, humans and bulls (Fig. 3.2). The most striking feature here is the bull in the lowest position with a boat-shaped body, indeed similar to the shape of the boat depicted to the right on the same panel. Above the bull is a human scene showing 'males' with phalluses in a moving sequence. Thus a 'herd' of boats and bulls seems to surround the human scene as if they were slightly different species, yet from the same herd. Thus, once again we see the close interaction between

bulls and boats on the rock art panels. Our third example is taken from the so-called Gerum panel, Tanum 311 (Fig. 3.4). The low-lying position of this panel, 14.5–16.5 m above sea level is striking, and it presents a perfect case for shoreline dating (Ling 2008). It includes some remarkable figures and combinations (see Almgren 1927; Fredell 2003; Skoglund 2012). One of the most striking features is the large bull found in the top right of the panel. It is accompanied by another bull and surrounded by a fleet of boats. The bodies of both bulls follow the shape of a boat hull. In fact, the whole scene with boats with in-turned prows/horns and bulls could be seen as a herd/fleet on the move, staged for a special maritime event (Fig. 3.4).

We consider the dominant animal and boat forms to be transformations of each other. Specifically, the shape of the bull, as a principal animal form, transforms into a boat form, and both are joined together in groups that suggest a herd/fleet in movement. The boat may have been regarded as a fragile feature during the Bronze Age, and fixing it into the firm and permanent rock and depicting it alongside strong features or symbols such as the bull could be seen as a way to ensure the durability and safety of the journey of the boat. Moreover, some panels with typical Early Bronze Age features include depictions of bulls that seem to emanate from the cracks in the rocks. These bulls are never completely depicted, only half of the animal is ever displayed, and it is as if the rock deliberately holds back the other part of the beast. This feature could be seen as an example of the potency of the rock, and as an extension of the transformation between stone/animal and boat.

The bull–boat combination is a feature typical of northern Bohuslän during period I and into period II. In other regions, animals such as wild boars take the place of the bull (Nordén 1925; Coles 2000; Ling 2013). It seems therefore that the transformative features of the boat were articulated differently in various parts of Scandinavia in the Early Bronze Age, but could have served a similar animistic function, namely, to ensure the strength and durability of the boat and maritime ventures (cf. Westerdahl 2005).

In the later part of period II, the horse replaced the bull and its transformative role in larger parts of southern Scandinavian and became an integral part of the prows of the boats (Kaul 2013; Ling 2013). This impact can be seen in all regions and is a considerably more homogeneous trait in the ST (Kaul 2013). Interestingly, horse–boat transformations occur on the same panels that include bull-boat transformations in Tanum and Kville,

indicating that this is both a continuous chronological practice and a long-lasting ideological theme.

The Bronze Age metal trade and aggregation sites

Another significant aspect that needs to be stressed regarding the connection assumed here between the NT and the ST is the fact that the NT was arguably carved in connection with seasonal socio-ritual gatherings. In other words, rock art could be seen as one aspect of the hunter-gatherer groups' need to aggregate or interact on a seasonal basis. These meetings took place when there was a seasonal abundance of prey animals at specific locations in the landscape, such as seems to be the case at sites like Vingen (Sogn and Fjordane), Nämforsen (Ångermanland) and Alta (Finnmark) (Helskog 1999; Goldhahn 2002; Gjerde 2010; Lødøen 2012).

In the following we shall argue that the engagement with metals in the Bronze Age created or triggered similar, yet different, social needs to interact on a seasonal basis at maritime communicative places in the landscape (Fig. 3.5). Even if there were great differences between the interactions that took place in the NT and ST areas, the two traditions nevertheless seem to have been governed by similar practices. Possibly, at some locations, the ST was directly structured by previous rock art traditions and the history embedded in the landscape.

Based, among other things, on evidence of overseas import, it seems likely that the large Bronze Age metal workshop sites in Scandinavia functioned as market places and aggregation sites, which gathered people from far and near at certain times of the year (Melheim 2015). It is clearly not a coincidence that some of these sites are located in areas with abundant ST rock art. To illustrate this connection, we shall use the Hunn burial ground near Fredrikstad in Østfold as an example (Fig. 3.6). Hunn lies at the heart of one of the densest rock art areas in southern Norway, in the broader rock art region of Tanum-Østfold. The adjacent Skjeberg plain has 100 rock art sites within an area of 6 sq km, and immediately to the west and north of Hunn lie ST sites like Begby, Opphus and Lille Borge. With rich evidence of specialised bronze production, Hunn was most likely a regional

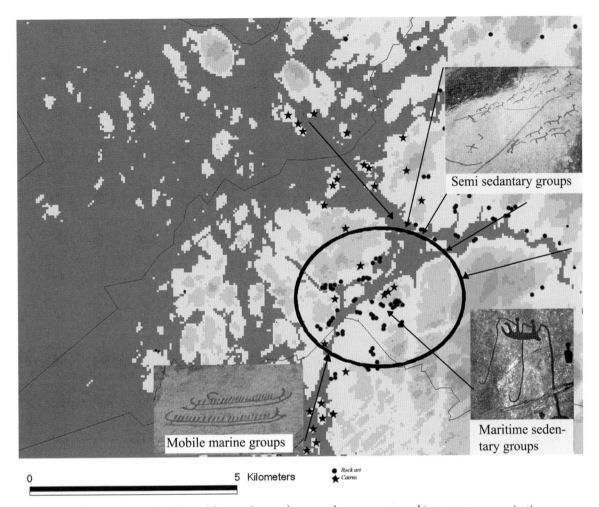

Semi sedantary groups

Maritime sedentary groups

Mobile marine groups

0 5 Kilometers ● Rock art ★ Cairns

Figure 3.5. In the Bronze Age, the demand for metal created new needs to aggregate and interact at communicative maritime locations at the coast. Map of the Kville area at the west coast of Sweden with rock art (stars) and cairns (circles) illustrated with a Bronze Age shore line of approx. 15 m.a.s.l. (After Ling 2008). The communicative maritime setting of this rock art area indicates that it could have worked as an aggregation site for different groups with different aims.

centre for craft production and trade 1300–700 BC (Melheim *et al.* 2016). The presence here of unalloyed copper is an indication of trade in raw metals to Scandinavia, which is also in a broader perspective indicated by evidence from Swedish workshop sites like Hallunda near Stockholm and Kristineberg near Malmö. Evidence of the production of metal preforms at *e.g.* Hunn and

Hallunda suggests that a further transformation of raw materials into locally accepted 'currencies' took place at these sites.

The aggregation aspect is likely to relate to natural features of the landscape. Hunn has good conditions for embarking inland on rivers and prehistoric tracks, and is situated by a protected, natural harbour, which is connected with the sea through a 2 km long narrow passage that could be monitored from the nearby cliff Ravneberget, later to become a hillfort (Fig. 3.6). A possible interpretation of the very ancient place name Hunn is that it has to do with 'catching' and relates to the nearby water basin (Hunnebunn) and it being a good fishing ground (Hoel 2015). We may ask whether this place name could also be considered in more literary terms as a place for 'catching' goods or for that matter boats. Quite possibly, the significance of the site and the name developed through time, beginning with the establishment of sites in the area when the land dried up in the Mesolithic and continuing with farms in the Late Neolithic–Early Bronze Age, and eventually developing into a central area with metal workshops, burials and ST rock art in the Middle and Late Bronze Age (Melheim *et al.* 2016).

In the Early Bronze Age, the interregional trade and especially the exchange of metals, often from source areas far away, created new needs to aggregate, quite likely on a seasonal basis and at communicative maritime locations along the coast. We suggest that some of the central rock art sites in the coastal ST rock art regions served as seasonal aggregations sites for groups with a mobile way of living, such as travellers, warriors and/ or traders (Fig. 3.5). At these sites, which we consider to be rudimentary 'ports of trade', the live models for the boats that were depicted on the rock art panels could unload their cargo and exchange finished products as well as imported raw materials. We may assume that people from a larger catchment area visited the ST rock art areas in order to maintain, reproduce or initiate socio-ritual structures of power, identity, ideology and cosmology and that the exchange of commodities and gifts may have been another crucial aspect of these meetings. In a sense, one may say that the interregional exchange networks of the Bronze Age triggered needs to interact and aggregate which were comparable to the situation in rock art aggregation sites like Nämforsen or Alta during the Neolithic, whilst the Bronze Age 'prey' that was in focus for gatherings of people from near and far was made of metal and other exotica rather than flesh and blood.

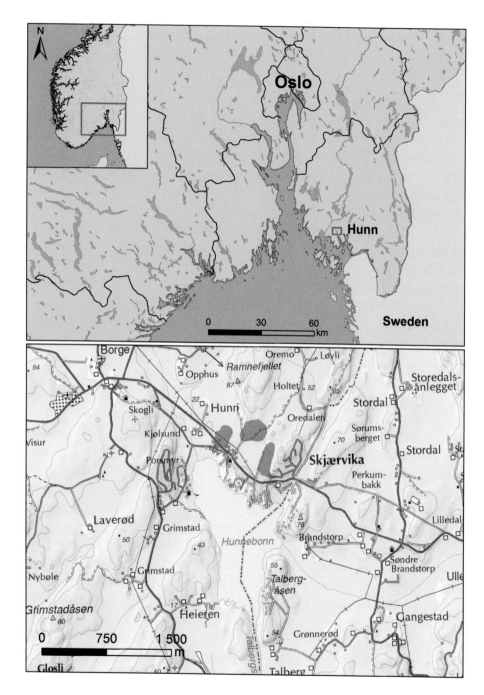

Figure 3.6. Map of Norway with the area of Hunn indicated. Hunn in Østfold, Norway has good conditions for embarking inland on rivers and prehistoric tracks, and is situated by a protected, natural harbour which is connected with the sea through a 2 km long narrow passage which could be monitored from the nearby cliff Ravneberget (Ramnefjellet), later to become a hillfort (map: Steinar Kristensen; map data: Kartverket, norgeskart.no.)

The plank-boat revolution and the maritime impact of the BBC

Indo-European words for boats are regarded as belonging to an older substratum, a language used by indigenous groups in the areas later populated by Germanic-speaking Indo-Europeans (Østmo 1997; Wikander 2010). In other words, linguistic evidence may be considered to support the idea of a maritime legacy from the NT in the areas populated by Nordic Bronze Age groups. An indication of a continuation of contact between the NT and the ST are the panels widely spread on the Scandinavian Peninsula which show a mix of the two traditions – *e.g.* Åmøy (Rogaland), Bardal (Trøndelag), Sporaneset (Telemark), and Nämforsen (Ångermanland) (Hagen 1969: 120–139). However, there is no clear continuity in space between the first ST boats and older boat images, as NT boat depictions in general have a more northeasterly distribution (Gjerde 2010: 399) than the first ST boat images.

The earliest ST boat images (for convenience called the 'Krabbestig/Nag type', Fig. 3.7) appear along the Norwegian coast, in Vest-Agder, Rogaland, Sogn and Fjordane, Møre and Romsdal, and Trøndelag (de Lange 1912, Mandt 1983: 26; 1991: 334–335, Mandt and Lødøen 2004: 128, Nordenborg Myhre 2004: 172–172). Similar boat images are also known from a few panels in the Tanum-Østfold rock art region (Ling 2008: 127–130; Marstrander 1963: 65). In Bohuslän, altogether seven sites have Krabbestig/Nag boat types, all located along the coastline (Fig. 3.8). These are one site in Brastad parish (26), two sites in Kville parish (173, 66) and four sites in Tanum parish (67, 75, 484, 487). Some of these sites show several boats of the Krabbestig/Nag type; this goes for Tanum 75 and 487 (Fig. 3.9). Of special interest with regard to shoreline dating is that none of these sites is located below 20 m above sea level, and most of them at higher altitudes, at 20–27 m above sea level. The fact that no boats of Krabbestig/Nag type in Bohuslän are closer to the Bronze Age seashore is a strong indication that they, like their typological counterparts in western Norway, are likely to have been made before the Bronze Age.

Norwegian researchers have for some time argued that the Krabbestig/Nag type boats can be traced back to the Late Neolithic and the idea that these boats represent a Late Neolithic 'substratum' and a predecessor to the first Bronze Age boats has been vividly discussed. They are often placed

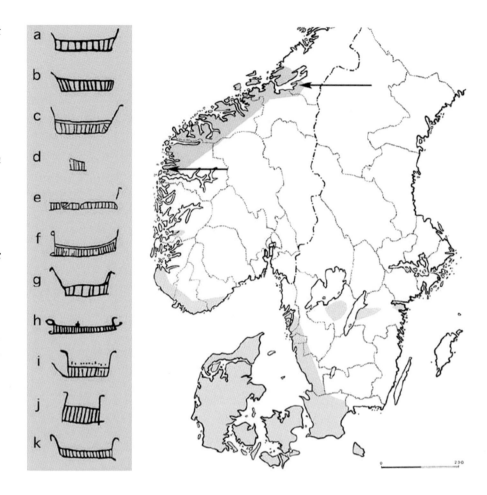

Figure 3.7. The earliest ST boat images (for convenience called the 'Krabbestig/Nag' type) occur along the Norwegian coast from Vest-Agder and Rogaland to Trøndelag. Illustration from Goldhahn (2006) showing boat images from the core area (darker grey, between the arrows) in northwestern Norway: a) Auran, b) Leirfall, c) Røkke, d) Skjervoll, e) Mjeltehaugen, f) Krabbestig, g) Domba, h) Unneset, i) Leirvåg, j) Leirvåg, k) Vangdal. Reprinted with the permission of the author.

in the Early Bronze Age or more cautiously in the Late Neolithic II (2000–1700 BC) on typological grounds (Fett and Fett 1941: 112; Engedal 2006; Ling 2008: 128–130; Mandt 1991; Nordenborg Myhre 2004: 172–175, 186; Prescott and Walderhaug 1995; Sognnes 2001, 2003; Østmo 2005). The solitary position of boats of the Krabbestig/Nag type on many rock art panels, and the fact that they, as in Bohuslän, occur on higher altitudes are good chronological indicators (*cf.* Ling 2008). For instance, the placement at Nag in Rogaland of such boat images on the upper part of the panel, and with lower-lying period I boats, supports an early date (Nordenborg Myhre 2004: 144, 195). At the multiphase Leirvåg site in Sogn and Fjordane the conjunction between the

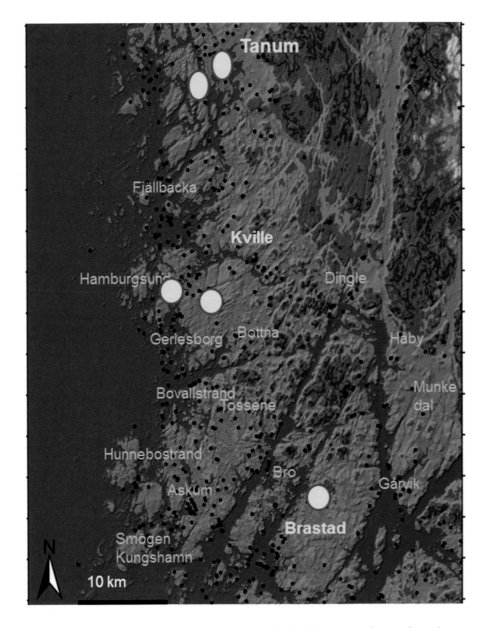

Figure 3.8.
Krabbestig/Nag
boats are also found
in Bohuslän, western
Sweden. The yellow
dots on the map
indicate the location
of these sites.

earliest boat images and period I boats with bull horns and somehow later horse-headed boats is striking. Examples of this kind of continuity are also known from sites in Tanum and Kville, always with the earliest boat type in higher-lying parts of the panel (Ling 2008: 127–130).

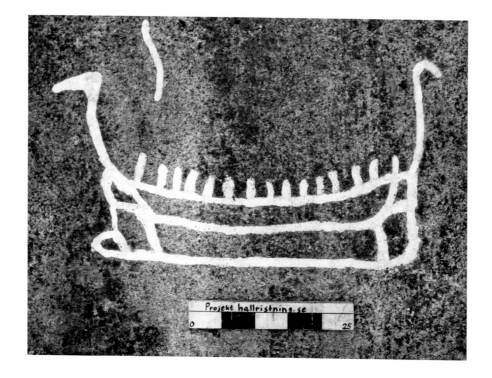

Figure 3.9. Rock art panel (Tanum 484) from Heljeröd in Tanum, showing a typical Krabbestig/ Nag boat. Photo by A. Toreld. Source: SHFA.

The Krabbestig boats on the slabs from the Mjeltehaugen barrow on the island of Giske, Møre and Romsdal are central to this discussion (Fig. 3.7). Bordered zigzag patterns reminiscent of the Mjeltehaugen slabs occur on BBC pottery (Jensen 1973, Liversage 2003: 39, Prieto-Martínez 2008: 146–149, fig. 19, Vandkilde 2001: 338–341, 347). Through time, the non-figurative patterns on the slabs have been linked to finds from Middle Neolithic Europe (Marstrander 1963: 325, Mandt 1983: 23–25), the BBC (Østmo 2005: 70), and most recently to a group of stelae and slabs from Le Petit Chausseur (Switzerland), Göhlitzsch (Germany) and Insua (Spain) (Sand-Eriksen 2015). Interesting indeed is the identification by Anette Sand-Eriksen (2015) of a depiction of a Remedello type dagger dating to *c.* 2500 BC on the back of one of the slabs.

Based on this, the boat images may well belong in the BBC phase, or the transition from the Middle to the Late Neolithic. The many arguments posed against a BBC date, *e.g.* the size of the chambers and the assumption that they contained cremation burials (de Lange 1912: 28; Linge 2007; Mandt and

Lødøen 2004), do not necessarily affect the dating of the slabs themselves, which may have been reused or used continuously for a longer period of time. Neither can the presence of other similarly decorated stelae in western Norway be decisive (*cf.* Mandt 1983, Syvertsen 2002). These stelae are assumed to belong in the Bronze Age but most of them are indirectly dated, and could just as well point to the historical impact of the legacy of the BBC in this area. The tradition of making such stelae was possibly adopted from Iberian BBC/Bronze Age groups (*cf.* Harrison 2004). In this regard, it is of some interest that the wagon images with horses so typically seen on the somewhat later ST panels in Tanum-Østfold, *e.g.* vividly represented on the Begby panel adjacent to Hunn, has clear parallels in the rock art of the Iberian Peninsula. Boats, however, are exclusively found in Nordic rock art. A boat image from Unneset in Askvoll, Sogn and Fjordane is also illustrative – representing the new Bronze Age paradigm of predominant boats and a wagon drawn by two horses.

The eponymous Krabbestig rock art panel itself is situated at the inlet of Skatestraumen, in Vågsøy in Sogn and Fjordane. A nearby (burial) find of 40 amber buttons with V-perforations (Lødøen 1993, Lillehammer 1994: 90), clearly speaks of an impact from the BBC. Several, now lost, barbed and tanged flint arrowheads are reported to have come from the nearby Vingen rock art site (Østmo 2005: 75; Prescott and Walderhaug 1995), but whether they were actually BBC points has not been confirmed. However, two BBC arrowheads occurred in a similar coastal environment, on the island of Gulen further south, during excavations in 2014 (Ramstad 2014). The BBC-related finds from coastal sites in Sogn and Fjordane provide a glimpse into a historical scene of cultural meetings, and may even suggest that there was a direct link between the earliest boat depictions and BBC influence in the area.

It is plausible that the background to the change of motifs with the new emphasis on boats which we retrospectively perceive as the ST may have been a series of ground-breaking events limited in time and space. The rock art boats may, as inherent in the theory of an external origin for the Nordic boat, represent the local population's first encounters with seagoing vessels (Østmo 2005: 71). The hypothesis that the Krabbestig/Nag type boats represent a new boat type with better seafaring capacities may also explain the boom in boat depictions with the ST (Nordenborg Myhre 2004: 173). On the other hand, recalling the theory of an indigenous technological

development, it is also feasible that the boat pictures depict the local population embarking on journeys. An extension of the seagoing vessel's history back in time provides an explanation for the changes in distribution patterns at the Middle–Late Neolithic transition, notably the large-scale import of flint daggers to south-western Norway and Sweden (Apel 2001; Nordenborg Myhre 2004: 174; Østmo 2005; Prescott 2009). Judging from find distributions, BBC maritime ventures followed the Atlantic fringe (the Maritime Route), a trail that was crucial also much earlier for the spread of megaliths and stone-axe trade.

It is striking that the much older Mesolithic animal figures of western Norway, *e.g.* at Vingen and Ausevik in Sogn and Fjordane (Lødøen 2012), have hatched bodies very similar to the later boat images; again, perhaps showing the *longue durée* of the animal–boat transformation. When turned upside-down, boats of the Krabbestig type look very much like Mesolithic big game. However, the theory of continuity and a north-south development of boat imagery and technology seem to be contradicted by the boat images themselves. While typical boat images of the NT are found in an area spanning the northerly and middle parts of the Scandinavian Peninsula, and not in western Norway, the earliest boat images belonging to what may be defined as the ST are most prominently seen on panels along the western and south-western shoreline of Norway, *e.g.* at sites like Leirvåg, Unneset and Krabbestig (Sogn and Fjordane), Nag and Åmøy (Rogaland) and Mjeltehaugen (Møre and Romsdal). The biased distribution of Krabbestig/Nag boat depictions indicates that another factor than the NT itself was crucial for the ST transformation.

The rock art of western Norway played centre stage in Christopher Prescott and Eva Walderhaug's (1995) theory of BBC impact and the possible immigration of Indo-European speaking people to Scandinavia towards the end of the Middle Neolithic, which arguably paved the way for the Scandinavian Late Neolithic. They maintained that in this phase, when the first boat images of the ST occur, old traditions were broken down and traditional rock art aggregations sites left behind. The potentially vital role played by BBC seafarers, the mBBC, is a 'joker' that may explain this discontinuity in space. No doubt the BBC was a very influential factor that strongly shaped Europe in the mid-third millennium BC. Firstly, the BBC was pivotal in introducing developed Bronze Age metallurgy and hence also more functional metal axes to the Nordic realm. Secondly, the Beaker

cultures profited greatly from their command of transport technologies that enabled more rapid movement – horse riding and also quite possibly seafaring, as is indicated by the distribution of BBC finds across north-western Europe (Fitzpatrick 2011), and more clearly evidenced by finds of plank-built boats in the UK, going back to *c.* 2000 BC (Van de Noort 2012).

Based on the distribution of settlements, BBC groups were probably the first Europeans to use boats for major trade. Although no direct evidence exists for their boats, they must have been adequate to established regular inter-regional connections and commodity transport across the sea and along rivers. The potential cost advantage of the Maritime Route apparently triggered the formation of improved maritime technologies and institutions to enter macro-regional networks. That maritime groups used the sea currents is supported by the fact that currents facilitate sailing to the coasts of western Sweden and Norway (Earle *et al.* 2015). These are the areas where the highest concentrations of figurative rock art and monumental burial cairns from the Bronze Age exist.

Investment in maritime forces of production

The steep increase in metalwork of local manufacture in south Scandinavia after 1600 BC (Vandkilde 1996) indicates that these societies entered a commercialised trade in metals. Moreover, and most intriguing, this is also the first phase when Scandinavia seems to have imported copper from the Mediterranean world (Ling *et al.* 2014). From around the same period in time, common European cosmopolitan codes and features were depicted on Scandinavian rocks as never before. These 'hybrid' features may be regarded as exclusive 'social codes' or 'core values' shared over a large part of Europe. Different articulations and configurations of these codes in Bronze Age Europe are found in different media including rock art, metals, pottery and graves (Treherne 1995; Harrison 2004; Coles 2005; Kristiansen and Larsson 2005). In Scandinavia, these codes were articulated and most vividly expressed in rock art showing representations of bulls, boats, chariots, oxhide ingots, sun images and later on armed humans associated with boats (Fig. 3.10).

It is logical to assume that the ST rock art was made in connection with specific maritime tasks such as travels, trading and raids, involving

Figure 3.10. Cosmopolitan codes and features from different parts of Bronze Age Europe. Top: warriors in Spanish rock art marked with C'; Swedish rock art to the right with no marks. Mid-section: horned figurines from Grevesvænge, the horned helmet from Viksø, and the camp stool from Guldhøj, Denmark. Bottom left: Acrobats and bulls from the Mycenaean world and from Scandinavian rock art (after Winter 2002). Bottom right: Warriors on Nuragic figurines compared with Scandinavian rock art (after Sjöholm 2003).

maritime skills combined with martial arts (Ling 2008). For instance, there are numerous boat images with a crew kneeling, sitting or performing actions or poses such as raising paddles or weapons or blowing lures, possibly presenting social 'initiations', staged in the rock. Social inequality is also stressed in the ST. The clearest examples depict enlarged warriors together with numerous smaller anonymous 'collective' oarsmen. The enlarged individuals are placed fore and aft in what seem to be commanding positions, often with weapons or other items aimed, pointed or directed at an anonymous bunch of oarsmen in the mid-section of the boat (Ling 2008:

202ff). The latter form of representation may even in an active way have illustrated that certain individuals had some kind of control over boats, at least in the process of building, crewing and launching, but perhaps not in the same way when at sea.

This indicates that the Scandinavian societies had established a maritime infrastructure that enabled them to actively partake in and enter maritime exchange (Fig. 3.11). The development of plank-built boats made it possible to cross open waters on a regular basis and carry up against 1 ton

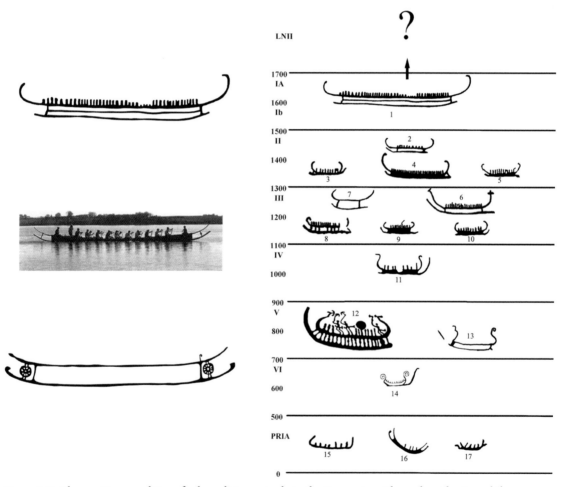

Figure 3.11. *The maritime conditions for long distance trade in the Bronze Age. The rock art boats and the war canoe from Hjortspring.*

of commodities (Kvalø 2007; Ling 2008; Van de Noort 2012). Tests and trials of the reconstructed boat from Hjortspring, largely similar to the Bronze Age boats depicted on the rocks (Kaul 2004; Ling 2008), show that in good weather conditions this kind of boat could be propelled about 800–100 km in a day. This means that a sea journey from west Sweden to, say, the Isle of Wight would take about 13–14 days, including stops for rest and water supply etc.

Conclusion

We suggest that the formation of new maritime institutions with an emphasis on building and crewing boats for maritime trading/raiding and warfare constituted a crucial feature for the societies in the coastal areas of the Nordic Bronze Age. Thus, transformative features of the boat were articulated differently in various parts of Scandinavia in the Early Bronze Age, but could have served a similar animistic function as in the NT, namely, to ensure the strength and durability of the boat and maritime ventures. Another significant aspect that needs to be stressed regarding the connection between the NT and the ST is that the NT was arguably made in connection with seasonal socio-ritual gatherings. Thus, we argue that some of the central rock art sites in the coastal ST rock art regions also worked as seasonal aggregations sites for Bronze Age groups. In a sense one may say that the overall demand for bronze and other commodities triggered needs to interact and aggregate which were comparable to the ones that occurred in Nämforsen or Alta during the Neolithic.

By incorporating the different social elements and legacies from the NT tradition on both a practical and a symbolic level the societies in southern Scandinavia created new maritime institutions which enabled them to enter and participate actively in the maritime exchange networks of the Nordic Bronze Age. The ST practice of depicting boats on rocks, but also the extensive use of boat symbolism in other media such as grave monuments and bronzes, reflect the growing importance of this new kind of maritime ideology. The fact that more metal circulated in Scandinavia between 1600 and 1100 BC than ever before probably relates to the chiefly families' capacity to invest in boats and crew. In short, individual chiefly households

with a surplus production enabling them to invest in the maritime forces of production, became the leading strata and the driving force to accumulate wealth in Bronze Age Scandinavia. Thus, a qualitative step could be seen from the Neolithic economy, based on the elite's ability to control the maritime forces of production. We regard the institutionalisation of maritime-ness as a crucial feature of the Nordic Bronze Age, and a *doxa* for the reproduction of the Nordic Bronze Age societies.

References

Almgren, O. 1927. *Hällristningar och kultbruk: Bidrag till belysning av de nordiska bronsåldersristningarnas innebörd.* Stockholm.

Bertilsson, U. 1987. *The Rock Carvings of Northern Bohuslän: Spatial Structures and Social Symbols.* Stockholm University. Stockholm.

Bradley, R. 2000. *An Archaeology of Natural Places.* Routledge. London and New York.

Bradley, R. 2006. Visions and Revisions – Northern Influence in South Scandinavian Rock Art? *Samfunn, symboler og identitet - Festskrift til Gro Mandt på 70-årsdagen* (R. Barndon, S. Innselset, K. Kristoffersen and T. Lødøen, eds): 163–170. Universitetet i Bergen arkeologiske skrifter. Nordisk 3. Bergen.

Bradley, R. 2009. *Image and Audience: Rethinking Prehistoric Art.* Oxford University Press. Oxford.

Carrasco, L. 2009. Maritim praksis i senneolitikum og eldre bronsealder: En analyse av båtristningene på Lista fra et maritimt perspektiv. Unpublished MA thesis. University of Oslo. Oslo.

Coles, J. M. in association with B. Gräslund 2000. *Patterns in a Rocky Land: Rock Carvings in South-west Uppland, Sweden.* Vol. 1. Department of Archaeology and Ancient History, Uppsala University. Uppsala.

Cornell, P. and J. Ling 2010. Rock Art as Social Format. *Changing Pictures: Rock Art Traditions and Visions in Northern Europe* (J. Goldhahn, I. Fuglestvedt and A. Jones, eds): 73–87. Oxbow Books. Oxford.

Engedal, Ø. 2006. På bølgje og berg – båten i røynd og risting. *Samfunn, symboler og identitet - Festskrift til Gro Mandt på 70-årsdagen* (R. Barndon, S. Innselset, K. Kristoffersen and T. Lødøen, eds): 171–182. Universitetet i Bergen arkeologiske skrifter. Nordisk 3. Bergen.

Earle, T. K., J. Ling, C. Uhnér, Z. A. Stos-Gale and L. Melheim 2015. The Political Economy and Metal Trade in Bronze Age Europe: Understanding Regional Variability in Terms of Comparative Advantages and Articulations. *European Journal of Archaeology* 18(4): 633–657.

Fett, E. and Fett, P. 1941. *Sydvestnorske helleristninger: Rogaland og Lista.* Stavanger museums skrifter 5. Stavanger museum. Stavanger.

Fredell, Å. 2003. *Bildbroar: Figurativ bildkommunikation av ideologi och kosmologi under sydskandinavisk bronsålder och förromersk järnålder.* Gotarc Serie B. Gothenburg Archaeological Thesis 25. Gothenburg.

Fredsjö, Å. 1981. *Hällristningar: Kville härad, Kville socken.* Studier i Nordisk Arkeologi 14/15. Gothenburg.

Gjessing, G. 1936. *Nordenfjelske ristninger og malinger av den arktiske gruppe.* Aschehoug. Oslo.

Gjerde, J. M. 2010. *Rock Art and Landscapes: Studies of Stone Age Rock Art from Northern Fennoscandia.* Universitetet i Tromsø. Tromsø.

Goldhahn, J. 2002. Roaring Rocks – an Audio-visual Perspective on Hunter-gatherer Engravings in Northern Sweden and Scandinavia. *Norwegian Archaeological Review* 35(1): 29–61.

Goldhahn, J. 2006. Om döda och efterlevande med exempel från Bredrör, Skelhøj, Sagaholm och Mjeltehaugen. *Samfunn, symboler og identitet - Festskrift til Gro Mandt på 70-årsdagen.* (R. Barndon, S. M. Innselset, K. Kristoffersen and T. Lødøe, eds): 283–303. UBAS Nordisk 3. Bergens universitet. Bergen,

Goldhahn, J., Fuglestvedt, I. and Jones, A. 2010. Changing Pictures: An Introduction. *Changing Pictures - Rock Art Traditions and Visions in Northernmost Europe* (J. Goldhahn, I. Fuglestvedt and A. Jones, eds): 1–22. Oxbow Books. Oxford.

Goldhahn, J. and Ling, J. 2013. Scandinavian Bronze Age Rock Art – Contexts and Interpretations. *Handbook of European Bronze Age* (H. Fokkens and A. Harding, eds): 270–290. Oxford University Press. Oxford.

Hagen, A. 1969. *Studier i vestnorsk bergkunst: Ausevik i Flora.* Norwegian Universities Press. Bergen and Oslo.

Harrison, R. J. 2004. *Symbols and Warriors: Images of the European Bronze Age.* WASP. Bristol.

Helskog, K. 1999. The Shore Connection: Cognitive Landscape and Communication with Rock Carvings in Northernmost Europe. *Norwegian Archaeological Review* 32 (2): 73–94.

Henley, D. and Caldwell, I. 2008. Kings and Covenants: Stranger Kings and Social Contract in Sulawesi. *Indonesia and the Malay World* 36 (20): 269–291.

Hodder, I. 2011. Human-Thing Entanglement: Towards an Integrated Archaeological Perspective. *Journal of the Royal Anthropological Institute* (N.S.) 17: 154–177.

Hodder, I. 2012. *Entangled: An Archaeology of the Relationships between Humans and Things.* Wiley-Blackwell. Malden, MA.

Hoel, K., T. Schmidt and Harsson, M. 2015. *Bustadnavn i Østfold. Bind 14. Borge, Glemmen og Fredrikstad.* Solum. Oslo.

Jensen, J. A. 1973. Bopladsen Myrhøj: 3 hustomter med klokkebægerkeramikk. *Kuml* 1972: 61–122.

Kaul, F. 1998. *Boats on Bronzes: A Study in Bronze Age Religion and Iconography.* National Museum. Copenhagen.

Kaul, F. 2013. The Nordic Razor and the Mycenaean lifestyle *Antiquity* 87 (2013): 461–472.

Klem, P. G. 2010. Study of Boat Figures in Alta Rock Art and Other Scandinavian Locations: With a View to Elucidate their Construction, and Discuss the Origin of the Nordic Boat. Unpublished MA thesis. University of Oslo. Oslo.

Kristiansen, K. and Rowlands, M. J. 1998. *Social Transformations in Archaeology: Global and Local Perspectives.* Routledge. London.

Kristiansen, K. 1998. *Europe before History*. Cambridge University Press. Cambridge.

Kristiansen, K. 2004. Seafaring Voyages and Rock Art Boats. *The Dover Boat in Context: Society and Water Transport in Prehistoric Europe* (P. Clark, ed.): 111–121. Oxbow Books. Oxford.

Kristiansen, K. and T. B. Larsson 2005. *The Rise of Bronze Age Society: Travels, Transmissions and Transformations.* Cambridge University Press. Cambridge.

Kvalø, F. 2007. Oversjøiske reiser fra Sørvest-Norge til Nordvest-Jylland i eldre bronsealder – en drøfting om maritim realisering og rituell mobilisering. *Sjøreiser og stedsidentitet. Jæren/Lista i bronsealder og eldre jernalder* (L. Hedeager, ed.): 13–134. Oslo Archaeological Series 8. Oslo.

de Lange, E. 1912. Ornerte heller i norske bronsealdersgraver. *Bergens Museums Aarbok* 4: 3–33.

Lévy-Bruhl, L. 1927. *L'âme primitive*, 3rd edition. Librairie Félix Alcan. Paris.

Lévy-Bruhl, L. 1925. *La mentalité primitive,* 4th edition. Librairie Félix Alcan. Paris.

Ling, J., 2008. *Elevated Rock Art: Towards a Maritime Understanding of Bronze Age Rock Art in Northern Bohuslän, Sweden.* GOTARC Serie B. Gothenburg Archaeological thesis 49, Gothenburg.

Ling, J., Stos-Gale, Z., Grandin, L., Billström, K., Hjärthner-Holdar, E., Persson, P.-O. 2014. Moving Metals II: Provenancing Scandinavian Bronze Age Artefacts by Lead Isotope and Elemental Analyses. *Journal of Archaeological Science* 41, 106–132.

Ling, J. 2013. *Rock Art and Seascapes in Uppland.* The Swedish Rock Art Research Series. Oxbow Books. Oxford.

Ling, J. and M. Rowlands, 2015. The 'Stranger King' (Bull) and Rock Art. *Picturing the Bronze Age* (P. Skoglund, J. Ling and B. Bertilsson, eds): 89–104 Oxbow Books. Oxford.

Linge, T. E. 2007. *Mjeltehaugen: Fragment frå gravritual.* Universitetet i Bergen. Bergen.

Liversage, D. 2003. Bell Beaker Pottery in Denmark – Its Typology and Internal Chronology. *The Northeast Frontier of Bell Beakers: Proceedings of the Symposium held at the Adam Mickiewicz University, Poznań (Poland), May 26-29, 2002* (J. Czebreszuk and M. Szmyt eds): 39–49. BAR. Oxford.

Lødøen, T. K. 1993. Et gravfunn fra sein steinalder. *Arkeo* 2: 4–7.

Lødøen, T. K. 2012. *Vingen: Et naturens kollosalmuseum for helleristninger.* Akademika forlag. Trondheim.

Mandt, G. 1983. Tradition and Diffusion in West-Norwegian Rock Art: Mjeltehaugen revisited. *Norwegian Archaeological Review* 16 (1): 14–32.

Mandt, G. 1991. *Vestnorske ristninger i tid og rom: Kronologiske, korologiske og kontekstuelle studier.* Universitetet i Bergen. Bergen.

Mandt, G. and Lødøen, T. 2004. *Bergkunst: Helleristningar i Norge.* Det norske samlaget, Oslo.

Marstrander, S. 1963. *Østfolds jordbruksristninger: Skjeberg.* Universitetsforlaget, Oslo.

Melheim, L. 2015. Støpeplasser og handelsplasser – to sider av samme sak? *Bronzestøbning i yngre bronzealders lokale kulturlandskab* (N. Terkildsen, M. Mikkelsen and S. Bodum, eds). Yngre bronzealders kulturlandskab vol. 4. Viborg and Holstebro Museum. Viborg.

Milstreu, G. and Prøhl, H. (eds) 1996. *Dokumentation och registrering av hällristningar i Tanum 1.* Tanums hällristningsmuseum. Tanumshede.

Montelius, O. 1876. *Bohuslänska hällristningar.* Norstedt. Stockholm.

Nordén, A. 1925. *Östergötlands bronsålder: Med omkr. 500 textbilder och 141 pl.* Uppsala universitet. Uppsala.

Nordenborg Myhre, L. 2004. *Trialectic Archaeology: Monuments and Space in Southwest Norway 1700-500 BC.* AmS-skrifter 18. Arkeologisk museum i Stavanger. Stavanger.

Østmo, E. 1997. Horses, Indo-Europeans and the Importance of Boats. *The Journal of Indo-European Studies* 25 (3/4): 285–326.

Østmo, E. 2005. Over Skagerak i steinalderen: Noen refleksjoner om oppfinnelsen av havgående fartøyer i Norden. *Viking* LXVIII: 55–82.

Østmo, E. 2009. The Northern Connection: Bell Beaker Culture Influences North of Skagerak. Comments on M. Pilar Prieto-Martínez: 'Bell Beaker Communities in Thy: The First Bronze Age Society in Denmark'. *Norwegian Archaeological Review* 42 (1): 86–89.

Prescott, C. and Walderhaug, E. 1995. The Last Frontier? Processes of Indo-Europeanization in Northern Europe: The Norwegian case. *Journal of Indo-European Studies* 23 (3/4): 257–281.

Prescott, C. 2009. History in Prehistory – the Later Neolithic/Early Metal Age, Norway. *Neolithisation as if History Mattered: Processes of Neolithisation in North-Western Europe* (H. Glørstad and C. Prescott eds): 193–215. Bricoleur Press. Lindome.

Prieto-Martínez, M. P. 2008. Bell Beaker Communities in Thy: The First Bronze Age Society in Denmark. *Norwegian Archaeological Review* 41 (2): 115–158.

Ramstad, M. 2014. Utgravingsprosjekt Halsvik. Små leirplasser, sjeldent fine funn. Steinalderundersøkelser i Halsvik, Gulen. *NORARK.* Available at: http://www.norark.no/prosjekter/halsvik/sma-leirplasser-sjeldent-fine-funn-steiderundersokelser-i-halsvik-gulen/ [accessed 09.03.2017].

Raphael, M. 1945. *Prehistoric Cave Paintings.* Pantheon Books. New York.

Rowlands, M. 1980 Kinship, Alliance and Exchange in the European Bronze Age. *Settlement and Society in the British Bronze Age* (J. Barrett and R. Bradley eds): 15–155. BAR. Oxford.

Sahlins, M. D. 1981. *Historical Metaphors and Mythical Realities: Structure in the Early History of the Sandwich Islands Kingdom.* University of Michigan Press. Ann Arbor.

Sahlins, M. D. 1985. *Islands of History.* University of Chicago Press. Chicago.

Sahlins, M. D. 2009. The Stranger King, or the Elementary Forms of Political Life. *Indonesia and the Malay World* 36 (105): 177–199.

Sand-Eriksen, A. 2015. Mjeltehaughellene – et klokkebegeruttrykk? Stil som uttrykk for sosial identitet. MA thesis, University of Oslo. Oslo.

Sjöholm, Å. 2003. Scandinavian Rock Carvings and Sardinian Bronzes. *Adoranten* 2003: 35–46.

Skoglund, P. 2012. Culturally Modified Trees – a Discussion Based on Rock-art Images. *Image, Memory and Monumentality: Archaeological Engagements with the Material World. Papers in Honour of Professor Richard Bradley* (A. Jones, J. Pollard, M. J. Allen and J. Gardiner, eds). Oxbow Books. Oxford.

Sognnes, K. 2001. *Prehistoric Imagery and Landscapes: Rock Art in Stjørdal, Trøndelag, Norway.* Archaeopress. Oxford.

Syvertsen, K. J. 2002. Ristninger i graver – graver med ristninger. MA thesis Universitetet i Bergen. Bergen.

Thrane, H. 1990. The Mycenean Fascination: A Northerners' View. *Orientalisch-ägäische Einflüsse in der europäischen Bronzezeit: Ergebnisse eines Kolloquiums* (T. Bader, ed.): 156–175. Römisch-Germanisches Zentralmuseum. Habelt. Bonn.

Van de Noort, R. 2012. Exploring Agency behind the Beaker Phenomenon: The Navigator's Tale. *Background to Beakers: Inquiries into Regional Cultural Backgrounds of the Bell Beaker Complex* (Fokkes, H. and Nicolis, F. eds): 61–79. Sidestone Press. Leiden.

Vandkilde, H. 1996. *From Stone to Bronze: The Metalwork of the Late Neolithic and Earliest Bronze Age in Denmark.* Jutland Archaeological Society Publications XXXII. Aarhus.

Vogt, D. 2011. *Rock Carvings in Østfold and Bohuslän, South Scandinavia: An Interpretation of Political and Economic Landscapes.* Novus Press. Oslo.

Westerdahl, C. 2005. Seal on Land, Elk at Sea: Notes on and Applications of the Ritual Landscape at the Seaboard. *International Journal of Nautical Archaeology* 34: 2–23.

Wikander, O. 2010. *De indoeuropeiske språkenes historie: Et tre med mange grener.* Transl. Lars Nygaard. Pax forlag. Oslo.

Willerslev, R. 2007. *Soul Hunters: Hunting, Animism, and Personhood among the Siberian Yukaghirs.* University of California Press. Berkeley.

Wrigglesworth, M. 2006. Explorations in Social Memory – Rock Art, Landscape and the Reuse of Place. *Samfunn, symboler og identitet - Festskrift til Gro Mandt på 70-årsdagen* (R. Barndon, S. Innselset, K. Kristoffersen and T. Lødøen): 147–162. Universitetet i Bergen arkeologiske skrifter. Bergen.

Chapter 4

Nämforsen – A Northern Rock Art Metropolis with Southern Pretences

Ulf Bertilsson

Abstract: In this article, the focus is on the rock carvings at Nämforsen, and the comprehensive study they have been subjected to over the past half-century. This applies to the documentation, dating and interpretation of the carvings and also to the surrounding archaeological context. Hallström's starting point has been that the Northern Tradition masterpiece carvings were heavily influenced by the Southern Tradition, a view he later modified. Although other researchers have pointed to certain similarities to the Southern Tradition, the notion that the carvings belong to the Stone Age and are completely characterised by the northern

hunting and trapping cultures has become very firmly established. One difficulty in this reasoning is that the two neighbouring settlements, Ställverket and Rainget, had their most intensive settlement during the Bronze Age *i.e. after* the period carvings are considered to have occurred. Another problem is apparent in the lack of bones of elk, and instead finds of bones of fish that indicate their food did not come from the animals they depicted the most. The author incorporates the numerous coastal burial cairns from the Bronze Age in the analysis and believes that, because they are to a large extent simultaneous with these settlements, they may also have a connection to the carvings. For these, he highlights a special type of manned ships that seem to occur at 'strategic' locations on the rocks. Moreover, bronze casting was done at Rainget. A possible explanation for these phenomena is the advancing Bell Beaker culture that also left its mark in the form of a very typical flint arrowhead at the Ställverket settlement. This shows that the area was drawn into a growing network of trade and exchange in the Bronze Age.

Key words: Nämforsen, rock carvings, Mesolithic, Neolithic, Bronze Age, settlements, pitfalls, burial cairns, Northern Tradition, Southern Tradition, bronze casting, Ananino bronze axe, Bell Beaker arrowhead.

The rock carvings at Nämforsen in Näsåker, Ångermanland, are among Scandinavia's most significant rock art metropolises with now close to 3400 prehistoric images (Larsson and Broström 2011). Gustaf Hallström recorded these rock carvings throughout his life, and published his findings after half a century of documentation and research (Hallström 1960). His book was based on a scholarly discourse that had developed back in the 19th century, but still characterises much rock art research of today (Bertilsson *et al.* 2017). A supplementary inventory performed in the early 2000s by Thomas B. Larsson and Sven-Gunnar Broström (2011) resulted in the discovery of more than 700 previously unregistered figures. So far, including theirs, all the documentations of the rock carvings at Nämforsen have been accomplished using traditional analogue 2D techniques. Therefore, there has been an almost desperate need to test and apply more modern digital 3D techniques. In 2015, tests applying new 3D documentation commenced,

Figure 4.1. SFM-documentation of rock carving G: 1 Lillforshällan performed by Catarina Bertilsson. The camera is positioned on a monopod, and at the ends of the rock carving are placed markers that serve as georeferences. Photo: Ulf Bertilsson (source: SHFA).

using the digital photography technique Structure from Motion (SFM) by the Swedish Rock Art Research Archives (www.shfa.se) at the University of Gothenburg, commissioned by the County Administrative Board of Västernorrland (Fig. 4.1). As the results of the experiment were rewarding, producing intriguing new information, it was decided to continue the SFM documentation work into 2016 (Bertilsson and Bertilsson 2015; Bertilsson 2016).

Context and chronology

This work has also given reason to ponder the context and dating of the rock carvings. Traditionally, they have been dated to the Late Mesolithic and the Early and Late Neolithic and its way of life based on hunting, trapping and fishing that has characterised this inland area of central Norrland, although it should not be forgotten that this was at the time located in the coastal belt. These dates are based on both a general rock art

context (Hallström 1960) and the putative connection to the contemporary shoreline (Forsberg 1993). Most recently, however, a revision of this well-established hypothesis has been made after a new analysis performed by Jan Magne Gjerde (2016), based on new data and the link to the shoreline. The result is that the practice of making petroglyphs at Nämforsen is suggested to have started several hundred years earlier in the Mesolithic, about 5000 BC but still ending during the Early Bronze Age (Gjerde 2016, *cf.* Sjöstrand 2015). The credibility of this new hypothesis will be scrutinised a little further on in this article.

Without fundamentally questioning the overall dating hypothesis, there is still reason to wonder whether there other circumstances – contemporary archaeological phenomena or other facts that support this redating and/ or allow for a more complete picture of the chronology and context of Nämforsen (Fig. 4.2). One obvious reason is that the nearby Ställverket settlement was in use for a long period of time, starting in the Mesolithic and ending in the Early Iron Age, but with an emphasis on the Bronze Age (Baudou 1977: 73; *cf.* Käck 2009).

Baudou also believes that a large part of the carvings were produced during the same periods and with only a few touches of figures otherwise typical of the Bronze Age rock art tradition of southern Scandinavia – the footprints and sun crosses. First Mats Malmer (1981 and 1992), and later the author of this article, Ulf Bertilsson (1994 and 1995), have emphasised this southern connection. The latter also drew attention to the similarities in the organisation of the carvings to the placement of the figures on the rock surfaces (1994 and 1995). This view, also advocated by Hallström (1960) and later by Bolin (1999), was originally based on the difference in technology between the contour-carved and the completely carved-out figures, the latter technique considered to point to a south Scandinavian influence (*e.g.* Lindgren 2001 and Fig. 4.3). This view was later challenged, first by Baudou (1993) and soon after by Lindqvist (1994), but with two partly different starting points: Baudou believed that Malmer in his hypothesis overestimated the significance of the carving technique when it comes to the different types of ship carvings, and that he instead should have weighed in the 'whole of northern cultural environment during the Neolithic and Bronze Age' (Baudou 1993: 259 translated here); Lindqvist objected on the grounds that completely carved images also are a dominant technology in

Figure 4.2. Overview of the Nämforsen area with the electric power plant and the different carving areas, Laxön with Lillforshällan, Brådön, Södra Stranden and Notön. Photo: Sven-Gunnar Broström (source: SHFA).

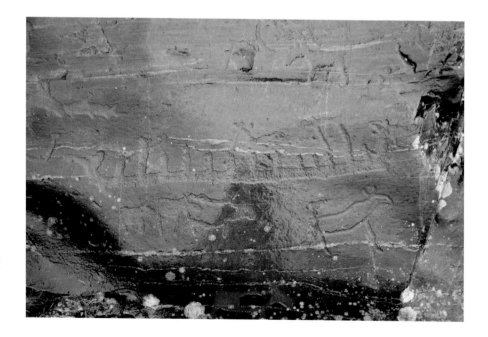

Figure 4.3. A section of the great rock carvings of Lillforshällan G: 1 showing that completely carved and contour carved figures, considered to belong to two different phases, actually may occur together. This rock carving is dominated, however, by completely carved figures (photo: Ulf Bertilsson, source: SHFA).

the rock carvings at Lake Onega in Russian Karelia, generally considered to belong to the Mesolithic and Neolithic (Lindqvist 1994).

Pia Nykvist has analysed the rock carvings at Nämforsen by making comparisons with other rock art sites in northern Europe. There she demonstrates that there is a time difference between the carved-out and contour-carved carvings, the outcome of the study being that the completely carved-out images are the oldest (Nykvist essay script). This is based on the analysis showing that on surfaces with completely carved-out images, there are few if any of the contour-carved ones and vice versa. In addition, older carvings seem to have been respected when new ones were made. This indicates that the existing carvings were visible or otherwise known. Although there are examples of superimposed images, to a large extent the older carvings were still respected. The result of Nykvist's interesting study is completely opposite to that of Malmer (1992).

Contemporary settlements

If we look for other archaeological phenomena that may offer additional contextual conditions for the rock carvings during the long period of time when they were produced, a possible maximum of four millennia, there is the upstream settlement at the nearby Råinget that was has both previously and recently excavated (Baudou 1977; Käck 2001; George 2001). Accepting the hypothesis that the rock carvings at Nämforsen are shoreline-bound and that their placement on the islands of Laxön, Brådön and Notön followed and mirrored the withdrawal of the sea, there ought to be other archaeological phenomena connected to this process. So far, there are rather few settlements in the immediate area to support the claim of such an early start, about 5000 BC, of the tradition of making rock art, as suggested by Gjerde (2016). Results from recent excavations still show that a certain settlement in the surrounding area occurred at this time (Persson 2014). A settlement (RAA 158) on the opposite bank, the Southern Shore, from the Ställverket settlement gave a C14 dating of the oldest activity, a 1.5 m × 0.6 m large red ochre accumulation of 5255 + 45 BP or 4230–3970 BC (George 2005). The settlement position at a height of 78 m above sea level means that the stream was almost fully developed at this time. In essence, this means that

the practice of engraving images at Nämforsen theoretically may have started already during the Mesolithic – but still not as early as Gjerde claims (2010).

In addition, there is also the Ställverket settlement with finds covering the period from the Early Neolithic to the cessation of settlement in the Early Iron Age (Baudou 1977). According to Käck (2001), the earliest possible dating is 4000 BC with a level of 80–85 m above the present sea level on the assumption that the settlement was located close to the shore and concurrent with the oldest carvings. As for the dating of the carvings at Nämforsen, George in his article (2001) about the excavations at Råinget emphasises that the carved slate plate with an elk figure and an anthropomorphic figure and on one narrow side a spear, according to the sequence of settlement layers, may be dated to the Neolithic. This thereby creates possibilities to date similar carvings to the same period (*cf.* Baudou 1993; Lindqvist 1994). This is virtually the same conclusion as presented by Forsberg (1993) in his analysis based on the seriation of the entire rock carving materials that were known at that moment. Simultaneously, George emphasises that the majority of the finds belong with certainty to the Bronze Age and thus, in this regard, resemble the Ställverket settlement. This hypothesis is further enhanced by finds from the Råinget 2 settlement of remnants of bronze casting in the form of a crucible/melting pot that was probably used to produce an Ananino bronze axe (George 2001: 112, *cf.* Ojala 2016 and Figs 4.4–4.6). Forberg's analysis of ceramics at Råinget also shows a

Figure 4.4. Fragments of a crucible mounted in a sheet of glass, to show the crucible original shape and size. The crucible was found on Råinget settlement likely to have been used in the manufacturing process of the celt of Ananinio type also found fragments of there (photo: SHM).

Figure 4.5. Fragment of a celt of Ananino type, which was also found during the excavation of Råinget settlement (photo: SHM).

Figure 4.6. Fragments of clay, possibly part of a core for moulding a celt of Ananino type, of which was also found a fragment, on Råinget settlement (photo: SHM).

clear emphasis on the Late Neolithic and Early Bronze Age, which indicates that the hut had the same dating (Forsberg 2001).

Elk pits and fish trapping

The habit of making pitfalls became more common during the Neolithic and then increased significantly during the period corresponding to the Bronze Age (Selinge 2001). In the surrounding landscape are also a number

of pitfalls generally dating to the Viking Age and early medieval times, but the tradition as such has actually been shown to go back to the Neolithic (Selinge 1974; Baudou 1977) and in a few cases even to the Late Mesolithic (Selinge 2001; Ramqvist 2007; Gjerde 2016). Selinge notes, however, that:

> the large central settlements in Nämforsen and Råinget have no secure connection with pitfalls, although there are a few smaller systems nearby. An old hypothesis about the rapids as fish traps can be dismissed, not least for functional reasons (Selinge 2001: 173 translated here).

Another and more plausible hypothesis might be that the reason for settling at Nämforsen was primarily to catch fish, especially salmon, using specially built permanent trapping devices (Lindqvist 2001).

Graves from this times are extremely rare, the most famous one being at Lagmansören in the Indal river valley in Medelpad, about 120 km further south as the crow flies (Baudou 1977; Persson 2014). If we, regardless of their dating, were looking for an equivalent to the types of well-represented archaeological phenomena such as settlements, pitfalls and rock carvings, we have already found that it does not apply to category of graves. Even if finds during recent years are included, the total number is still vanishingly small. However, if we turn our gaze to the east, towards the coast, an entirely different picture emerges, because there we find a category of prehistoric tombs that are very abundantly represented.

Bronze Age burials in coastal cairns

Let us then consider the Bronze Age cairn graves that are plentifully represented along the coast of Västernorrland. Baudou (1974 and 1977) indicates a total of 920 in Ångermanland and Medelpad together (690 and 230 respectively). A compatible result using the revised inventory of the Ancient Monuments of this area, performed at the beginning of the 1990s, is difficult to obtain. This is due to the fact that the category 'cairn-like stone setting' is not discernible or searchable in the nationwide database Fornsök of the Swedish National Heritage Board. Oddly enough, a search then results in a decrease, probably due to a number of cairns then assessed

different and re-registered as 'cairn-like stone settings', a category which, however, cannot be retrieved because the search tools in Fornsök are too coarse. Chronologically, they cover almost the entire period from the Early Bronze Age to the Late Bronze Age, starting at least in period II and ending in period V and thus 1600–600 BC. But there are also cairns which may be older, and even ones that were built in different parts of the Iron Age.

The large number of coastal cairns makes the area – Västernorrland – one of the country's densest, on a level with Tjust in Småland and above that of Blekinge. This clearly shows that the construction of the cairn tombs cannot be regarded as a temporary phenomenon, but rather a firmly established practice with a period of usage that extends more than a millennium (Baudou 1978). It is also proven amply by the typical constructions of full-length cists for skeletal burials and other abundant details such as dry stonewalling and covering rock fills (Fig. 4.7). Although the total number of cairn tombs is less than in, for example, Bohuslän, Småland and Uppland, the spread in Västernorrland is just as dense locally. Consequently, the cairn burials there seem to have been an equally prevalent archaeological element during the Bronze Age as in these southerly areas.

The detailed design of burial customs follows the same trend as in southern Scandinavia from the Early to the Late Bronze Age, starting with the full-length cists covered with stone slabs for skeletal burials, followed

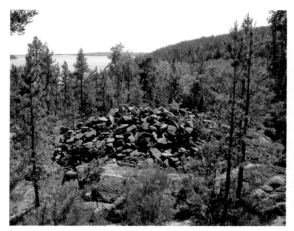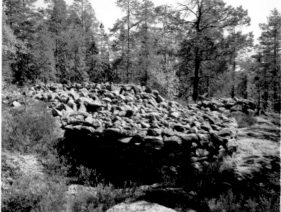

Figure 4.7. Bronze Age cairns of characteristic types with rock fill and dry stone walling at Harphagen in Vibbygerå and Grundsunda in Ångermanland (photos: Pia Nykvist).

by smaller cists for cremation burials (Baudou 1977: 111). Cairn graves exist at levels between 50 and 30 m above sea level and have a marked peak in prevalence between 40 and 35 m (Baudou 1977). Baudou's analysis shows convincingly that the cairn tombs are closely attached to the contemporary shoreline and in an obvious way follow its withdrawal during the Bronze Age, and the relative time sequence fully corresponds to what is known from southern Scandinavia.

The majority of the excavations of ancient monuments from the Bronze Age have concerned graves. No less than 67 tombs from the Bronze Age have been investigated in the county, most of which are cairns (Persson 2014). With reference to Baudou's shoreline connection analysis (1977), Persson (2014) highlights the fact that some cairns are located at higher levels than the Bronze Age, and others at levels that better match the Iron Age. Theoretically, this would make it possible that certain cairns were been built already during the Neolithic. Another and perhaps more likely possibility would be that the cairn tombs were built even higher up from the shoreline during the Bronze Age. Such examples can be found elsewhere in the country, including in Bohuslän, where a number of large and monumental mounds are built on high mountain crests, such as the 225-metre high Björnerödspiggen in Näsinge at Idefjord, and the mighty Kuballe Vette cairn on a 115-metre high mountain crest on top of the island of Tjörn. Another large cairn in Halland proved to be vaulted over a Neolithic dolmen, which shows that early cairn tombs also exist (Petersen 1972).

The Northern Tradition of rock art

It has been argued (Ling and Rowlands 2015 with references) that the transformative depictions of elks, and some other animals, and ships are the most typical expression of the Northern Tradition regarding structure, should be seen as a the prime legacy of this rock art tradition. This in turn would mean that such expressions in the Southern Tradition would have received their ideological background from the north but the real image content from the south. As the author of the article has shown previously, this hypothesis may in many respects be correct although some types

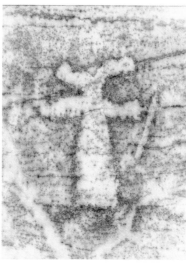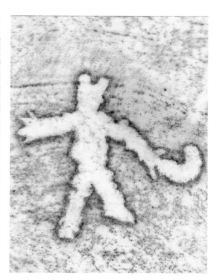

Figure 4.8. Examples of the twin-horned anthropomorphic figures at Nämforsen, left Laxön. Photo: Ulf Bertilsson. Middle and right Brådön. Rubbings: Dietrich Evers (source: SHFA).

of figures, also represented among the Nämforsen carvings, such as the antlers of elk and deer shaped like boats and anthropomorphic figures with twin-horned heads, may also exhibit a much more extensive distribution in time and space, indicating that they may have occurred in different places independently of direct contact (Bertilsson 2015 and Fig. 4.8).

Why and how the diffusion process of the Northern Tradition to southern Scandinavia during the Early Bronze Age took place and were designed are absolutely fundamental questions that nobody has been able to give a concrete answer to yet. However, there is little reason to doubt that the Northern Tradition rock art was produced in connection with seasonal socio-ritual gatherings. Jenny Käck's analysis (2009) of the settlement and its different phases shows, perhaps surprisingly, that the settlement does not have any traces of the settlement of a larger group of people, but rather that the group seems to have been relatively small. A frequently expressed view is that these meetings took place when there was a seasonal abundance of prey animals at these specific locations in the landscape, such as at Nämforsen or Alta (Gjerde 2010 with references). The obvious prey then, of course, was the elk. No matter how obvious this may be, the animal bones found at the Ställverket settlement do not support this hypothesis. These

indicate instead that salmon was the main food (*cf.* Selinge and Lindqvist above). In this case, we can establish the existence of an interesting contradiction – the most common edible animal on the settlement seems to have been salmon, trout, pike and ide, while the animal most frequently depicted in carvings was the elk (Baudou 1993; Lindgren 2001). This would then give an opportunity to rewrite the saying 'What you see is what you get' as 'What you see is *not* what you ate'.

Lindgren (2001), citing parallels in America which show depictions of animal species on pottery, emphasises that the animal bones encountered as residues of the food consumed do not match the depicted animals.

Visual art in this case is clearly not a reflection of the main economic resources. This should be considered when looking at Nämforsen's elk pictures (Lindgren 2001: 69, translated here). Let us first note that there is little reason to doubt, the long-established knowledge that the rock carvings at Nämforsen belong to the Northern Tradition, constituting one of its most prominent expressions ever. No one has perhaps expressed this better than Klas-Göran Selinge:

> Nämforsen is one of Norrland's most famous and important archaeological sites. It is both unique and typical. It is unique in terms of its quantitative relationships: it has by far the largest number of rock art carvings and is also the settlement with the richest finds throughout the northern Swedish hunting region. It is typical in qualitative terms: its antiquities contain a collection of pictures and finds which are of the same kind as at the thousands of smaller localities of the ancient hunting culture, and it thus has a clear connection with these. A prerequisite for this is the outstanding location. The waterfall environment was created by land upheaval in a culturally appropriate era and thus gave good opportunities for contact both outwards and inwards, and it has a central location in one of the largest and water-richest river valleys, first beginning at the estuary. It is these archaeological and physical circumstances that lie behind the now mainstream perception of Nämforsen as an important (the most important?) 'assembly site' of social and religious nature of the hunting culture. Within the area than can be characterised as the catchment of the assembly site, there lived more or less mobile groups of people who temporarily took part in or were indirectly dependent on the activities as the assembly site (Selinge 2001: 153, translated here).

Since Selinge's focus in this paper is on pitfalls, he expresses no particular opinion of the chronology except for the general reasoning above regarding a common perception in his discussion of the 'hinterland'.

Rethinking the dating issue

As we have stated earlier, the overall picture – the explanations and datings discussed for the rock carvings at Nämforsen, originally constructed and launched by Gustaf Hallström, were later refined and confirmed by Baudou (Hallström 1960; Baudou 1977, 1993). Its essence is that the start of the practice of making rock carvings is considered to be quite far forward in time, namely around 3500 BC (Baudou 1993: 261, tab. 2). Forsberg supported this view in his chronological analysis in which he placed the carvings in the Early and Late Neolithic (Forsberg 1993: 244). Commenting on the segment of the images of the south Scandinavian tradition, Baudou expresses the opinion that they were made during the Bronze Age around 1200 BC, but that the 'domestic' carving tradition at that time had already ended (1993). Ramqvist (1992) believes that the end point of making petroglyphs should be set even later, *c.* 1000 BC. Bolin, on the other hand, argues that the practice of engraving images on flat rocks lasted even longer, until the transition between the Bronze and Iron Age, *c.* 500 BC (Bolin 1999).

This view stands in stark contrast to that of Jan Magne Gjerde presented in his thesis, and summarised in a recent article in *Adoranten* (Gjerde 2010; 2016; *cf.* Bertilsson and Ling 2016). He argues there that the actual start of making rock carvings at Nämforsen should be set as early as 5000 BC, his opinion being founded on newer land elevation data and the stylistic similarities to the rock carvings in Alta in Finnmark, Norway. A question then arises unsought: how could it be possible to arrive at such different perceptions of the dating of the same archaeological material, the rock carvings? One reason could be that Gjerde's analysis focuses mostly on the rock carving landscape and its proximity to the shoreline, while not paying much attention to the rest of the archaeological material – assuming that the pitfalls and settlements in the area are part of one and the same prehistoric complex. Other researchers, above all Baudou and Käck, but also

Forsberg and George, include that material in their analyses and study it in depth.

In my view, the latter practice is definitely necessary if we want to understand the Nämforsen rock carvings. Without a broader context that includes settlements, pitfalls, tombs and other archaeological phenomena, it becomes significantly more difficult to understand and interpret the petroglyphs, their functionality, content and time of creation. This leads us once more to the question of the possibility of the existence of a direct or indirect link between the two dominant archaeological complexes, rock carvings and burial cairns. Is there any archaeological evidence to support such a hypothesis? Both Forsberg (1993) and Baudou (1993) tackle this most interesting problem and appear to agree that those two phenomena did not have any direct connection, but should be seen as two completely separate. Forsberg's opinion, based on his analysis of the concept of 'assembly site', culminates in the following statement:

> It thus seems that we have two completely different conditions in the inland districts and on the coast. In the inland there is a change from relatively immobile societies to more mobile communities, while at the coast there is a broadening of the resource base and a transition to a completely different form of production ... During the Neolithic period in the inland there are small, immobile hunter groups who mainly live by elk hunting. On the coast there appear relatively sedentary complex communities of hunters who mainly live by hunting seal. During the Bronze Age larger, more mobile hunter groups move into the inland districts ... On the coast there are then smaller semi-sedentary or sedentary tribal communities who subsist on farming, seal hunting and animal husbandry (Forsberg 1993: 241–243 translated here).

Forsberg finally concluding that since the rock carvings at Nämforsen were produced during the Early and Late Neolithic, possible contacts between inland and coastal populations can be completely be ruled out for chronological reasons. This fairly firmly cemented picture of an almost cutthroat cultural dualism in central Norrland has subsequently been repeatedly questioned but with no apparent effect (Bolin 1999; Carlsson 2001; *cf.* Persson 2014).

In any case, researchers to date studying the rock carvings, their period of creation and usage, have reached similar conclusions, namely that the

rock carvings at Nämforsen were overwhelmingly made before the so characteristic Bronze Age cairns started to be built along the rocky coast of Västernorrland. Quite irrespective of any link between the carvings and cairns, Selinge claims (1979) that the inland settlements and coastal cairns belonged to the same population and mirror its seasonal use of the respective areas. At the same time, he argues that the construction of burial cairns resulted from the diffusion of ideas and not from actual immigration (*cf.* Melheim and Ling 2017).

Stone Age rock art and Bronze Age settlement

Confusion has been created by the fact that, regardless of the results of the excavations of the different settlements, the focus has been directed towards the evidence pointing to the Stone Age. This period usually comes up as the first feasible chronological alternative, not only for the settlements around Nämforsen, despite the fact that the most intensive period for many settlements there seems to be the Bronze Age, witnessed by the fact that the majority of finds from Ställverket and Råinget belonging to precisely that period. This results in difficulties when it comes to interpreting the relationship between rock carvings and settlements. If, according to the common view that the carvings were overwhelmingly produced during the late Mesolithic and the Early and Late Neolithic, the inevitable conclusion must be that the practice of making petroglyphs had already ended when the settlement became most intense in the Bronze Age (*e.g.* Baudou 1993: 261, tab. 2). Although this might be a partly correct interpretation it is not a completely obvious one. It has many similarities to Forsberg's (1993) conclusion that the then current cultures in the inland and the coast areas lived in completely different worlds that almost never met or intermingled. It is all the more interesting, then, that the result of the review of the archaeological source materials accomplished by surveys, excavations and examination of archival records by Persson (2014) shows a largely opposite picture.

This picture requires new analyses to be performed and new questions asked by researchers. There is already comprehensive and information-rich source material that includes what began to develop in earlier times but also has multiplied in modern times. Persson (2014) recognises 120 datings

to the Bronze Age of which nearly half are derived from human settlements and similar contexts. To understand this information better, and to extract new information and knowledge from it, it is vitally important that it be studied at the right level and analysed in a larger context otherwise there is a risk that the research will result in 'factoids' or 'alternative facts' like the illustrative example of Arctic bronzes and south Scandinavian bronzes (Persson, 2014: 175). I have previously pointed out the often overlooked ability to study and analyse the petroglyphs and specific motifs of these on a higher meta-level (Bertilsson 2015). In this way you can avoid getting into the trap of believing that the design of all human culture is totally dependent on natural conditions, and instead also take into account human cognitive capacity based and developed on intellect and experience as equally weighty factors. In that study Persson shows an example of a similar design of specific figure carvings at Nämforsen and at Ekenberg in Norrköping illustrating this approach (Persson, 2014: 169).

Regardless of how we toss and turn this problem, it persists, and a number of central issues remain unanswered:

- If the carvings were made only during the Late Mesolithic and Early and Late Neolithic, why were none made during the Bronze Age?
- Was it because the elk was drastically reduced in number as a result of climate change (Larsson 2012; Larsson *et al.* 2012)?
- Can the explanation for the lack of rock carvings from the Bronze Age be that people no longer ate elk and therefore no longer needed to depict it?
- But how can one explain the numerous depictions of boats?
- If salmon and other fish species were now the main diet, why were they not depicted to a greater extent?
- Could it have been that most rock carvings, after all, were made during the Bronze Age?

The last question presupposes that a high proportion of the rock carvings could still have been made close to the shoreline, especially if the high water levels in the spring are included in the calculation. And this would also mean that the carvings would get a completely different dating with a difference of several thousand years. As we see, there are so many questions but few answers so far.

The settlement (RAA 158) on the opposite bank from the Ställverket settlement gave ^{14}C dating of the oldest activity, a 1.5 m × 0.6 m large red ochre accumulation of 5255 + 45 BP or 4230–3970 BC (George 2005). The position at a height of 78 m above sea level means that the stream was almost fully developed at this time. This basically means that the practice of engraving images at Nämforsen theoretically may have started already during the Mesolithic – but still not as early as Gjerde claims (2010). The importance of this settlement may have occurred when the rapids became an obstacle for salmon and trout to migrate up the river. The fish could then be collected below the rapids where they were easy to catch. This made the place an unusually rich food resource that people were drawn to a natural meeting place. The very special location at the intersection of land, sea and sky, the three basic elements, meant that it had a special and significant loading, which could explain the presence of rock carvings but not why the people living there depicted elk while they were revelling in salmon (*cf.* Bertilsson 2000, Wrigglesworth 2015). Actually, a rather simple analysis shows that the few existing depictions of salmon (Larsson and Broström 2011: Laxön D:7a, D:16b, E:3a, Lillforshällan G:1, Södra Stranden Z:1, Notön U:1, Brådön F:4 and N) are located on a small number of carved surfaces with a (strategic?) location in the different main carving areas (Fig. 4.9).

Figure 4.9. *Triptyk of rock carving with two full and one fragmentary salmon in a low position on Laxön documented with SFM technology. To the left, a screen shot in Mesh Lab with the texture and in the middle one without and to the right an orthophoto. The fragmented salmon which, is located below the two previously registered salmons, is best visible on the non-textured image to the left (photo: Catarina Bertilsson, source: SHFA).*

The southern pretences

Hallström's original study of the rock carvings at Nämforsen had as a starting point a close link to the south Scandinavian rock carving tradition, as evidenced by the large number of ship images. He gradually came to modify this view, influenced by the work with other northern rock carvings (Hallström 1960). His followers Baudou, Forsberg and Ramqvist emphasised the opposite, the carvings almost entirely representing an exclusively northern imagery sprung from a society based on hunting, trapping and fishing, with only a marginal impact from the south (Baudou 1993; Forsberg 1993; Ramqvist 1992). All these scholars championed the notion that the southern picture element was almost negligible, consisting of a vanishingly small number of images of footprints, circle crosses, and ships (Fig. 4.10).

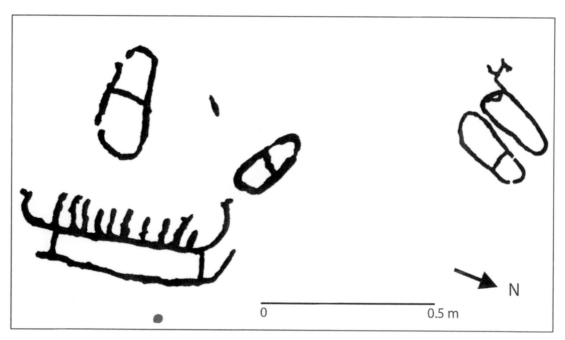

Figure 4.10. Rock carving on Brådön with a ship of south Scandinavian type and footprints. Ships of this type are usually dated to the period II-III of the Nordic Bronze Age corresponding to 1500-1100 BC. On the large Brådö carving, there are a few more ships with southern elements (Larsson and Broström 2010).

Ramqvist (1992) distinguished four figure categories with possible links to the south Scandinavian tradition, namely ships, circle crosses, footprints and cup marks. His conclusion is that only footprints lacks root in the Northern Tradition; ships of the Scandinavian type may have come in from the west via Trøndelag, cup marks appearing on the rock carvings at Norrfors outside Umeå in northern Sweden and a circular cross on one of Scandinavia's oldest carvings, Leiknes in Nordland, Norway. Thus, only the footprints remain as a possible influence from the Southern Tradition, although it may just as easily have gone through Trøndelag, 'but it seems impossible to escape the fact that the motif came from agrarian areas' (Ramqvist 1992: 49 translated here). Regarding the number of figures concerned, there is no reason to question this assertion. What influence and impact these few figures may have had is a completely different question, although not easily answered (*cf.* Bertilsson 2013). Therefore, we refrain from doing so, and instead take a new look at the images to see if there may be additional elements with an external and/or southern accent.

As the carvings, with a few exceptions (Forsberg 1993; Nykvist unpublished paper; Sjöstrand 2014), have not been analysed excessively in terms of figure types and detailed design, there may be an opportunity to study the ships beyond the few that are purely south Scandinavian in design. As a more comprehensive analysis is impractical in this context it is concentrated on a special ship type, the often large (length approx. 0.5–1.6 m), keel and gunwale line equipped ships with slightly upturned stern and stem rods and bar-shaped crew-lines (Larsson and Broström 2011: Laxön G: 6, Y 1a–c, Notön C: 6 7, D: 9, E: 2, G: 2, H: 1, A: 6 and Fig. 4.11). These ships stand out from others of the same shape which are consistently smaller and unmanned. In terms of form, they are also very different from the single-lined ships, with elk heads as ornate bows. These admittedly have crew-lines too, but, as with the keel line, they have usually a less distinctive design (Larsson and Broström 2011: Laxön D: 14–15, E: 3, G: 1 among others). According to Helskog's chronological schema for the rock carvings in Alta, this type of ship, in different variants, belongs in periods II and III, which corresponds to 4800–4000 BC and 4000–2700 BC, or the Late Mesolithic and Early and Middle Neolithic (Helskog 2012: 29). The latter ship type is also common, and the only one that exists, in the rock paintings in Finland (Bertilsson 2015 with references). There it is dated to the period 4200–2000 BC and is

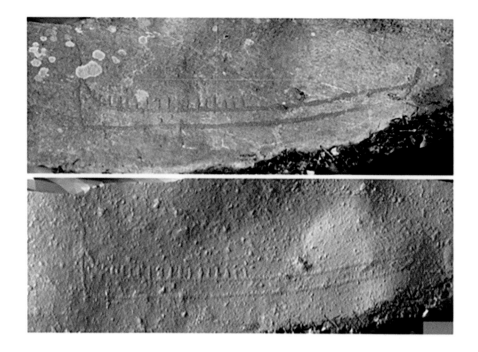

Figure 4.11. A manned double-lined ship of a specific type with upturned stern and bows documented with the SFM-technique. Top, a screen shot in Mesh Lab with the texture and bottom, one without. In this, 1.3-meter long ship that is located next to the power plant dam on Lillforshällan, the manning lines do not fill out the entire railing line (photo: Catarina Bertilsson, source: SHFA).

considered to belong to the Comb Ware culture and/or Pitted Ware group (Kivikäs 1995; Lahelma 2012).

The impression that the first boat type we have focused on above, the one with the double-lined hull, may have had a special significance is enhanced by the fact that it is extremely rare, with a total of only a dozen instances, one on a carving on Lillforshällan, and four on another one on Södra Stranden. All the other six ships of this type are found on four major carvings on Notön, while they are absent on Brådön (Fig. 4.12). Moreover, all these special carvings are placed at what appear to be particularly selected locations, on the rocks near the waterline on Notön and Södra Stranden and, interestingly enough, high on Lillforshällan close to the outlet of the current hydroelectric dam. This means that they occur on both high and low level carvings. If they were strictly tied to a specific carving period and a shoreline-related chronology, the type should have had a more limited distribution. The distribution pattern suggests that it had a meaning that is related to other factors. Given that the design displays several elements that can be argued to be typical of the Southern Tradition, it may also be

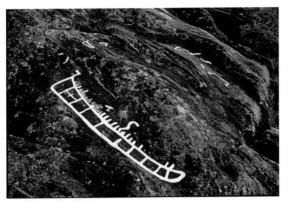

Figure 4.12. Two manned double-lined ships with compartmented hull and upturned bow (left) and bows (right) of South Scandinavian type on Notön. In the left appears likely a bronze lure depicted on the same manner as the Bronze Age rock carvings in Bohuslän (photos: Sven-Gunnar Broström, source: SHFA).

interpreted as an expression of this, but in a local design. A comparison with Alta is obviously interesting, but this specific type does not seem to occur there and in other respects there are many differences. One reason could be that it is conceivable that a more unified interregional culture with interregional manifestations, including the single-lined manned ship, were widespread in northern areas during the Mesolithic. When these areas, in the beginning of the Neolithic and with greater intensity in the Early Bronze Age, became subject to increasing influences in the form of ideas from and regular contacts with external cultures and distant areas, this initiated the development of regional and local expressions directly affected by these. Sjöstrand's study (2011) on mobile versus static depictions of elks as reflecting societal stress in the face of change, in this case, hunter-gatherers becoming conscious of the intrusive 'Neolithic influences' that threatened their own social structure, may serve to illustrate that.

In a recent paper (Melheim and Ling 2017) a new and exciting hypothesis is launched, claiming that the pronounced emphasis on images of boats in the Southern Tradition had its origin in the Northern Tradition, deriving from supposed seasonal gatherings in places with appropriate sea-bound positions, as reflected in the motifs by the presence of boats with specific animistic elements as at Nämforsen (Fig. 4.13). Another equally important influence, according to Melheim and Ling (2017), came from the Bell Beaker culture advancing by sea, in search of trade in amber and metal, which helped to promote new maritime

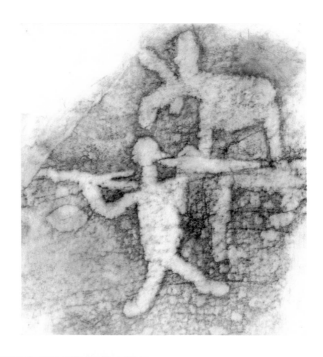

Figure 4.13. Rock carving at Laxön showing obvious southern influences in the scene with a broad-shouldered warrior with a beaked head, armed with a spear (?) and shield (?) along with, and seemingly superimposed on, an elk (rubbing: Dietrich Evers, source: SHFA).

Skala 1:1

Fig. 5. Pilspets av sydskandinavisk typ från Ställverksboplatsen. Foto: Fredrik Herrlander.

Figure 4.14. The flint arrowhead of Bell Beaker type from the Ställverket settlement (after Käck 2001).

phenomena that enabled participation in the emerging Bronze Age network of long-distance exchange of goods in Scandinavia (Melheim and Ling 2017).

Although their hypothesis refers primarily to southern Scandinavia, it is tempting to assume that the Västernorrland coast may also have been involved in the network. It would then be well suited to explain the presence of the prominent archaeological phenomena we have discussed here: the Bronze Age cairns on the coastal rocks that lead the way to the amazing rock carvings at Nämforsen, the settlements there and at Rånget, the latter with unambiguous traces of bronze craftsmanship. And if fits amazingly well with the flint arrowhead of unmistakeable Bell Beaker type found at the Ställverket settlement (Fig. 4.14).

Acknowledgements

My thanks to Catarina Bertilsson SHFA, Pia Nykvist County Administrative Board Västernorrland and Malou Backlund-Blank University of Gothenburg.

References

Baudou, E. 1968. *Forntida bebyggelse i Ångermanlands kustland.* Arkeologiska undersökningar av Ångermanlands kuströsen. Arkiv för norrländsk hembygdsforskning XVII: 1–20.

Baudou, E. 1977. Den förhistoriska fångstkulturen i Västernorrland. *Västernorrlands förhistoria* (E. Baudou and K.-G. Selinge, eds): 11–52. Västernorrlands läns landsting. Motala.

Baudou, E. 1993. Hällristningarna vid Nämforsen – datering och kulturmiljö. *Ekonomi och näringsformer i nordisk bronsålder* (L. Forsberg and T. B. Larsson, eds): 247–261. Umeå universitet. Umeå.

Bertilsson, U. 1994. Nämforsen – empiri och poststrukturalism. Några kommentarer till aktuell forskning. *Odlingslandskap och fångstmark* (R. Jensen ed.): 47–57. Riksantikvarieämbetet. Stockholm.

Bertilsson, U. 1995. Rock Art, Recent Research and Religion. *Perceiving Rock Art: Social and Political Perspectives. The Alta Conference on Rock Art* (K. Helskog and B. Olsen, eds): 207–214. Instituttet for sammenlignende kulturforskning. Serie B: Skrifter XCII. Oslo.

Bertilsson, U. 2000. Rock Art at the End of the World – Deciphering the Images of the Rock Art of Northern Europe. *Ristad och målad. Aspekter på nordisk bergkonst* (T. Edgren and H. Taskinen, eds): 39–45. Museiverket. Vammala.

Bertilsson, U. 2015. Boundless Rock Art – Symbols, Contexts and Times in Prehistoric Imagery of Fennoscandia. *Ritual Landscapes and Borders within Rock Art Research. Papers in Honour of Professor Kalle Sognnes* (H. Stebergløkken, R. Berge, E. Lindgaard and H. Vangen Stuedal, eds): 79–98. Archaeopress. Oxford.

Bertilsson, U. 2016. *SFM-dokumentation inom Ådals-Liden 193:1 Nämforsens hällristningsområde.* Opus Heritas rapport 2016:1. Tanum.

Bertilsson, U. and C. Bertilsson 2015. *Rapport över 3D-fotografering inom Ådals-Liden 193:1-Nämforsens hällristningsområde.* Svenskt Hällristnings Forsknings Arkiv. Göteborgs universitet. Gothenburg.

Bertilsson, U. and J. Ling 2016. Rock Art Studies in the Nordic Countries 2010–2014. *Rock Art Studies: News of the World V* (P. Bahn, N. Franklin, M. Strecker and E. Devlet, eds): 19–32. Archaeopress. Oxford.

Bertilsson, U., Ling, J., Bertilsson, C., Potter, R. and Horn, C. 2017. The Kivik Tomb: Bredarör enters into the digital arena – documented with OLS, SfM and RTI. *New Perspectives on the Bronze Age. Proceedings of the 13th Nordic Bronze Age Symposium held in Gothenburgh 9th to 13th June 2015.* (S. Bergerbrant and A. Wessman, eds.) Archeopress. Oxford.

Bolin, H. 1999. *Kulturlandskapets korsvägar. Mellersta Norrland under de två sista årtusendena f. Kr.* Stockholm Studies in Archaeology 19. Stockholms universitet. Stockholm.

Carlsson, A. 2001. *Tolkande arkeologi och svensk forntidshistoria. Bronsåldern.* Stockholm Studies in Archaeology 22. Stockholms universitet. Stockholm.

Forsberg, L. 1993. En kronologisk analys av hällristningarna vid Nämforsen. *Ekonomi och näringsformer i nordisk bronsålder* (L. Forsberg and T. B. Larsson, eds): 195–247. Umeå universitet. Umeå.

Forsberg, L. 2001. Keramiken från Råingetlokalerna, mångfald i tid och formspråk. *Tidsspår. Forntidsvärld och gränslöst kulturarv* (M. Bergvall and O. George, eds): 129–150. Länsmuseet Västernorrland. Härnösand.

George, O. 2001. Boplatsen vid Råinget. *Tidsspår. Forntidsvärld och gränslöst kulturarv* (M. Bergvall and O. George, eds): 105–128. Länsmuseet Västernorrland. Härnösand.

George, O. 2005. *Arkeologisk kursundersökning av Raä 158 Ådals-Lidens sn. Boplats och lämningar från stenålder-historisk tid.* Länsmuseeet Västernorrland, kulturmiljöavdelningen. Härnösand.

Gjerde, J. M. 2010. *Rock Art and Landscapes. Studies of Stone Age Rock Art from Northern Scandinavia.* University of Tromsø. Tromsø.

Gjerde, J. M. 2016. A Stone Age Rock Art Map at Nämforsen, Northern Sweden. *Adoranten* 2015: 74–91.

Hallström, G. 1960. *Monumental Art of Northern Sweden from the Stone Age: Nämforsen and Other Localities.* Almqvist & Wiksell. Stockholm.

Helskog, K. 2012. *Samtaler med maktene. En historie om Verdensarven i Alta.* Tromsø Museums Skrifter XXXIII. Tromsø.

Käck, B.-O. 2001. Boplatsen vid forsen. *Tidsspår. Forntidsvärld och gränslöst kulturarv* (M. Bergvall and O. George, eds): 25–42. Länsmuseet Västernorrland. Härnösand.

Käck, J. 2009. *Samlingsboplatser? En diskussion om människors möten i norr 7000 f.Kr. - Kr.f. med särskild utgångspunkt i data från Ställverksboplatsen vid Nämforsen.* Studia Archaeologica Universitatis Umensis 24. Umeå Universitet. Umeå.

Kivikäs, P. 1995. *Kalliomaalaukset - muinainen kuva arkisto. Paintings on Rock - An Ancient Picture Archive.* Atena. Jyväskälä.

Lahelma, A. 2012. Politics, Ethnography And Prehistory. In Search of an 'Informed Approach' to Finnish and Karelian Stone Age Rock Art. *Working with Rock Art* (B. W. Smith, K. Helskog and D. Morris, eds): 113–134. Wits University Press. Johannesburg.

Larsson, T. B. (2012). När älgen försvann för fyratusen år sedan. *Populär Arkeologi* (4), 10–12.

Larsson, T. B. and S.-G. Broström 2011. *The Rock Art of Nämforsen, Sweden. The Survey 2001-2003.* UMARK 62, Umeå.

Larsson, T. B., G. Rosqvist, G. Ericsson and J. Heinerud, J. 2012. Climate Change, Moose and Humans in Northern Sweden 4000 cal yr BP. *Journal of Northern Studies* 6(1): 9–30.

Lindgren, B. 2001. Hällbilder - Kosmogoni & Verklighet. *Tidsspår. Forntidsvärld och gränslöst kulturarv* (M. Bergvall and O. George, eds): 43–81. Länsmuseet Västernorrland. Härnösand.

Lindqvist, C. 1994. *Fångstfolkens bilder: en studie av de nordfennoskandiska kustanknutna jägarhällristningarna.* Theses and Papers in Archaeology New Series A. No. 5. Stockholm University. Stockholm.

Lindqvist, C. 2001. Nämforsen, Ådalen och Ångermanlandskusten – en gynnsam natur- och kulturmiljö under förhistorisk tid. *Tidsspår. Forntidsvärld och gränslöst kulturarv* (M. Bergvall and O. George, eds): 83–104. Länsmuseet Västernorrland. Härnösand.

Ling, J. and M. Rowlands 2015. The 'Stranger King' (Bull) and Rock Art. *Picturing the Bronze Age* (J. Ling, P. Skoglund and U. Bertilsson, eds): 90–104. Swedish Rock Art Series Volume 3. Oxbow Books. Oxford.

Malmer, M. 1981. *A Chorological Study of North European Rock Art*. KVHAA. Stockholm.

Malmer, M. P. 1992. Har nordlig och sydlig hällristningstradition påverkat varandra – i så fall hur, och varför? *Arkeologi i Norr* 3: 7–18. Umeå.

Melheim, L. and Ling, J. 2017 (this volume). Taking the Stranger on Board – The Two Maritime Legacies of Bronze Age Rock Art.

Nykvist, P. *Ristat i berg. En diskussion kring fångstfolkens bilder i norr.* Unpublished essay. Länsstyrelsen Västernorrland.

Ojala, K. 2016. I bronsålderns gränsland: Uppland och frågan om östliga kontakter. Doctoral dissertation. Institutionen för arkeologi och antik historia, Uppsala universitet. Uppsala.

Persson, P. 2014. *Forntid i Västernorrlands län. En historik över arkeologiska undersökningar under drygt 330 år.* Rapportnummer 2014:17 Kulturmiljö- och samlingsavdelningen, Murberget, länsmuseet Västernorrland/Rapportnummer 2014:24 Samhällsbyggnadsenheten, Länsstyrelsen Västernorrland.

Petersen, B. 1970. En långdös i ett bronsåldersröse – en preliminär redogörelse. *Årsboken Halland* 1970: 13–22.

Ramqvist, P. H. 1992. Hällbilder som utgångspunkt vid tolkningar av jägarsamhället. *Arkeologi i Norr* 3: 31–54.

Ramqvist, P. 2007. Fem Norrland. *Arkeologi i Norr* 10: 153–180.

Sandén, E. 1996. Sävar 202, en kustboplats från äldre bronsålder i Västerbotten. *Arkeologi i Norr* 6/7: 23–33.

Selinge, K.-G. 1974. Fångstgropar. Jämtlands vanligaste fornlämning. *Fornvårdaren 12.* Jämtlands läns museum. Östersund.

Selinge, K.-G. 1979. *Agrarian Settlements and Hunting Grounds.* Stockholms universitet. Stockholm.

Selinge, K.-G. 2001. Fångstgropar i Nämforsens uppland. *Tidsspår. Forntidsvärld och gränslöst kulturarv* (M. Bergvall and O. George, eds): 153–186. Länsmuseet Västernorrland. Härnösand.

Sjöstrand, Y. 2011. *Med älgen i huvudrollen: om fångstgropar, hällbilder och skärvstensvallar i mellersta Norrland.* Stockholm Studies in Archaeology 55. Stockholms universitet. Stockholm.

Sjöstrand, Y. 2015. Memory and Destruction – Pictorial Practices Surrounding Red Ochre Paintings in Late Neolithic Northern Sweden. *Ritual Landscapes and Borders within Rock Art Research. Papers in Honour of Professor Kalle Sognnes* (H. Stebergløkken, R. Berge, E. Lindgaard and H. Vangen Stuedal, eds): 167–180. Archaeopress. Oxford.

Wrigglesworth, M. 2015. Between Land and Water: The Ship in Bronze Age West Norway. *Ritual Landscapes and Borders within Rock Art Research. Papers in Honour of Professor Kalle Sognnes* (H. Stebergløkken, R. Berge, E. Lindgaard and H. Vangen Stuedal, eds): 111–118. Archaeopress. Oxford.

A Boat Journey in Rock Art 'from the Bronze Age to the Stone Age – from the Stone Age to the Bronze Age' in Northernmost Europe

Jan Magne Gjerde

Abstract: The research history of rock art in Scandinavia has a clear division between the hunter and the agrarian rock art tradition. This divide was established in the early 1900s and was continued during the 20th century. Well-established boat typologies of south Scandinavian rock art and chronologies have been supported by well-dated bronzes with boat incisions. The good chronologies led to an association between the boat as rock art motif and a Bronze Age date. An unparalleled discovery of Stone Age rock art in northernmost Europe during the last few decades has contradicted the strict divisions based on economy, geography and time for the boat motif.

The earliest known boat depictions in the rock art of northern Europe are dated to the Stone Age, *c.* 5000 BC. They have a clear north-eastern distribution and most of them are depicted with an elk-head stem, thereby named elk-head boats. Key sites with Stone Age boat depictions are Alta in northern Norway, Nämforsen in northern Sweden and Vyg in north-western Russia. The well-dated boat depictions in northernmost Europe predate the south Scandinavian Bronze Age rock art boats by about 3000 years. This chapter focuses on the Stone Age boat depictions in northernmost Europe and is an attempt to nuance this strict north–south division.

Key words: rock art, boat, Stone Age, research history, Fennoscandia.

Introduction

The present record of rock art in Fennoscandia is biased and divided in many ways. There is a geographical, an economic and a time aspect dividing the rock art material, where established boundaries and constraints have been nourished by research traditions, which in turn have had a local, regional and national focus in their studies of rock art.

The unparalleled growth of the material record has not been adequately published; hence earlier material publications have been applied in the comparative studies where motif type has been assigned to time. The important discoveries of rock art in northern Fennoscandia have shown that boats are frequently depicted in Stone Age rock art. A Late Stone Age date for the earliest boat depictions in Fennoscandia was argued in the 1980s

and 1990s, and recent studies show that the earliest known boat depictions were made in the Late Mesolithic (Gjerde 2010). The earliest boat depictions in northern Fennoscandia are dated to about 5000 BC, predating the more commonly known Bronze Age boat depictions of southern Scandinavia by about 3000 years. At the large Alta site in northern Norway, boats are depicted in rock art from about 5200 BC until about the year 0. While the earliest boats clearly have an eastern affinity, the latter boat depictions have their counterparts in southern Scandinavia.

In this chapter, I will address rock art from a northern perspective. To grasp why Stone Age boats have not ended up in the right time, one has to look at the research history. I argue that five central steps in re-dating the chronology of rock art boats can be suggested that would briefly account for some of the biases in the rock art boat/ship chronologies. These stepping stones would aid the understanding of the continuous chronology of boats in rock art and how they have been discussed in rock art research. Firstly, the 'short chronology' for rock art argued by *e.g.* Simonsen (1974: 42f; 1978: 32f; 1991) for the north Norwegian material was challenged in the 1990s (Hesjedal 1993b; Hesjedal 1994). Secondly, the finds in Russia with boat depictions dated to the Neolithic were rarely discussed in a Scandinavian context, with the rare exception of Bakka (1976). Thirdly, the dating of the large Alta site (Helskog 1983; Helskog 1988) and work on dating the Nämforsen carvings (Baudou 1993; Forsberg 1993) really challenged the boat motif as a Bronze Age motif. Finally, boat depictions in northern Fennoscandian rock art show that the earliest boats have their younger counterparts along the Norwegian coast shown in this coastal journey.

The wider picture – the time frame of rock art in Fennoscandia

The initial studies of rock art assigned the boats to the Viking Age or historical times, such as the boat figures at Leirvåg in western Norway (Christie 1837) while a Bronze Age date has clearly updated their context (Mandt 1991; Wrigglesworth 2000; Wrigglesworth 2006). Some researchers 'neglect' to look at the dating and/or apply 'old' or dating suggestions

that are repeated to 'strengthen the authenticity'. There has been a scepticism about an 'old' age for rock art, as the well-known evolutionistic ladder (Gjessing 1936: 158–169; Hallström 1938: 183) from naturalistic (large game animals) to schematic has been repeatedly moved from Stone Age to the Bronze Age. Few sites have also been dated to the Iron Age making most rock art funnel into the Bronze Age. The evolutionistic scheme was ordered, repeated and virtually unchallenged until the 1990s in Scandinavia.

The general scepticism about 'old dates' for rock art was already foreseen in 1919 by the geologist Rekstad dating the Sagelva carvings by shoreline dating to the Early Stone Age (Mesolithic), questioning whether the archaeologists would dare ascribe them to such an age (Rekstad 1919: 54f). At a general level dating rock art in Fennoscandia may be portrayed as a division between arguments for a 'long chronology' and a 'short chronology'. The 'short chronology' was strongly argued by Simonsen (1974: 42f; 1978: 32f; 1991), placing all the rock art of northern Norway between 3000 BC and AD 200. The earliest hunter's art (style I – the polished rock art of Nordland) was seen as an independent creation from c. 3000 BC to 2000 BC spreading to south Norway, the northernmost parts of Norway and eastwards to Russian Karelia. Simonsen's style II was placed between c. 2000 BC and 1000 BC, style III between 1000 BC and 500 BC and style IV between 500 BC and AD 200 (Simonsen 1974: 42f). The 'long chronology' of rock art was already put forward for the 'naturalistic art' in northern Norway by its Palaeolithic origin in central Europe (Brøgger 1909a; Hallström 1907a; 1907b; 1908: 78–83; 1909). The Palaeolithic link was not completely rejected (Gjessing 1932: 52ff) and the current record may reopen this link. Gjessing argued by shoreline dating for a long continuous tradition of making rock art, from the earliest in the Early Stone Age into the Late Stone Age and potentially well into the Bronze Age (Gjessing 1932: 47, 50; 1945: 264, 272). Accepting an old age for rock art in general was upheld by Gjessing (1974: 8). Even though some may question the earliest dates for the rock art of northern Norway, the present record argues for a 'long chronology'.

In a brief statement, Hagen questioned the general evolutionistic chronological line from the older naturalistic to the younger schematic style based on the Russian (Karelian) material (Hagen 1969: 140, 144). However, it was the Alta material in northern Norway that showed that there was

no gradual change from naturalistic to unrecognizable small schematic art in the northern Norwegian material (Helskog 1989b: 99–101). Even though the so-called naturalistic style shows content separated from the known rock art from the Late Mesolithic onwards in northern Fennoscandia, there seems to be no such evolutionistic change from *c.* 5500 BC onwards. All the large rock art concentration in northern Fennoscandia has its starting phase about 5500 BC–5000 BC, with people making rock art for thousands of years. Alta bears witness to the longest tradition of making rock art in the same area from about 5200 BC until about the year 0, 5000 years of rock art. The current material shows that we have to re-evaluate this strong evolutionistic line of development.

The two types of rock art – determined by a geographical find history – leading to Bronze Age boats in the Stone Age?

The rock art division in Scandinavia, where hunter's rock art was separated from agrarian rock art, has been defined a straitjacket (Helskog 1990) after comparisons of rock art over large geographical areas. The division of the Norwegian rock art into agrarian and hunter's rock art by Brøgger (1906: 359; 1909b: 105) and Hansen (1904: 323f) led to an established division between the hunter's and the agrarian rock art which has been a premise for virtually all studies of rock art in Scandinavia for at least a century. The 'Scandinavian focus' separated the material from the Russian material, and at the time of Brøgger and Hansen's initial publications there were no known Finnish rock art sites. Hansen separated the rock art by 'ethnic group', content and geographical distribution and dated both the hunter's art and the agrarian art to the Bronze Age, while Brøgger assigned the hunter's art to the Stone Age and the agrarian art to the Bronze Age (Brøgger 1906: 356, 1909b: 105f). Brøgger based his division on Ziegler's (1901) shoreline study of the Bogge site in north-western Norway and the difference in weathering at Bardal in central Norway where the agrarian art was superimposed on the hunter's art. Similarity in motifs made both Brøgger (1909b) and Hallström

(1909: 155) assign the sites with paintings to the same tradition as the carvings. The strict division between the hunter's art and the agrarian art was rarely questioned in this phase of rock art research, except briefly by Ekholm (1917).

Reviewing the last century of rock art research, the iterative division is manifested by the find history, the available material record (including available material publication) and administrative borders – hence the research focus. The typological and chronological 'dogma' of Bronze Age boat studies left out the anomalies; hence the boat as such was/is assigned to the Bronze Age and spread from south Scandinavia northwards (*e.g.* Malmer 1981: 31). The manifestation of this divide in the 1930s was established in Scandinavia by the numerous publications of material (Bøe 1932; Engelstad 1934; Gjessing 1936; Hallström 1938) while the Russians did not make such a divide (Ravdonikas 1936; Ravdonikas 1938). These publications have been presented as 'the complete' record since they have been accessible. It is therefore questionable that many studies build their material studies on roughly 100-year-old material publications with their notable shortcomings (Goldhahn 2006: 71). Most comparative studies have been conducted at a local level (Lindgaard 1999; Sognnes 2002) and/or and with a lack of available material with a general lack of focus on dating. Unfortunately, the large chorological study by Malmer (1981) was performed before the large rock art sites in Alta and at Vyg were available. A major problem at a more general level is the lack of good material publications since the 1930s, with a few exceptions (Hallström 1960; Kolpakov and Shumkin 2012; Lødøen and Mandt 2012; Simonsen 1958).

> As far as can be seen, there are no really positive reasons for placing the carving [Forselv, northern Norway] to the Bronze Age. The boats can scarcely be any proof in that direction – they are entirely associated with the sphere of ideas of the Stone Age carvings. (Gjessing 1931: 285).

Gjessing's (1931: 285) Stone Age date for the Forselv carving in northern Norway was left out of the general discussion, leaving the boat figures in the Bronze Age sphere. It was to take about half a century before Gjessing's foresighted dating of the boats depicted at Forselv in northern Norway had a general breakthrough. The acceptance of dating rock art boats to the Late Stone Age occurred as a result of 'looking east and north', where the Russians

had dated the Vyg carvings with numerous boats to the Late Stone Age (Savvateev 1970; Savvateev *et al.* 1978; Savvateyev 1977; 1988; commented by Bakka 1976) and Helskog's study of the Alta material in northern Norway where he placed the earliest boat depictions in the Late Stone Age (Helskog 1983, 1985, 1989a, 1989b). Lindqvist's study of the boat depictions was based on shoreline dating relating the boat depictions to percentages of the Tapes limit (Lindqvist 1983; Lindqvist 1984, 1994) with its methodological problems (Gjerde 2010; Ramstad 2000). Contemporary with this, the Nämforsen studies by Forsberg (1993) and Baudou (1993) independently dated the earliest carvings (earliest boat depictions) at Nämforsen to the Late Stone Age. Comparative studies of the eastern (Russian) and western (Scandinavian) material have been problematic and few studies have crossed these boundaries. Until recently the ideas of Hallström has been neglected due to the distance and lack of overview of material culture in large areas (*e.g.* Tilley 1991). Lindqvist's study was important for reopening Hallström's (1960) initial idea of similarity between Onega (north-west Russia) and Nämforsen (northern Sweden) due to cultural contact. These eastern–western similarities have recently been explored (Gjerde 2008, 2010) and the dating results show that the boat depictions have their origin in north-western Russia and northern Norway between 5500 BC and 5000 BC. These early dates are contemporary with the earliest boat depictions in the Finnish paintings (Lahelma 2008). Late Stone Age boats are present in central Norway (Sognnes 1995, 1996), western Norway (Gjerde 1998, 2002; Mandt 1971, 1980) and northern Sweden (Baudou 1993; Forsberg 1993; Gjerde 2010: 351–358). The real melting pot is in central Scandinavia with the Trøndelag material, where one find a continuous tradition of depicting boats from the Late Stone Age throughout the Bronze Age and into the Iron Age. Even though the Bronze Age boat typologies and chronological framework is established, more south Scandinavian boat depictions should be assigned to the Stone Age as suggested by Ling (2008: 101), crossing the timeframes of the south Scandinavian boat typologies including the anomalies rarely discussed.

The works by Ling (2008, 2013) and Kaul (1998, 2012) nuance the traditional Bronze Age boat chronologies (*e.g.* Glob 1963). These 'new south Scandinavian ship chronologies' have altered the established chronologies for Bronze Age boats. Kaul's study on ships on bronzes

has given us a remarkable tool for comparing boat figures on well-dated bronze artefacts, which gives us a finer chronological frame for the rock art boats. The impressive study of elevated rock art by Ling (2008, 2013), where ship figures were accurately measured relating them to their altitude above the present shore level, show a remarkable concurrence between the different boat types and their altitude. Based on shore displacement of the boats in Tanum Ling (2008) argues for a shore location of the rock art in the Bronze Age in this area. Including boat depictions from bronzes and burial contexts, Ling shows some divergences from Kaul's schema (Kaul 1988: 88). The combination of the two chronological methods – shore displacement and comparative chronology – has introduced a new framework for the dating of rock art in this area. The current chronologies presented by Kaul (1988: 88) and Ling (2008: 105) are a good tool for studying boat figures in other areas in Scandinavia. A recent study by Kaul (2012) on the boat depictions from the Bronze Age in northern Norway comparing them to the southern Scandinavian boats, suggests that they depict boats reflecting long-distance journeys and communication over large distances. More studies should discuss the later boats in northern Fennoscandia, relating them to the well-established south Scandinavian boat chronologies; however, a further discussion will have to wait for a later occasion.

This brief overview of the 'history' of Stone Age boats in Fennoscandian rock art leaves the record with interesting twists and questions concerning our research history and current practice in rock art research. Say if the Alta carvings had been found by Bøe and Nummedal's (1936) large Stone Age investigations when lunching in the rock art area, the hunter's rock art tradition and the agrarian rock art tradition would have made a complete different boat journey. The geographical distribution, content and 'ethnic groups' division of the rock art material would not have been so straightforward. There is still a distinct difference in the content of the hunter's and the agrarian rock art; there are no ploughing scenes in the hunter's art and there are no whaling scenes in agrarian art. However, similarities between the hunter's and agrarian rock art tradition (*e.g.* Bradley 2009; Ling and Rowlands 2015) should be further explored. Yet again, I think the vantage point for such studies is central Scandinavia, and in particular the Trøndelag area in Norway.

Stone Age boats of the north

To set the background for the early boat figures in northern Fennoscandia, I will take the well-dated large rock art concentrations at Vyg in north-western Russia, the Alta site in northern Norway and the Nämforsen site in northern Sweden as vantage points. These sites all have boats dated to the latter phase of the Mesolithic, *c.* 5000 BC. The following discussion on boats will compare Stone Age rock art sites with boat depictions in a chronological perspective. The earliest dated boats in Fennoscandia are depicted with an elk-head stem and show a north-eastern origin (Fig. 5.4). They are at present only found in the north-eastern part of Fennoscandia, in northern Norway, northern Sweden, Finland and north-western Russia (Gjerde 2010: 397–400).

In north-western Russia, the Vyg carvings stand out with superimposed carvings by transgressions. The New Zalavruga site was covered by marine/riverine sediments and has a fairly complex geology. The rock art at Vyg has been dated by shoreline dating and relations to adjacent settlements. Even though a careful date of the initial phase of the Vyg carvings to the early fourth millennium was suggested by Stolyar (2000: 164f), traditionally the carvings have been dated to the Late Stone Age (Neolithic) from the late third millennium BC to the very beginning of the second millennium (Savvateyev 1988: 83). The main dating suggestions are based on shoreline dating and relation to adjacent settlements (some of them covering the rock art sites) (Deviatova 1976; Savvateev 1970, 1977; 1984; Savvateev *et al.* 1978; Stolyar 2000; Tarasov and Murashkin 2002). The dating suggestion presented by Savvateev (Savvateev *et al.* 1978; Savvateyev 1988), is still endorsed in Russia and supported by both Zhulnikov (2006) and Lobanova (2007: 134f), both dating the initial carvings to 6000–5000 years BP or *c.* 4000–3000 BC.

Gjerde (2010) and Janik (2010), both working with the Vyg material during the last decade, rely on geological data (Deviatova 1976; Kaplin and Selivanov 2004: 30–32), but emphasize a relative chronology based on comparison with the settlement data, and argue that the rock art is older than previously suggested. Several radiocarbon dates from the settlement covering the Jerpin Pudas site at Vyg (Savvateev 1977; Savvateev *et al.* 1978) were not included due to their early age in relation to the established chronology. Janik (2010: 94) dates the rock art between *c.* 5600 BP and 4000 BP (4600–2000 BC), while I have previously suggested a range between *c.* 5300 and 2000 BC

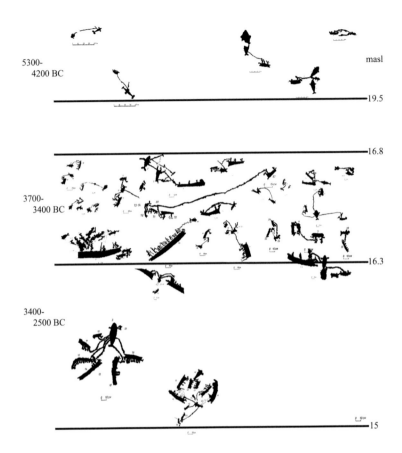

Figure 5.1. Whale hunting scenes at Vyg with dating suggestion based on shoreline dating. Tracings after Savvateev (1970). All the hunting scenes are in the same scale (dating, compilation and illustration: Jan Magne Gjerde).

5300-
4200 BC

masl

19.5

16.8

3700-
3400 BC

16.3

3400-
2500 BC

15

(Gjerde 2010: 291–300). The internal chronology is problematic, although it is possible to divide the figures into phases based on their elevations and the ^{14}C dates from the adjacent settlements, suggesting a relational chronology based on the land uplift (Gjerde 2010: 291–300). Based on the whale hunting scenes at Vyg, a relative chronology of the carvings can be suggested where a clear difference in the whaling and the boats can be observed (Fig. 5.1). The prevailing boat type is the so-called elk-head boat. The boat-type is assumed to be a skin boat resembling the Greenlandic *umiak*.

The Alta carvings have been convincingly dated by shoreline dating by sequential phases following the land uplift (Helskog 1983, 1985, 1988, 1989a). The carvings at the same level above the present shoreline show a uniform similarity in style and theme. This is best illustrated in the Hjemmeluft area

by the bear tracks, bear hunting scenes and the reindeer corrals that only occur at certain levels above sea, about 23–25 m above sea level (Helskog 2005). Later, Helskog revised the dating and the phases, hence, 'The five diachronic phases (I–V, previously called I–4B) are based on visual inspection of their geographic and altitudinal location, and statistical analysis of morphologically classified carvings, and shoreline-displacement' (Helskog 2000: 7). When comparing Helskog's suggested dating of the earlier works from the 1980s to 2000 (*e.g.* Helskog 1988: 32; 2000: 6, fig. 2), the change is the internal dating between the phases. The new data is related to the new shoreline data, although with the same starting phase set at 4200 BC in both 1988 and 2000, with a possible start as early as 4500 BC (Helskog 2000: 6).

As part of my PhD research (Gjerde 2010), I revised the dating of Helskog's phases in Alta and found the initial carvings to be as early as about 5200 BC, and likely as early as 5500 BC – about 1000 years earlier than Helskog's dating. The results came as a consequence of adjusting the shoreline chronology according to elevations of excavated adjacent sites (Bell 2004, 2005). Furthermore, other Stone Age material (artefacts/lithics) dating to the transition between the Early and the Late Stone Age were found at a lower elevation than the highest carvings. This made the shoreline-dated rock art older, hence it can be assigned to the latter part of the Early Stone Age. The excavations revealed that the geological shoreline curve had to be adjusted. Adding to this there are several places with superimposed figures with a difference in what is interpreted as water erosion (Gjerde 2010: 247, fig. 149). Helskog has recently revised his chronology (Helskog 2012a: 221–225; 2014: 28–33). The latest dating suggestion by Helskog (Fig. 5.2) is in line with Gjerde's dating suggestion, however to sum up the dating of the Alta carvings: 'The datings and demarcations between the periods are approximate and will undoubtedly be revised as we gain increased knowledge and understanding' (Helskog 2014: 29).

Even though Sidenbladh (1869: 206f) already in 1869 argued for a Late Stone Age date for the Nämforsen carvings based on land uplift, the boat motif has been used as a lodestar for a Bronze Age date for the carvings (Hallström 1907b: 164, 177). Hallström, in his early works, dated all the rock art in Nämforsen to the Bronze Age. Later, however, he accepted the initial carvings at Nämforsen as being from the Late Stone Age based on land uplift data compared to the carvings with the rock art of northern

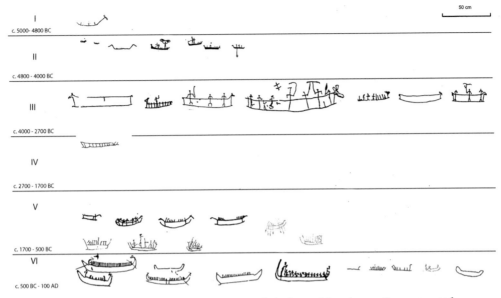

Figure 5.2. Helskogs dating suggestion compiled after Helskog (2012a: fig. 2; 2014: 28f).

Fennoscandia (Hallström 1960: 372). The few figures belonging to the Bronze Age are crucial in the dating discussions on Nämforsen (Malmer 1975, 1981). The few Bronze Age figures were dated, hence representative for the site. Thereby, Malmer (1981)[1] entered Nämforsen in what appears to be a 'South Scandinavian Bronze Age boat of type AIIIc1'. Even though Hallström (1960: 372) had suggested a Late Stone Age date for the earliest carvings at Nämforsen and placed only a few of the boats[2] in the Bronze Age and the majority as 'boats of 'Nämforsen type' (Hallström 1960: 295–296), Malmer saw no problem since 'all the ship designs at Nämforsen are easily fitted into the system of classification used in this study' (Malmer 1981: 41) of Bronze Age boats.

> So far the result of this investigation into the chorology and chronology of the ship motif can be summarised as follows: the ship motif first appears in Period 1, probably towards the end of the period (at about the date of the Rørby sword). At this time it takes the form of type A (double-line ships) and it is found in Denmark. From here the ship motif spreads northwards, reaching as far as northernmost Norway (Malmer 1981: 31).

About 50 of the more than 2300 figures at Nämforsen can be assigned by stylistic comparison to the Bronze Age. It is therefore noteworthy and surprising that these few motifs are emphasized in the discussion of dating. The thorough work on dating by Baudou (1993), Forsberg (1993) and Lindqvist (1994) has strengthened the argument that the majority of the carvings at Nämforsen date to the Late Stone Age. The general acceptance that the boat motif at Nämforsen could belong to the Stone Age as a result of the finds at Vyg in north-western Russia, as suggested by Bakka (1976: 121) and in Alta, northern Norway (*e.g.* Helskog 1985), can, in my opinion, be read between the lines in the above-mentioned Swedish works.

The rock carvings at Nämforsen today are located between 87 m a.s.l. and 73 m a.s.l. However, before the dam was built at the Power Station at Nämforsen, Hallström had observed carvings at a slightly higher location at the H-group of main group I at about 90 m above sea level (Hallström 1960: 180f, plate XXVII Group I H). Previously, the geological data about 65 km to the east of Nämforsen, in the Anundsjö region (Miller and Robertsson 1979) was applied for shoreline dating. Geological land uplift data for the south-eastern part of the Ångermanälven region (Berglund 2004) was extrapolated to give a more accurate shoreline displacement curve for the Nämforsen area (Gjerde 2010: 354–355, fig. 252). The data indicate a maximum age for the carvings at about 5000 BC and that the islands with the lowest situated carvings were available before 4200 BC.

The 'Ställverksboplatsen' (Raä 10) site at 84–86 m above sea level indicates that the settlement was in use from 4000 BC to about the year 0 based on diagnostic artefacts and raw material (Käck 2001, 2009). Added to this, excavations on the northern riverbank of the Ångermanälven, close to the Nämforsen rapids, were situated at between 75 and 80 m above sea level. The Ådals-Liden 158:1 site with impressive finds of red ochre was dated by [14]C to 4200–4000 BC, 3700–3500 BC, 2800–2400 BC (Larsson and Engelmark 2005). These excavations suggest that the activities related to the Nämforsen area was at least initiated by *c.* 4200 BC based on these excavations. However, when the first carvings were made at Nämforsen, assuming they were shore-related, the settlement and activity areas at Ställverksboplatsen and Ådals-Liden 158:1 would have been under water; hence suggesting that the initial carvings are older.

At present the typology presented by Forsberg and Lindqvist seems to be as close as we can approach a relative dating of the Nämforsen material based on the current data. New shore displacement data has given the opportunity to redate the initial phase of Nämforsen. Most likely people started making carvings at Nämforsen about 5000 BC. The new dating suggestion makes the initial carving phase at Nämforsen about 800–1000 years older than previous suggestions. It also means that people made carvings at the Nämforsen site for nearly 4000 years. After the initial rock carvings were made between 5000 BC and 4200 BC, the sea had retreated from the Nämforsen rapids. The people living by and revisiting Nämforsen continued making rock art close to the rapids of Nämforsen. Based on stylistically similarity to south Scandinavian Bronze Age boats, the latter figures at Nämforsen were made *c.* 1000 BC. The majority of the carvings at Nämforsen were made between 5000 BC and 2000 BC (Fig. 5.3).

The rock art and boat depictions at Alta, Vyg and Nämforsen show that the earliest boat depictions in northern Fennoscandia are of a Late Mesolithic date. However, there must be no doubt that the people settling northern Fennoscandia about 11,000 years ago had boats (Bjerck 2008, 2009a, 2009b; Glørstad 2013). The early boats are depicted with an elk-head in the stem and show striking similarity in northern Fennoscandia (Fig. 5.4). The elk-head boats are found only in the north-eastern parts of Fennoscandia including northern Norway, northern Sweden, Finland and north-western Russia (Fig. 5.5). No such boat depictions have to my knowledge been found in the Trøndelag-region in central Norway or in southern Scandinavia.

Dating is crucial when looking at the innovation, origin and spread of material culture. It has been suggested that the earliest boats in southern Scandinavia (Sognnes E-type and Mandt A1-type) date to the latter part of the Late Stone Age, even though most researchers end up with an Early Bronze Age date (Fett and Fett 1941: 137; Fett and Fett 1979; Mandt 1991: 334; Marstrander 1963: 137; Sognnes 1987: 76; Sognnes 2001). The Mjeltehaugen grave, where similar boat-types are found, is dated to the Early Bronze Age (Linge 2004, 2006, 2007; Mandt 1983; Marstrander 1978). The similarity between Stone Age boats and the oldest Bronze Age boats has previously been demonstrated (Sognnes 1990: 64f; Vogt 2006: 224). Even though Sognnes accepts that similar boat types are found in northern Fennoscandia, he regards the boats from central Norway and western Norway as a separate

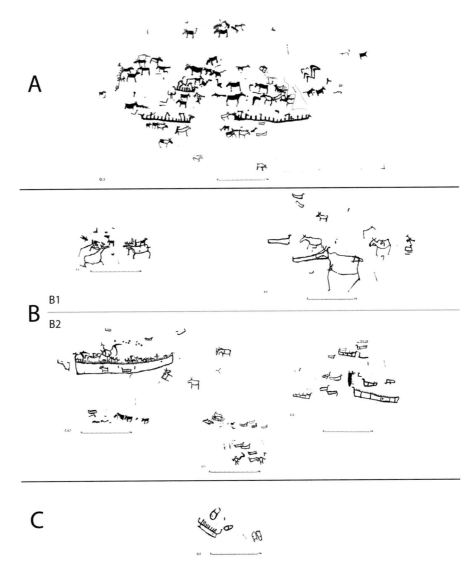

Figure 5.3. Relative chronology of the figures at Nämforsen. The typology is based mainly on Lindqvist (1994: 213-220). Tracings reworked after Hallström (1960: plate XIII, XIV, XXI, XVII, XXII, XVIII, XXVI). The figures belonging to phase A are the oldest. Figures of phase A and B type belong to the Stone Age while the figures belonging to phase C are the youngest with a Bronze Age origin. The first carvings at Nämforsen could have been made as early as 5000 BC, while the latter was made in the Early Bronze Age. The internal chronology between the different styles cannot at present be separated further than with the older/younger line of argument (illustration: Jan Magne Gjerde).

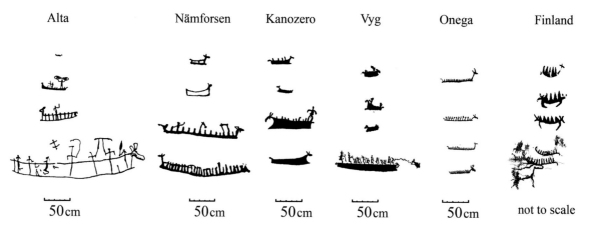

Alta	Nämforsen	Kanozero	Vyg	Onega	Finland
50cm	50cm	50cm	50cm	50cm	not to scale

Figure 5.4. Elk-head boats from the north dated to the late Mesolithic (early Stone Age)/early Neolithic (late Stone Age). Boats from Alta, northern Norway after Helskog (1989b: figure 4). Boats from Nämforsen, northern Sweden after Hallström (1960). Boats from Kanozero, northwestern Russia (tracing Jan Magne Gjerde). Boats from Onega, NW Russia after Hallström (1960: plate XXVIII) and Ravdonikas (Ravdonikas, 1936: plate 1 and plate 13). Boats from sites in Finland after Lahelma (2005: fig 1) (illustration: Jan Magne Gjerde).

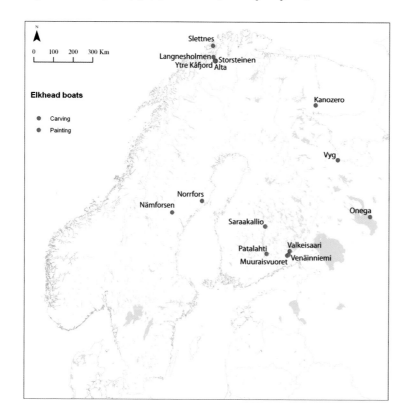

Figure 5.5. Distribution map of sites with elk-head boats in Fennoscandia. This show that the early elk-head boat is clearly an eastern phenomena (illustration: Jan Magne Gjerde).

Figure 5.6. The new figures at Kirkely at Tennes discovered in 2010 (photos, frotage and illustration: Jan Magne Gjerde).

group of west Scandinavian boat figures (Sognnes 1990: 65) in line with Mandt's suggestion (1971, 1991). Later in the paper I will question this idea put forward by Mandt and Sognnes, and suggest that the boat types we see depicted along the Norwegian coast have a northern origin that dates back to the latter phase of the Early Stone Age. The earliest depicted boats in central Norway and western Norway date to the latter phase of the Late Stone Age or the earliest phase of the Scandinavian Bronze Age.

A boat journey along the Norwegian coast

I will journey along the Norwegian coast, calling at important sites for the boats of the north (see Fig. 5.9). Starting in Alta and moving along the coast, the first stop is one of the best-dated boat depictions from Fennoscandia: the Slettnes site. The Slettnes site was found during excavations in the early 1990s (Damm *et al.* 1993; Hesjedal *et al.* 1996; Hesjedal *et al.* 1993). The boulders with rock art was covered by marine deposits resulting from the Tapes transgression. Consequently, the rock art at Slettnes is dated to before 6500 BP, about 5500 BC. The carvings on the Slettnes 2 boulder also show significant wave erosion on the lower figures (Hesjedal *et al.* 1996: 78f; Hesjedal *et al.* 1993: 81). Based on the marine sediments covering the boulders with rock art related to the Holocene transgression maximum, Hesjedal found it likely that the rock art at Slettnes was older than 4000 BC and made in the latter phase of the Early Stone Age (Late Mesolithic) (Hesjedal 1993b: 35ff). The similarity in the boat type at Slettnes and Alta made Hesjedal (1993b) and Olsen (1994) question

Helskog's starting phase of the Alta carvings based on the geologically dated Slettnes carvings and a 'relative' flat shoreline curve in this period in Alta.

The other sites with boat depictions with a similar context of a transgression in northern Norway are the boulder with rock art found at Leirbukt, Kvalsund in Finnmark, and the Kirkely site in Tennes, Troms. The large boulder at Leirbukt was found resting on clay under about 75 cm of peat. The boulder and the lowest figures have been wave-polished (Gjessing 1938: 137f). Gjessing found the boat depiction similar to the ones known in northern Norway and central Norway (Trøndelag) (Gjessing 1938: 138), similar to the Forselv and Kirkely boats (Simonsen 1958: 55). At Kirkely (Tennes) the lower part of the panel was covered by marine deposits (shore gravel, sand and muscle shell fragments). The lowermost figures were wave-polished while the higher ones were not (Gjessing 1938: 139, 141f; Simonsen 1958: 27). Still Gjessing and Simonsen found the carvings to be late based on content and stylistic comparison, and Simonsen related them within his 'short chronology'. Recent work at Kirkely uncovered more figures covered by marine deposits (Jacob Møller 2010 pers. comm.). The figures at Kirkely are boats, whales and elk (deer family). The elk figure to the left (Fig. 5.6) is heavily wave-polished and hard to see even in good light. It is almost eroded away and no peck marks are visible. The other figures (whales and boats) are clearly visible and with clear peck marks. This is interesting for the dating. Either the elk figure was placed in the shore-zone being wave-polished, or it was made during a regression in the shore zone. Then a transgression wave-eroded the elk figure followed by a new regression where the boats and whales were carved. After this a new transgression occurred, covering all the figures. The incidents are likely to be connected to the tapes transgression, placing the figures before or during the Tapes transgression at about 5500 BC. The boats have their clear counterparts in the earliest phase in Alta dated to about 5200–4200 BC. This argues for a Late Mesolithic date for the Kirkely carvings. There are also examples of such superimposition of carvings with wave-polishing at Alta (Gjerde 2010: 247 and fig. 149).

At Forselv in Skjomen, near Narvik in northern Norway, the boat figures were dated by elevation to the Stone Age by Gjessing (1931: 285; 1932: 49).[3] Halibut fishing from boat is depicted at Forselv. By shoreline dating, Hesjedal (1990; 1994) dated the Forselv site to about 5300 BP (calibrated to *c.* 4100 BC). Recent measurements of elevation show that the Forselv site is

about 3 metres higher than the elevation data applied by Hesjedal (1990, 1994) making the site slightly older.[4] Applying the computer program SeaLev (Møller and Holmeslet 1998), aware of its drawbacks, the suggested dating for the Forselv site is about 4700–4600 BC (Gjerde 2010: 194–196). Minor excavations at Forselv adjacent to the site produced few finds. However, the scarce material found indicates a dating to the transition between the Early Stone Age and the Late Stone Age (Helberg 2008: 52f). The results of the excavations are contemporary with the shoreline dating and it is likely that the first carvings at Forselv were made in the latter parts of the Early Stone Age (Late Mesolithic), continuing during the early parts of the Late Stone Age.

At the Rødøy site, the boat figures were stylistically assigned to the Bronze Age, based on motifs, by Hallström (1938: 187), while Gjessing (1936: 168, 179) placed them in the Late Neolithic based on comparison with the Evenhus and Hammer carvings. Simonsen (1974) related the boats at Rødøy to his phase II from about 2000–1000 BC. Sognnes (1989) related the Rødøy carvings to the Late Stone Age (Late Neolithic). Petersen (1930) dated the Rødøy carvings to the latter phase of the Stone Age based on similarity to the Evenhus site, elevation, higher elevation than adjacent Bronze Age carvings and a nearby site with slate finds.[5] Comparison of the boat figures with similar boats in northern Fennoscandia suggests a Late Stone Age date for the Rødøy boat figures.

The Hammer site is one of the large sites with rock art, including about 26 panels at different elevations. The Hammer 5A panel shows by its erosion a long chronology at the same panel, with eroded large figures being superimposed by smaller figures with virtually no erosion (Gjerde 2010: 394). Some of the panels in central Norway were used for a long time. The Bardal site seems to have about 6000 years of rock art, from the Mesolithic to the Iron Age. I have previously discussed the Hammer site (Gjerde 2010: 45) since the Hammer 6 site has been applied as a fixed point for the evolutionistic development of Hunter's art (Hagen 1976: 163) after Bakka's documentation of the rock art and excavations at the site (Bakka 1975; Bakka 1988; Bakka and Gaustad 1975). The rock art at the Hammer 6 site was overlayered with marine deposits. Bakka distinguished three phases that fit the evolutionistic scheme (Hagen 1976: 163). The overlayering was important for the dating, and still is. However, Bakka's phases must be seen as a strong wish to separate phases and to force the material to fit a general model (see Fig. 5.7). The difference between Bakka's three phases is about

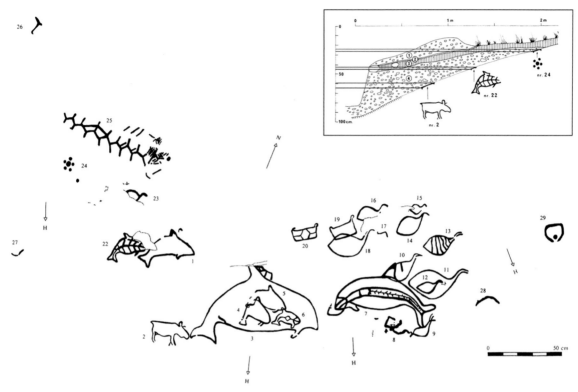

Figure 5.7. Bakka's tracing of Hammer VI after Bakka (1988: plate V). Illustration upper right reworked from Bakka (1975: 14, fig. 19). The elk figure (nr. 2) is between 59-65 cm, the sea mammal figure (nr. 22) is between 42-45 cm and the cupmark figures (nr. 24) are between 23 and 27 cm (illustration: Jan Magne Gjerde).

42 cm in elevation.[6] The layer covering all the figures (layer 4) is the same. There might be three phases with rock art at the Hammer 6 site. However, as shown in Figure 5.7, figures that fit the typological evolutionistic idea were selected, and presented as three chronological phases. The boat figures at Hammer are important for the dating suggestion. Bakka placed the Hammer carvings at about 4000 BC and probably no later than 3500/3800 BC (Bakka 1975: 18). Sognnes applied geological data and dated the carvings in central Norway by shoreline dating and found the maximum date for the Hammer 5, 6, 7 and 10 sites to be *c.* 5400 BP (Late Mesolithic) and the Hammer 8, 14 and 15 panels to be *c.* 4700 BP (Early Neolithic) (Sognnes 2003: 198). Calibrating these dates for the two panels with boats gives a date about 4300 BC for

the Hammer 5, 6, 7 and 10 sites and 3400 BC for the Hammer 8, 14 and 15 panels. The boat depictions at Hammer 6, Hammer 8 and Hammer 14 have a Stone Age date.

Similarity between the hunter's rock art boats (Evenhus and Hammer) and the type E boats has been suggested, where the E-type boats have been related to the latter part of the Neolithic and Early Bronze Age (Fett and Fett 1941: 133–137; 1979: 67; Sognnes 1987: 76f; 1990: 63–66, 102–104). Evenhus was early suggested by its style to be in the transition between the Stone Age and the Bronze Age. However, the boats and the circles advocated a Bronze Age date. (Petersen 1927: 31). Gjessing placed the Evenhus carvings by shoreline and stylistic arguments in the Late Neolithic and maybe slightly older (Gjessing 1936: 179f). Sognnes used shoreline dating to give the Evenhus carvings a maximum date of about 3700 BP, Late Neolithic (Sognnes 2003: 197). Calibrated, this equals about 2100 BC. The current dating suggestion for the Evenhus carvings would be the latter phase of the Late Stone Age.

In western Norway, the Krabbestig site has the so-called A1 boats, which Mandt saw as a western Norwegian variant of rock art boats. Similar boats are also present at the Domba site and Vangdal 1 in western Norway. These A1 boats have their counterparts in central Norway (Late Neolithic) and in Alta from about 2700 BC (Helskog 2012b). One of the boat figures at Domba has a bird shape including a bird stem (see Fig. 5.8). Such boats are previously described as bird boats in central Norway by Hallström (1938: 345) and Sognnes (1982: plate 5; 1996: 40) and for Nämforsen in northern Sweden by Hallström (1960: 328). These boats have their counterparts at Forselv (Gjessing 1931), where the boats are also depicted with a bird-stem (bird-head boat). In her study of the western Norwegian carvings, Mandt came to the conclusion that the Mjeltehaugen boats of the A1 type were from the Early Bronze Age, however could have a Neolithic origin (Mandt 1991: 273ff, 328ff). Marstrander sees the Mjeltehaug boats as similar to the hunter's boat representations (Marstrander 1963: 71f, 148f, 325) while Mandt sees them as a locally

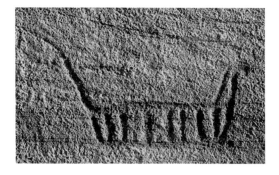

Figure 5.8. Boat figure at Domba, western Norway. Notice the bird-boat similar to the bird-boats in central Norway and Forselv in northern Norway (photo: Jan Magne Gjerde).

developed boat-type in western Norway (Mandt 1971; 1983: 28). Trond Linge dates the slabs with boat figures in Mjeltehaugen to Early Bronze Age period II or III (Linge 2004: 72ff; 2006: 541f; 2007).

An overview of the A1 boats was presented by Mandt (1991: 274, fig. 278.218).[7] The early western Norwegian A1 boats were placed by Mandt in her phase 1, in the Early Bronze Age period I with a possible Late Neolithic origin. That applies to the Mjeltehaugen, Krabbestig and Domba sites. The other sites, such as the A1 boats at Leirvåg (Leirvåg 1 and Leirvåg 3) are placed in her phase 2 (Early Bronze Age period I – Early Bronze Age period III) (Mandt 1991: 328–334). Lindqvist placed the Leirvåg carvings from the middle to the Late Neolithic (Lindqvist 1984). Wrigglesworth (2011: 110–112), in her recent study of Bronze Age rock art in western Norway, shows that the earliest figures (A1 type boats) at the sites Vangdal and Linga could be placed by shoreline dating in the Late Neolithic (about 2000 BC). However, she also cautiously puts in at the shore in the Early Bronze Age: 'I will not rule out the possibility that some of these ships were made in the Late Neolithic, but the available evidence does suggest that the majority were made in the Early Bronze Age, period 1–3' (Wrigglesworth 2011: 112). Similar boat types to the A1 boat are also found further south along the coast and Johnsen (1974: 166) dated these to the Late Neolithic. The rock art, and in particular the rock art boats along the coast, should be further studied, exploring at least sites such as Bru, Nag and Åmøy.

A preliminary review – moving from the 'Bronze Age' boat to a nuanced time frame – concluding remarks

The current preliminary overview of Stone Age boats has called at known sites with Stone Age boats in Fennoscandia (see Fig. 5.9). A dogma in rock art research has been the dating according to the motif/content whereby the boat generally has its origin in the south Scandinavian Bronze Age before it 'set sail northwards' (*e.g.* Malmer 1981). There has been a desire to date all boats to the Bronze Age and a reluctance to accept a Stone Age date for the boat motif. However, the rock art from northern Fennoscandia shows that

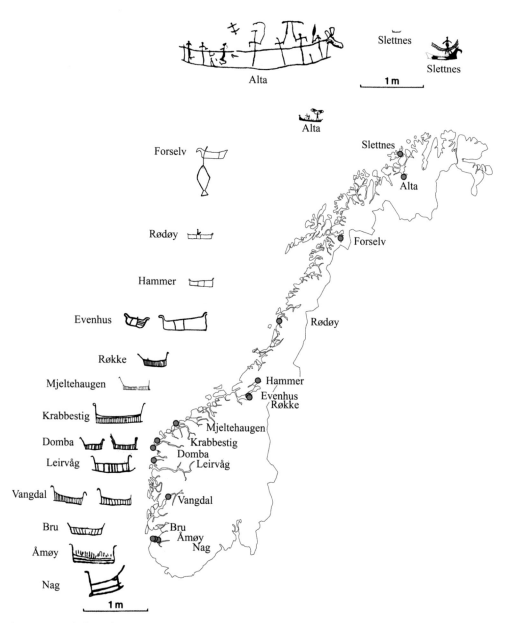

Figure 5.9. Early boat depictions at the Norwegian Coast (boats from Alta after Helskog 1989b: figure 4; boats from Slettnes after Hesjedal 1993a; boat from Forselv, author's tracing; boat from Rødøy after Gjessing 1936: plate XLIX; boat from Hammer after Bakka 1988: plate vi; boats from Evenhus after Gjessing 1936: plate LXXVII; boat from Røkke after Sognnes 1982: plate V; boat from Mjeltehaugen after Linge 2005: fig. 8; boat from Krabbestig after Mandt 1991: fig. 12.42; boat from Leirvåg after Mandt 1991: fig. 12.10; boats from Vangdal after Mandt 1972: plate 37; boat from Bru after Fett and Fett 1941: plate 7; boat from Åmøy after Fett and Fett 1941: plate 18; boat from Nag after Fett and Fett 1941: plate 3).

we have to consider a wider time frame for rock art in general, accepting a 'long chronology', and we must reconsider the boat dating in rock art. A brief overview of the earliest boat figures along the Norwegian coast shows that there are several sites with boats that have their origin in the Stone Age, the earliest about 7000 years ago–3000 years before the south Scandinavian Bronze Age.

For most researchers, it is still easier to consider south-to-north relations (a Continental origin) than north-to-south relations and definitely easier than east-to-west connections. The new material from northern Fennoscandia and Finland has increased immensely during the last decades, and several elk-head boats are found in Finland with dates contemporary with Nämforsen and Onega (Figs 5.4 and 5.5) supporting Hallström's eastern affinity. Important for the study of rock art in large geographical areas will be crossing boundaries. Knowledge and an overview of the material culture will always be important. Based on the current record, I am convinced that the 'Continental origin' for boats and the typological journey in Scandinavian rock art would have been a different story if, for instance, the Alta site had been discovered in the 1930s or if only parts of the Finnish material had been available in the 1930s.[8] Based on the recent growth of the material, it is time to re-evaluate some of the dogmas outlined about a century ago.

Even if the clear examples of Stone Age boats in central and western Norway have been known for decades, it seems safer to land in the Early Bronze Age. An overwhelming increase in the number of boats that can be dated to the Stone Age should not be neglected. We now know that boats from the Stone Age appear in large parts of Fennoscandia, but there are few in southern Scandinavia. The established typologies could perhaps be part of the explanation; hence, one may find that some of the anomalies that do not fit the Bronze Age boat typologies in some places may be related to an earlier date. For southern Scandinavian Stone Age rock art: 'Where are the missing boats in rock art?'

Notes

1. Malmer's work was written in 1972 but not published until 1981. This explain his strong stylistic focus. This also might explain why he did not look north for similarity in the boats. However, Malmer (1981: 97) mentions the usually called Stone Age boats

with reference to Gjessing (1936) and (Bakka, 1976), being aware of the Stone Age boats at Vyg.

2. 'At this point it will be appropriate to survey the boat figures, few in number, of a Bronze Age character at Nämforsen' (Hallström 1960: 296).
3. When Gjessing applies the term 'Stone Age' in this context, he is referring to the Late Stone Age.
4. Hesjedal also subtracted two metres from the dating due to tidal deviation.
5. Assumed to have a Neolithic date by Petersen.
6. The tidal difference for Trondheim and thereby Hammer region is about 2 m.
7. Based on Bøe's field notes when documenting Ausevik, Walderhaug documented a boat figure at Ausevik and added this as an A1 boat (Walderhaug 1994: 70–72, fig. 76.71). However, I agree with Bakka when he finds it more likely to be a line pattern (Hagen, 1969: 16) or part of the body of a deer. The area is eroded and it is questionable whether it is a boat figure.
8. The Alta site was discovered in 1973.

Acknowledgements

Thanks to Trond Linge for useful comments on an early manuscript of this paper. Thanks to the organizers of the symposium, Johan, Peter and Ulf, for some memorable days of rock art in Tanum. Special thanks to the 'Kräftskiva' that will be remembered for years.

References

Bakka, E. 1975. Geologically Dated Arctic Rock Carvings at Hammer Near Steinkjer in Nord-Trøndelag. *Arkeologiske Skrifter. Historisk Museum. Universitetet i Bergen* 2: 7–48.

Bakka, E. 1976. Bergkunst i barskogbeltet i Sovjetsamveldet. *Viking* 39: 95–124.

Bakka, E. 1988. *Helleristningane på Hammer i Beitstad, Steinkjer, Nord-Trøndelag: Granskingar i 1977 og 1981.* Det Kongelige norske Videnskabers Selskab. Trondheim.

Bakka, E. and Gaustad, F. 1975. *Helleristningsundersøkelser 1974 i Beitstad, Steinkjer, Nord-Trøndelag.* Det Kongelige norske Videnskabers Selskab, Museet. Rapport arkeologisk serie 1973 (8). Trondheim.

Baudou, E. 1993. Hällristningarna vid Nämforsen – datering och kulturmiljö. *Ekonomi och näringsformer i nordisk bronsålder*, 3rd edition (L. Forsberg and T. B. Larsson, eds): 247–261. Umeå Universitet/Arkeologiske Institutionen. Umeå.

Bell, T. G. 2004. *Tollevika.* Rapport i Tromsø Museums Topografiske Arkiv. Tromsø University Museum. Tromsø.

Bell, T. G. 2005. *Tollevika.* Rapport i Tromsø Museums Topografiske Arkiv. Tromsø University Museum 24. Tromsø.

Berglund, M. 2004. Holocene Shore Displacement and Chronology in Ångermanland, Eastern Sweden, the Scandinavian Glacio-isostatic Uplift Centre. *Boreas* 33: 48–60.

Bjerck, H. B. 2008. Norwegian Mesolithic Trends: A Review. *Mesolithic Europe* (G. Bailey and P. Spikins, eds): 60–106. Cambridge University Press. New York.

Bjerck, H. B. 2009a. Colonizing Seascapes: Comparative Perspectives on the Development of Maritime Relations in Scandinavia and Patagonia. *Arctic Anthropology* 46: 118–131.

Bjerck, H. B. 2009b. Colonizing Seascapes: Comparative Perspectives on the Development of Maritime Relations in the Pleistocene/Holocene Transition in North-west Europe. *Mesolithic Horizons/Papers Presented at the Seventh International Conference on the Mesolithic in Europe, Belfast 2005* (S. McCartan, R. Schulting, G. Warren *et al.*, eds): 16–23. Oxbow Books. Oxford.

Bøe, J. 1932. *Felszeichnungen im westlichen Norwegen*. John Griegs Boktrykkeri. Bergen.

Bøe, J. 1936. *Le Finnmarkien: Les origines de la civilisation dans l'extrême-nord de l'Europe.* Institutt for sammenlignende Kulturfoskning, Serie B Skrifter XXXII, Oslo.

Brøgger, A. W. 1906. Elg og ren paa helleristninger i det nordlige Norge. *Naturen* 10: 356–360.

Brøgger, A. W. 1909a. *Den arktiske stenalder i Norge*. I kommisjon hos Jacob Dybwad. Christiania.

Brøgger, A. W. 1909b. Hellersitninger og Hellemalerier: Primitiv Kunst. *Den arktiske stenalder i Norge.* Skrifter Videnskapsselskapet i Kristiania. Historisk-Filosofisk klasse 1909 no. 1. Christiania.

Christie, W. F. K. 1837. Om Helle-Ristninger og andre Indhugninger i Klipper, især i Bergens Stift. *Urda, et norsk antiqvarisk-historisk Tidsskrift* 1: 91–97.

Damm, C., A. Hesjedal, B. Olsen *et al.* 1993. *Arkeologiske undersøkelser på Slettnes, Sørøy 1991.* Universitetet i Tromsø. Tromsø.

Deviatova, E. I. 1976. *Geologija i Palinologija golocjenja i Kronologija pamjatnikov pervobytnoi epoki jugo-zaladnom Belomorje.* Akademia Nauk CCCP, Karelskii Filial, Institut Geologii. Nr. 33. Leningrad.

Ekholm, G. 1917. De skandinaviska hällristningarna och deras betydelse. *Ymer* 36: 275–308.

Engelstad, E. S. 1934. *Østnorske ristninger og malinger av den arktiske gruppe*. Aschehoug. Oslo.

Fett, E. N. and Fett, P. 1941. *Sydvestnorske helleristninger: Rogaland og Lista*. Stavanger Museum. Stavanger.

Fett, P. and Fett, E. N. 1979. Relations West Norway – Western Europe Documented in Petroglyphs. *Norwegian Archaeological Review* 12: 65–107.

Forsberg, L. 1993. En kronologisk analys av ristningarna vid Nämforsen. *Ekonomi och näringsformer i nordisk bronsålder,* 3rd edition (L. Forsberg and T. B. Larsson, eds): 195–261. Umeå Universitet/Arkeologiske Institutionen. Umeå.

Gjerde, J. M. 1998. *A Different Use of Landscape? The Visual Landscape Study of Rock Art Styles in Hardanger, Western Norway. A Method of Dating?* Department of Archaeology, University of Reading. Reading.

Gjerde, J. M. 2002. Lokalisering av helleristninger i landskapet. *Bilder av bronsålder - ett seminarium om förhistorisk kommunikation: Rapport från ett seminarium på Vitlycke Museum 19.e-22.e oktober 2000* (J. Goldhahn, ed.): 23–51. Almqvist & Wiksell International. Stockholm.

Gjerde, J. M. 2008. Boats of the North. *Kanozero Petrogliphs: The Kirovsk International Conference on Rock Art:* 58–63. Kirovsk Municipality/Finnmark County Council. Kirovsk.

Gjerde, J. M. 2010. *Rock Art and Landscape: Studies of Stone Age Rock Art from Northern Fennoscandia.* University of Tromsø. Tromsø.

Gjessing, G. 1931. The Skjomen Carving. *Acta Archaeologica* II: 278–285.

Gjessing, G. 1932. *Arktiske helleristninger i Nord-Norge.* Aschehoug. Oslo.

Gjessing, G. 1936. *Nordenfjelske ristninger og malinger av den arktiske gruppe.* Aschehoug. Oslo.

Gjessing, G. 1938. Nyoppdagete veideristninger i Nord-Norge. *Viking* 2: 137–144.

Gjessing, G. 1945. *Norges steinalder.* Norsk arkeologisk selskap. Oslo.

Gjessing, G. 1974. Veidekunst i Nord-Norge – litt spreidd småplukk. *Nicolay* 18: 3–9.

Glørstad, H. 2013. Where Are the Missing Boats? The Pioneer Settlement of Norway as Long-Term History. *Norwegian Archaeological Review* 46: 57–120.

Goldhahn, J. 2006. *Hällbildsstudier i norra Europa: Trender och tradition under det nya millenniet.* Göteborgs universitet, Institutionen för arkeologi. Gothenburg.

Hagen, A. 1969. *Studier i vestnorsk bergkunst: Ausevik i Flora.* Humanistisk Serie 1969:3, Universitetet i Bergen, Oslo.

Hagen, A. 1976. *Bergkunst: Jegerfolkets helleristninger og malninger i norsk steinalder.* Cappelen. Oslo.

Hallström, G. 1907a. Hällristningar i norra Skandinavien. *Ymer* 27: 211–227.

Hallström, G. 1907b. Nordskandinaviska hällristningar. *Fornvännen* 2: 160–189.

Hallström, G. 1908. Nordskandinaviska hällristningar. II. De norska ristningarna. *Fornvännen* 3: 4–86.

Hallström, G. 1909. Nordskandinaviska hällristningar. II. De norska ristningarna. *Fornvännen* 4: 126–159.

Hallström, G. 1938. *Monumental Art of Northern Europe from the Stone Age: The Norwegian Localities.* Thule. Stockholm.

Hallström, G. 1960. *Monumental Art of Northern Sweden from the Stone Age: Nämforsen and Other Localities.* Almqvist & Wiksell. Stockholm.

Hansen, A. M. 1904. *Landnåm i Norge: En utsigt over bosætningens historie.* Fabritius. Kristiania.

Helberg, B. H. 2008. Helleristningene på Forselv. Museum Nord-Ofoten *Årbok 2008 - fra bane, bygd og by:* 47–53.

Helskog, K. 1983. Helleristningene i Alta i et tidsperspektiv – en geologisk og multivariabel analyse. *Folk og ressurser i nord: Foredrag fra Trondheims-symposiumet om midt- og nordskandinavisk kultur 1982* (J. Sandnes, I. Østerlie and A. Kjelland, eds): 47–60. Universitetsforlaget. Trondheim.

Helskog, K. 1985. Boats and Meaning: A Study of Change and Continuity in the Alta Fjord, Arctic Norway, from 4200 to 500 Years B.C. *Journal of Anthropological Archaeology* 4: 177–205.

Helskog, K. 1988. *Helleristningene i Alta: Spor etter ritualer og dagligliv i Finnmarks forhistorie.* Alta Museum. Alta.

Helskog, K. 1989a. Helleristningene i Alta i et nordlig perspektiv: Kronologi og symbolisme *Iskos* 7: 67–75.

Helskog, K. 1989b. Naturalisme og skjematisme i nord-norske helleristninger. *Framskritt for fortida i nord: I Povl Simonsens fotefar* (A. Utne, R. Bertelsen and P. K. Reymert, eds): 87–104. Tromsø Museums Skrifter XXII, Universitetet i Tromsø, Tromsø.

Helskog, K. 1990. Fra tvangstrøyer til 90-åras pluralisme i helleristningsforskning. *Nordic TAG: Report from the third Nordic Tag conference 1990* (B. Solberg and C. Prescott, eds): 70–75. Historisk Museum. Bergen.

Helskog, K. 2000. Changing Rock Carvings – Changing Societies. A Case from Arctic Norway. *Scandinavian Society for Prehistoric Art* 2000: 5–16.

Helskog, K. 2005. Depictions of Prehistoric Reindeer Corrals: Hunting, Domestication or Both? *World of Rock Art: Papers presented at the International Conference* (E. G. Devlet, ed.): 344–351. Institute of Archaeology RAS. Moscow.

Helskog, K. 2012a. Helleristninger av båter og ressursutnyttelse i Europas nordlige ytterkant. *Nordlige verdener: Agrarsamfundenes ekspansion i nord* (F. Kaul and L. Sørensen, eds): 221–232. Nationalmuseet. Copenhagen.

Helskog, K. 2012b. *Samtaler med Maktene.* Tromsø Museums Skrifter XXXIII. Tromsø.

Helskog, K. 2014. *Communicating with the World of Beings: The World Heritage Rock Art Sites in Alta, Arctic Norway.* Oxbow Books. Oxford.

Hesjedal, A. 1990. *Helleristninger som tegn og tekst: En analyse av veideristningene i Nordland og Troms.* Institutt for Samfunnsvitenskap. Serie B. Historie /Arkeologi. Universitetet i Tromsø. Tromsø.

Hesjedal, A. 1993a. Finnmarks eldste helleristninger? *Ottar: Populære småskrifter fra Tromsø Museum* 194: 24–35.

Hesjedal, A. 1993b. Veideristninger i Nord-Norge, datering og tolkningsproblematikk. *Viking* 55: 27–53.

Hesjedal, A. 1994. The Hunters' Rock Art in Northern Norway: Problems of Chronology and Interpretation. *Norwegian Archaeological Review* 27: 1–28.

Hesjedal, A., C. Damm, B. Olsen *et al.* 1996. *Arkeologi på Slettnes: Dokumentasjon av 11.000 års bosetning.*Tromsø Museum. Tromsø.

Hesjedal, A., B. Olsen, I. Storli *et al.* 1993. *Arkeologiske undersøkelser på Slettnes, Sørøy 1992.* Universitetet i Tromsø, Institutt for museumsvirksomhet. Tromsø.

Janik, L. 2010. The Development and Periodisation of White Sea Rock Carvings. *Acta Archaeologica* 81: 83–94.

Johnsen, J. 1974. *Rogalandsristningane: Typologiske freistnader: Rogaland.* Universitetet i Bergen. Bergen.

Käck, B.-O. 2001. Boplatsen vid forsen. *Tidsspår: Forntidsvärld och gränslöst kulturarv* (M. Bergvall and O. George, eds): 25–42. Hemströms tryckeri AB. Härnösand.

Käck, J. 2009. Samlingsboplatser? En diskussion om människors möten i norr 7000 f Kr med särskild utgångspunkt i data från Ställverksboplatsen vid Nämforsen. *Institutionen för idé- och samhällsstudier.* University of Umeå. Umeå.

Kaul, F. 1998. *Ships on Bronzes: A Study in Bronze Age Religion and Iconography.* Nationalmuseet. Copenhagen.

Kaul, F. 2012. Fund, helleristninger og landskaber, Nordnorge. *Nordlige verdener. Agrarsamfundenes ekspansion i nord* (F. Kaul and L. Sørensen, eds): 205–220. Nationalmuseet. Copenhagen.

Kaplin, P. A. and A. O. Selivanov 2004. Lateglacial and Holocene Sea Level Changes in Semi-enclosed Seas of North Eurasia: Examples from the Contrasting Black and White Seas. *Palaeogeography, Palaeoclimatology, Palaeoecology* 209: 19–36.

Kolpakov, E. M. and V. Shumkin 2012. *Petroglify Kanozera.* Iskusstvo Rossii. St Petersburg.

Lahelma, A. 2005. The Boat as a Symbol in Finnish Rock Art. *World of Rock Art: Papers presented at the International Conference* (E. G. Devlet, ed.): 359–362. Institute of Archaeology RAS. Moscow.

Lahelma, A. 2008. *A Touch of Red: Archaeological and Ethnographic Approaches to Interpreting Finnish Rock Paintings.* Finnish Antiquarian Society. Helsinki.

Larsson, T. B. and Engelmark, R. 2005. Nämforsens ristningar är nu fler än tvåtusen. *Populär Arkeologi* 4: 12–13.

Lindgaard, E. 1999. *Jegernes bergkunst i et øst-vest perspektiv. En analyse av motiv og stiler i Midt-Norge og Mellan-Norrland.* Department of Archaeology, NTNU. Trondheim.

Lindqvist, C. 1983. Arktiska hällristningsbåtar – spekulationer om kulturellt utbyte via kust- och inlansvattenvägar i Nordfennoscandia. *Meddelanden från Marinarkeologiska Sällskapet* 6: 2–14.

Lindqvist, C. 1984. Arktiska hällristningsbåtar och den marina anpassingen. *Meddelanden från Marinarkeologiska Sällskapet* 7: 4–34.

Lindqvist, C. 1994. *Fångstfolkets bilder: En studie av de nordfennoskandiska kunstanknutna jägarhällristningarna.* Akademitryck AB Stockholm. Stockholm.

Ling, J. 2008. *Elevated Rock Art: Towards a Maritime Understanding of Rock Art in Northern Bohuslän, Sweden.* Göteborgs universitet. Gothenburg.

Ling, J. 2013. *Rock Art and Seascapes in Uppland.* Oxbow Books. Oxford.

Ling, J. and M. Rowlands 2015. The 'Stranger King' (Bull) and Rock Art. *Picturing the Bronze Age* (P. Skoglund, K. Ling and U. Bertilsson, eds): 89–104. Oxbow Books. Oxford.

Linge, T. E. 2004. *Mjeltehaugen: Fragment frå gravritual.* UBAS Hovedfag/Master. Universitetet i Bergen Arkeologiske Skrifter 3. Bergen.

Linge, T. E. 2005. Kammeranlegget i Mjeltehaugen – eit rekonstruksjonsforslag. *Mellan sten och järn: Rapport från det 9:e nordiska bronsåldersymposiet, Göteborg 2003-10-09/12* (J. Goldhahn, ed.): 537–559. Göteborgs universitet, Institutionen för arkeologi. Gothenburg.

Linge, T. E. 2006. Båtar på berg utmed havet – Om to ristningslokalitetar på kysten av Sogn og Fjordane. *Samfunn, symboler og identitet - Festskrift til Gro Mandt på 70-årsdagen* (R. Barndon, S. M. Innselset, K. K. Kristoffersen *et al.* eds): 539–549. Universitetet i Bergen. Bergen.

Linge, T. E. 2007. *Mjeltehaugen: Fragment frå gravritual.* Universitetet i Bergen. Bergen.

Lobanova, N. 2007. Petroglyphs at Staraya Zalavruga: New Evidence – New Outlook. *Archaeology, Ethnology & Anthropology of Eurasia* 29: 127–135.

Lødøen, T. K. and Mandt, G. 2012. *Vingen: Et naturens kolossalmuseum for helleristninger.* Akademika. Trondheim.

Malmer, M. P. 1975. The Rock Carvings at Nämforsen, Ångermanland, Sweden, as a Problem of Maritime Adaptation and Circumpolar Interrelations *Prehistoric Maritime Adaptations of the Circumpolar Zone* (W. W. Fitzhugh, ed.): 41–46. Mouton Publishers. The Hague/Paris.

Malmer, M. P. 1981. *A Chorological Study of North European Rock Art.* Almqvist & Wiksell. Stockholm.

Mandt, G. 1971. En Vestnorsk Variant av Bergbilde-båter. *arkeo* 1: 7–9.

Mandt, G. 1972. *Bergbilder i Hordaland: En undersøkelse av bildenes sammensetning, deres naturmiljø og kulturmiljø.* Norwegian Universities Press. Bergen.

Mandt, G. 1980. Variasjon i vestnorsk bergkunst. *arkeo* 1980: 12–15.

Mandt, G. 1983. Tradition and Diffusion in West-Norwegian Rock Art: Mjeltehaugen Revisited. *Norwegian Archaeological Review* 16: 14–32.

Mandt, G. 1991. *Vestnorske ristninger i tid og rom: Kronologiske, korologiske og kontekstuelle studier*. Universitetet i Bergen. Bergen.

Marstrander, S. 1963. *Østfolds jordbruksristninger: Skjeberg*. Universitetsforlaget. Oslo.

Marstrander, S. 1978. The Problem of European Impulses in the Nordic Area of Agrarian Rock Art. *Acts of the International Symposium on Rock Art: Lectures at Hankø 6-12 August, 1972* (S. Marstrander, ed.): 45–67. Universitetsforlaget. Oslo.

Miller, U. and Robertsson, A.-M. 1979. Biostratigraphical Investigations in the Anundsjö Region, Ångermanland, Northern Sweden. *Geological Investigations in the Anundsjö Region, Northern Sweden* (U. Miller, S. Modig and A.-M. Robertsson, eds): 1–76. Kungliga Vitterhets Historie och Antikvitets Akademien. Stockholm.

Møller, J. and Holmeslet, B. 1998. *Sealevel Change*. Version 3.51. University of Tromsø. Tromsø.

Olsen, B. 1994. *Bosetning og samfunn i Finnmarks forhistorie*. Universitetsforlaget. Oslo.

Petersen, T. 1927. Nye fund fra det nordenfjellske Norges helleristningsområde. *Finska Fornminnesföreningens tidsskrift* 36: 23–44.

Petersen, T. 1930. En nyopdaget helleristning på Rødøy, Tjøtta prestegjeld, Helgeland. *Det Kongelige Norske Videnskabers Selskabs Skrifter* 3: 116–119.

Ramstad, M. 2000. Veideristningene på Møre: Teori, kronologi og dateringsmetoder. *Viking*: 51–86.

Ravdonikas, V. I. 1936. *Naskal'nye izobraženija Onezskogo ozera i Belogo morja*. Izdatel'stvo Akademii nauk SSSR. Moscow.

Ravdonikas V. I. 1938. *Naskal'nye izobraženija Belego morja/Наскальные изображения Белого моря*. Leningrad.

Rekstad, J. 1919. Geologiske iakttagelser fra strekningen Folla-Tysfjord. *Norges Geologiske Undersøkelser. Årbok* 83: 1–60.

Savvateev, J. A. 1970. *Zalavruga: Arheologičeskie pamjatniki nizov'ja reki vyg: čast' pervaja Petroglify/Залавруга. Часть 1: Петроглифы*, Izdatel'stvo Nauka. Leningrad.

Savvateev J. A. 1977. *Zalavruga: Arheologičeskie pamjatniki nizov'ja reki vyg: čast' vtoraja Stojanki/Залавруга. Часть 2: Стоянки. Л.,* Izdatel'stvo Nauka. Leningrad.

Savvateev, Y. A., E. I. Deviatova and A. A. Liiva 1978. Dating of the Rock Art by the White Sea/Опыт датировки наскальных изображений Белого Моря. *Sovetskaja arheologija* 1978: 16–36.

Savvateyev, Y. A. 1977. Rock Pictures (Petroglyphs) of the White Sea. *Bolletino del Centro Camuno di Studi Preistorici* XVI: 67–86.

Savvateyev, Y. A. 1988. Ancient Settlements Connected with Rock Art in Karelia. *Bolletino del Centro Camuno di Studi Preistorici* XXIV: 45–68.

Sawwatejew, J. A. 1984. *Karelische Felsbilder*. Seemann. Leipzig.

Sidenbladh, K. 1869. Fornlemningar i Norrland. *Antiquarisk Tidsskrift för Sverige* 1869: 192–214.

Simonsen, P. 1958. *Arktiske helleristninger i Nord-Norge II,* Aschehoug. Oslo.

Simonsen P. 1974. The Rock Art of Arctic Norway. *Bolletino del Centro Camuno di Studi Preistorici* XI: 129–150.

Simonsen, P. 1978. New Elements for Evaluating the Origin and End of Northern Scandinavian Rock Art. *Acts of the International Symposium on Rock Art* (S. Marstrander,

ed.): 31–36. Universitesforlaget/Institutt for Sammenlignende Kulturforskning. Oslo/Bergen/Tromsø.

Simonsen, P. 1991. *Fortidsminner nord for polarsirkelen.* Universitetsforlaget. Oslo.

Sognnes, K. 1982. *Helleristninger i Stjørdal, 1: Skatval sogn.* Det Kongelige norske Videnskabers Selskab. Arkeologisk serie 1982:10, Trondheim.

Sognnes, K. 1987. *Bergkunsten i Stjørdal, 2: Typologi og kronologi i Nedre Stjørdal.* Universitetet i Trondheim, Vitenskapsmuseet. Trondheim.

Sognnes, K. 1989. Rock Art at the Arctic Circle: Arctic and Agrarian Rock Engravings from Tjøtta and Vevelstad, Nordland, Norway. *Acta Archaeologica* 59: 67–90.

Sognnes, K. 1990. *Bergkunsten i Stjørdal Hegraristningane 3.* Universitetet i Trondheim, Vitenskapsmuseet. Trondheim.

Sognnes, K. 1995. The Social Context of Rock Art in Trøndelag, Norway: Rock Art at a Frontier. *Perceiving Rock Art: Social and Political Perspectives* (K. Helskog and B. Olsen, eds): 130–145. Instituttet for sammenlignende kulturforskning. Novus. Oslo.

Sognnes, K. 1996. Dyresymbolikk i midt-norsk yngre steinalder. *Viking* 59: 25–44.

Sognnes, K. 2001. *Prehistoric Imagery and Landscapes: Rock Art in Stjørdal, Trøndelag, Norway.* Archaeopress. Oxford.

Sognnes, K. 2002. Land of Elks – Sea of Whales: Landscapes of the Stone Age Rock-art in Central Scandinavia. *European Landscapes of Rock-art* (G. Nash and C, Chippindale, eds): 195–212. Routledge. London.

Sognnes, K. 2003. On Shoreline Dating of Rock Art. *Acta Archaeologica* 74: 189–209.

Stolyar, A. D. 2000. Spiritual Treasures of Ancient Karelia. *Myanndash* (A. Kare, ed.): 136–173. Gummerus Kirjapaino. Jyväskylä.

Tarasov, A. and Murashkin, A. I. 2002. The New Material from the Site Zalavruga I and the Problem of Dating New Zalavruga's Rock Carvings/Новые материалы с лоселения эалавруга 1 и проблема датировки петроглифов новой эалавруга. *Arheologičeskie Vesti* 10: 41–44.

Tilley, C. 1991. *Material Culture and Text: The Art of Ambiguity.* Routledge. London.

Vogt, D. 2006. *Helleristninger i Østfold og Bohuslän: En analyse av det økonomiske og politiske landskap.* Universitetet i Oslo. Oslo.

Walderhaug, E. S. 1994. *'Ansiktet er av stein': Ausevik i Flora: en analyse av bergkunst og kontekst.* Universitetet i Bergen. Bergen.

Wrigglesworth, M. 2000. *Ristninger og graver som sted: En visuell landskapsanalyse.* Arkeologisk Institutt Universitet i Bergen. Bergen.

Wrigglesworth, M. 2006. Explorations in Social Memory – Rock Art, Landscape and the Reuse of Place. *Samfunn, symboler og identitet - Festskrift til Gro Mandt på 70-årsdagen* (R. Barndon, S. M. Innselset, K. K. Kristoffersen, *et al.*, eds): 147–162. Universitetet i Bergen. Bergen.

Wrigglesworth, M. 2011. *Finding Your Place: Rock Art and Local Identity in West Norway: A Study of Bronze Age Rock Art in Hardanger and Sunnhordland.* University of Bergen. Bergen.

Zhulnikov, A. M. 2006. K voprosu o datirovke Belomorskih petroglifov. *Pervobytnaja i srednevekovaja istorija i kultura evropeiskovo Severa: problemy, izučenija i rekonstruktsii:* 238–247. Arkhangelsk.

Ziegler, R. 1901. Arkæologiske Undersøgelser i 1900. *Det Kongelige Norske Videnskabers Selskabs Skrifter* 7: 3–5.

The Circumpolar Context of the 'Sun Ship' Motif in South Scandinavian Rock Art

Antti Lahelma

Abstract: Historically, the two 'great traditions' of north European rock art – the South Scandinavian type and the hunters' rock art of the north – have been studied by different scholars working within different research traditions. Even though the two rock art traditions overlap in both space and time, and show some evidence of communication and interaction, the scholarly traditions rarely do, but tend to interpret each type of rock art

according to models that seem oblivious to each other. This paper takes a look at the interpretations offered for a single type of motif in South Scandinavian rock art, the 'sun ship' or a ship figure that is associated with or attached to a symbol of the sun, and examines it in the context of the hunters' rock art. Ever since Oscar Almgren and others, the motif has played a central role in interpretations of Bronze Age rock art: it has been associated with elements of Indo-European mythology, and its roots have been traced to the Mediterranean world and Ancient Egypt. However, there is a lesser known research tradition, represented mainly by Russian and North American scholars, that points out parallels to the same motif also in the rock art of the northern circumpolar zone. Given other evidence of rock art phenomena with a circumpolar distribution, as well as the general resurgence of circumpolar studies, these 'sun ships of the east' do not appear isolated or incidental but would merit more attention in interpretations of South Scandinavian rock art.

Key words: circumpolar, rock art, sun ship, Scandinavia, Siberia, Canada.

Introduction

The 'sun ship' is one of the most iconic motifs of South Scandinavian Bronze Age rock art (Fig. 6.1). Even though the motif, consisting of a ship figure that is associated with or attached to what has been interpreted as a symbol of the sun (a ring, ring-cross or similar), is comparatively rare, it has played a central role in interpretations of the art for a century at least (*e.g.* Ekholm 1916; Almgren 1927). This is understandable, because unlike the vast majority of the baffling and alien imagery of South Scandinavian rock art, the sun ship seems to represent something that we can perhaps comprehend as reflecting cosmology or religious ideas. There seems to be something happening – the ship is carrying the sun – and thus there is perhaps an element of narrative. If there is a narrative, it may be a mythical one as it combines a cosmic element (the sun) with an earthly one (a ship). What is more, iconographic parallels to the sun ship and some related motifs appear to be found in the Mediterranean region (*e.g.* Winter 2002; Kaul 2004; Kristiansen and Larsson 2005), for example in the form of 'solar barks' of

Figure 6.1. A view from Vitlycke rock art museum at the UNESCO World Heritage site of Tanum, the central region of South Scandinavian rock art. The sun ship hanging from the ceiling underlines the significance of this motif for interpretations of the art (photo: Antti Lahelma).

Egyptian art, which seem to anchor the narrative to the mythology of early farming cultures and themes that may ultimately derive from Ancient Egypt.

A major turn in our understanding of Scandinavian Bronze Age art came with Flemming Kaul's (1998) detailed and plausible reading of the myth of the sun's journey as depicted in contemporary bronze razors. This was more recently complemented by Kristian Kristiansen and Thomas B. Larsson (2005; see also Kristiansen 2010), who have introduced a wealth of Indo-European mythology in support of Kaul's hypothetical narrative and also attempted to find parallels for the razor imagery in South Scandinavian rock art (Fig. 6.2).[1] Put very briefly, the myth relates the daily drama of sunset and sunrise. The sun maiden is chased by the monsters of the night, riding on her chariot through the bright sky, and is eventually engulfed by the waves at dusk and captured to the dark abyss of the night. She is rescued by the Twin Gods (the Dioscuri of Classical mythology), who defeat the forces of the night, take the sun on their divine ship and sail towards the safety of a new dawn – only to repeat it all over again the following day.

Identifying this rich mythology in Bronze Age iconography is a major intellectual accomplishment and a source of inspiration to all who take an optimistic stance on rock art interpretation. However, interpreting rock art is never a straightforward issue, and for instance Ling (2008) and Wehlin (2014)

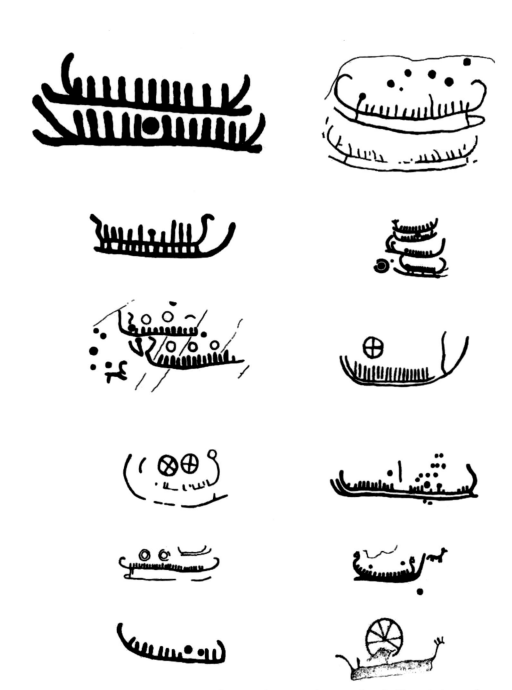

Figure 6.2. Examples of rock carvings from southern Scandinavia, identified by Kristiansen (2010, fig. 6.4) as representing scenes where 'the sun or suns are carried on a ship or on twin ships.'

have recently emphasised the maritime character of South Scandinavian rock art, the latter suggesting that the sun ships may in fact depict navigation with the help of the sun. For my part, I will try to approach the images from my own field of expertise, which lies in the study of hunter-gatherer rock art. Whereas Scandinavian Bronze Age scholarship has historically been oriented towards Central Europe and the Mediterranean, in this paper I attempt to place the South Scandinavian sun ships in a totally different, northern circumpolar context, by looking for parallels to the motif from areas to the north and east of Bohuslän, Sweden. This should not be seen as undermining the already established interpretations, but as an attempt to enrich our understanding of South Scandinavian rock art by exploring its connections with the 'Arctic' tradition, nor is it an entirely new approach.

Already Gustaf Hallström (1960: 339–358, 377–378) suggested that South Scandinavian solar symbols were related to similar solar images at Lake Onega in Karelia, north-western Russia. Soviet scholars, most notably Alexander Formozov (1966, 1969), pointed out several examples of sun ships in Central Asia[2] and Siberia, but this research has remained little known in the west. This is scarcely a wonder, as even without the Iron Curtain and the language barrier, Formozov's 'heliocentric' diffusionist reading of rock art – where the source of all of such motifs lay in Ancient Egypt – would probably have been dismissed by most contemporary Western archaeologists. Yet, the fact remains that sun ships more or less similar to those of Bohuslän can be found at rock art sites throughout northern Eurasia, and in fact are even found in North America, at the Peterborough petroglyphs site in Canada. This site is so incredibly distant from the banks of the Nile that surely even Formozov – had he been aware of it – would have hesitated to suggest an Egyptian origin for the sun ships recorded there. So how, then, are we to account for the Canadian sun ships?

The case of the 'Canadian sun ships'

The rock carving site generally known as 'Peterborough petroglyphs' lies in southern Ontario, c. 50 km to the north-east of the city of Peterborough. There are no historical or ethnographic records directly related to the carvings, which by the twentieth century had been forgotten by the native

population and were 'found' only in 1954. However, the rocks where the carvings are located – a type of crystalline, smooth limestone – were known to the local Algonquian-speaking Anishinaabe communities as *Kinoomaagewaapkong* or 'Teaching Rocks', suggesting a cultural affiliation with that group.[3]

The site was the subject of a ground-breaking monograph titled *Sacred Art of the Algonkians*, written by Joan and Romas Vastokas (1973), which presents a careful analysis of the various motifs (such as anthropomorphs, snakes, turtles, birds, animals tracks, *etc.*) at Peterborough and concludes that they were made by the prehistoric predecessors of present-day Algonquian-speaking peoples, possibly around 600 and 1100 BP (based mostly on a few fragments of pottery found at the site). The site is today considered sacred by the Anishinaabe, who identify characters of Algonquian myth in the carvings, such as the turtle-messenger or *Miqinaq*, the rabbit-eared culture-hero *Nanabush*, and the solar-headed supreme deity *Kitchi-Manitou* (Zawadzka 2011).

However, among the 300 or so carvings at the Peterborough petroglyphs, the images of fourteen boats or canoes have attracted by far the most attention from both the general public and the archaeologists studying the site (Fig. 6.3). This is related to the fact that some aspects of these boats appear to be out of place in a Native American context:

> Unlike native canoes, the watercraft engraved at the site are characterized by animal-like prows, stern-end underside extensions, which may be interpreted as a steering sweep or paddle, by a tall

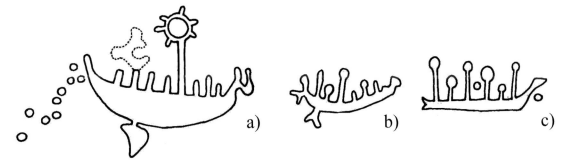

Figure 6.3. Three boat figures with globular or solar devices from Peterborough, eastern Ontario, Canada. Different scales (according to Vastokas & Vastokas 1973).

projection or 'mast' in the centre of the vessel, and, most significantly
in several instances, by a globular configuration or solar device at the
apex of the 'mast' (Vastokas and Vastokas 1973: 121).

The most striking of these vessels, which has become something of an
emblem of the entire site, is certainly a figure that captures the viewer's
attention and seems to be of particular importance, as it is one of the
largest motifs at the site, some 105 cm long and 75 cm high. This figure
has inspired wild speculations about Bronze Age 'Vikings' reaching North
America more than two millennia before the generally accepted first contact
(see Vastokas 2004). Proponents of the 'Viking theory' include some notable
figures, such as the famous Mayanist David Kelley (1994), a former professor
of archaeology at the University of Calgary, and a comparison has often been
drawn between the Peterborough sun ship and some of the famous sun-ship
carvings of southern Scandinavia, such as that from Bottna in Bohuslän
(Vastokas and Vastokas 1973: 126).

If Peterborough and Bohuslän were the only two points on a distribution
map, the notion of seafaring rock carvers from Scandinavia might possibly
seem like a viable explanation, but as Vastokas and Vastokas (1973: 125–127)
make it clear, this is not the case. Similar imagery can in fact be found in rock
art throughout the northern circumpolar zone. They note the similarity to
Scandinavian Bronze Age sun ships, but also point out similarities to the rock
paintings of the Canadian Shield and British Columbia, the carvings of Lake
Onega (north-western Russia) and lower Amur (Russian Far East), among
others. They argue that all of these images share a common background
in northern circumpolar shamanism, where both the boat and the sun are
fundamental elements of the mental imagery of the shaman.

The conceptual link between boat imagery and shamanic journeys is
indeed characteristic of circumpolar shamanism, and this is reflected in
north Eurasian rock art, where boats are sometimes evidently depicted not
as concrete objects but as the shaman's vehicles to the Otherworld (see
Lahelma 2007). According to Vastokas and Vastokas (1973: 126–127), the
image of a sun-boat in northern circumpolar religious imagination arises
when the notion of the soul-boat is brought into association with another
central shamanistic motif, the Cosmic Tree or Axis. The boat may thus refer
to travel on the horizontal plane, but also to the vertical axis: the celestial
journeys of the shaman. The Cosmic Axis, they write, may be topped by an

image of the sun: 'Hence, the soul-boat becomes also a vehicle of the sun' (Vastokas and Vastokas 1973: 127). Because this interpretation is based on a close reading of northern ethnographic literature, the argument carries much more weight than Formozov's simple form of diffusionism, but for some reason it has made just as little impact on Scandinavian rock art research. However, the past four decades have brought to light much new data, which justifies a new assessment of this 'circumpolar connection'.

The circumpolar connection

From an ecological and geographic perspective, both Fennoscandia and the Canadian Shield are part of a much larger entity, known as the northern circumpolar region. This vast area, which also includes Greenland, Alaska and the northern parts of Japan, Korea, Russia and Siberia, shares a flora and fauna that is distinct from the more southerly temperate regions. It can be roughly divided into two biomes: the Arctic tundra and the Boreal forest (or taiga). The majority of known rock art occurs in the Boreal zone, although some important sites – such as Norway's Alta (Helskog 2014a) and Pegtymel in north-eastern Siberia (Dikov 1999) – are located in the Arctic, well north of both the Arctic Circle and the northernmost extent of a sub-Arctic environment.

In addition to common features in the natural and physical environment of the circumpolar region, there are some striking commonalities in the traditional material and spiritual cultures of its inhabitants. In spite of the sparse population and vast distances, the existence of such commonalities is not altogether surprising, because contact networks in the north have traditionally been extensive due to the high mobility of circumpolar peoples. Although settled farming communities have existed in the southern parts of the Boreal zone since the Neolithic, such as parts of Scandinavia and Finland (*e.g.* Arntzen 2015), most peoples living in the circumpolar taiga and tundra have until recently led a mobile way of life based upon hunting, fishing, gathering and (more recently) reindeer herding.

Many of the shared cultural phenomena were noted already by nineteenth-century and early 20th-century explorers and anthropologists, who were not afraid to draft grandiose theories of a prehistoric *urkultur* that

belied all these commonalities (Hood 2009). Thus, for example, the Danish archaeologist and ethnographer Gudmund Hatt (1916) proposed that the prehistory of the circumpolar region reflects two ancient intercontinental cultures, an Arctic 'coastal culture' and an 'inland culture' confined to the Boreal forest zone, the latter having such characteristic features as the moccasin, a distinctive technique of skin dressing, cradle boards or carrying cradles for infants, the birch bark canoe, the conical tent or 'tipi', the snowshoe, etc.

Here it may be mentioned that imprints from snowshoes are depicted at three north European rock art sites at least, providing tantalising evidence of a lost circumpolar world. Although snowshoes were unknown in Europe in the historical period, probably because they were replaced by skis, the carvings of Alta in northern Norway (Helskog 2014a) and Kanozero on the Kola Peninsula, north-western Russia (Kolpakov and Shumkin 2012), feature scenes of people walking on snowshoes that appear to be distinctively Algonquian in style.

Although some of Hatt's ideas no longer stand closer scrutiny, the same cannot be said of the work of the American anthropologist Irving A. Hallowell, whose *Bear Ceremonialism in the Northern Hemisphere* (1926) discusses perhaps the most celebrated example of what appears to be a genuinely circumpolar cultural phenomenon. Hallowell's detailed analysis of the elaborate ceremonies surrounding the bear hunt spanned a wide selection of indigenous peoples – such as the Ojibwa of Canada, the Ainu of northern Japan, the Yukaghirs of Siberia and the Sámi of northern Fennoscandia – who, in spite of their different linguistic and cultural backgrounds, observed highly similar taboos, rituals and myths concerning the bear.[4] What is more, these myths sometimes appear to be depicted in rock art in both Siberia (McNeil 2005) and Norway (Helskog 2012).

A second phenomenon today commonly cited as having a circumpolar distribution is the 'classic' or Siberian-style shamanism, which should be seen as distinct from a more 'universalist' view of shamanism such as that discussed by Mircea Eliade (1964). As defined by Anna-Leena Siikala and Mihaly Hoppál (1992: 4–12), Siberian shamanism features a particular kind of vocation, initiation, cosmology, dress and seances (*kamlanie*) with the spirits. This type of shamanism has close parallels among the Algonquian-speaking peoples of Canada and the northern parts of the United States, as

demonstrated for example by Karl Schlesier's (1993) detailed comparative study of Cheyenne[5] and Siberian shamanism.

In addition to ritual, some elements of mythology have an equally wide distribution. The thunderbird, whose enormous wings cause thunder and swirling winds, is a major component in many Native American mythologies – especially of the Boreal zone – but is found widely also among north Eurasian peoples, including the Chukchi, Khanty, and the Finns (Siikala 2002: 238). Other examples of circumpolar phenomena on the level of spiritual culture include certain cosmogonic and astral myths, such as the 'earth-diver' motif, *viz.*, the diving into water for mud from which the earth is created (Berezkin 2007), as well as the notion of the Milky Way as a pathway of the migratory birds and a number of other similar mythical themes (Berezkin 2010).

By the first decades of the 20th century, many prominent researchers held that the circumpolar cultural affinities were so widespread and archaic in character that they must derive from a single Stone Age source (*e.g.* Brøgger 1909; Hallowell 1926: 161–162). From this intellectual background, the Norwegian archaeologist Gutorm Gjessing (1944) fashioned his theory of a 'circumpolar Stone Age', a relatively uniform band of hunter-gatherer cultures that would have inhabited the entire circumpolar zone during the later Stone Age. Various artefact types, such as curved-backed adzes, comb-stamped pottery vessels and tanged spear- and arrowheads made of slate played the main part in his analysis. He did make a few short references to rock art and noted, for example, that the convention of depicting a 'life-line' in the body of large mammals ranged from western Norway through Siberia to the Americas (Gjessing 1944: 61), but overall rock art played a small part in his analysis – no doubt because so little of it was then known from the vast expanses of Siberia, Alaska or Canada.

After Gjessing, interest in circumpolar archaeology waned for several decades, but there are signs of a rebirth (Westerdahl 2010) and archaeologists are once again addressing questions of wide geographical perspective, such as the dispersal of pottery among hunter-gatherers in northern Eurasia (Jordan and Zvelebil 2009) or the use of slate artefacts in the circumpolar zone (Osborn 2004). Rock art of the circumpolar zone has not yet been subjected to systematic study, but there are clear commonalities in style and the choice of depicted motifs. Even though it is quite rare, with just

individual cases occurring here and there, the sun ship is one of the motifs with a claim to having a circumpolar distribution.

Ship and sun imagery in the circumpolar north: a review

In the following, I will proceed to a compact review of sun ships and related figures to the east of Sweden and all the way to Ontario (Fig. 6.4). However, before looking at the sun ships *per se*, it needs to be emphasised that the boat figures of the circumpolar region are in some respects distinct from all other simplified boat figures in world rock art. The sickle-like motif, with little strokes representing the crew, is quite simple and as such could have arisen independently in different parts of the world. For example, trance-induced

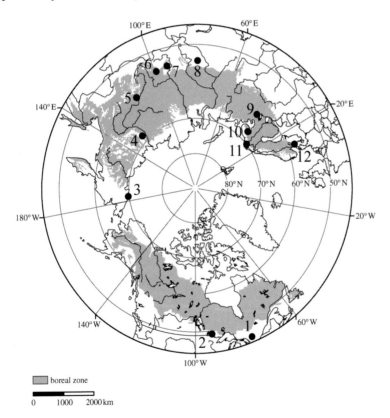

Figure 6.4. A map of the northern circumpolar area, showing the locations of select rock art sites mentioned in the text: 1) Peterborough petroglyphs, 2) Cuttle Lake, 3) Pegtymel, 4) Olguidakh, 5) Olekma, 6) Shishkino, 7) Shalabolino, 8) Tomskaya pisanicha, 9) Lake Onega, 10) Kanozero, 11) Alta, 12) Tanum.

drawings recorded by Reichel-Dolmatoff (1978) in the Columbian Amazon feature boats with a curved line and crew-strokes. Similarly, Ballard *et al.* (2003) compared boat symbolism in prehistoric Scandinavia and south-east Asia, which features many shared elements, but is likely to have arisen independently.

However, in the northern circumpolar zone, images of boats occur as an integral element in a rock art repertoire which features a range of other recurring motifs – such as large cervids, X-ray style, horned anthropomorphs and solar symbols – as well as shared elements of style, location, and technique. Moreover, these northern boats often feature an animal head (typically cervid) in the prow – a feature that is repeated in a strikingly similar manner from western Norway all the way to Chukotka in easternmost Siberia. Many South Scandinavian ship images share this feature, showing what seems to be a horse head in the prow and strongly suggesting that they are part of the same tradition. As noted above, the animal heads appear to be present even at the other extreme of the region – in Peterborough, Ontario. All of this art thus ought to be viewed as belonging in some sense to a shared circumpolar tradition (*cf.* Kulikova 2014).

In early comparative studies of northern rock art, an effort was sometimes made to identify the 'source' of the phenomenon in a particular geographic region and time period (*e.g.* Brøgger 1909), but I have decided here to bypass the issue of chronology simply because there are too few reliable datings available especially for the Siberian sites. For example, the site of Shishkino is often claimed to date as far back as the Palaeolithic (Okladnikov 1977; Devlet and Devlet 2005: 71), but Bednarik (1995) finds little evidence of this and suggests that it may mostly date from the historical period. The same is true of Tomskaya Pisanicha, which is claimed to have emerged around 4000 BC and continued until the Bronze Age, but all of the would-be datings presented are based on stylistic reasoning. There is thus little point in trying to address the 'origin' of the sun-ship motif or other similar culture-historical problems.

Eastern Fennoscandia

Turning to the sun ships of northern rock art, it has to be admitted that the closest actual combinations of a ship and a solar symbol are at a fair distance from Scandinavia, but a few less clear ones may be mentioned

from eastern Fennoscandia. A sun-ship was recorded by Pekka Sarvas (1969, group *n*) at the Finnish rock painting site of Astuvansalmi, giving him reason to date parts of it to the Bronze Age, but later writers (*e.g.* Kivikäs 1995) have dismissed the wheel-cross in the boat as a flaw in the tracing. This is probably the case, as there are no clear depictions of the sun elsewhere either in Finnish or Swedish red ochre rock paintings, and digitally manipulated photographs of the Astuvansalmi ship fail to reveal an unambiguous wheel-cross (Kivikäs 1999: 46).

The Neolithic carvings of Lake Onega (north-western Russia) deserve a brief mention because, as noted above, already Hallström (1960) found them relevant to interpreting South Scandinavian rock art. Even if no unambiguous solar vessels can be identified at Lake Onega, elk-headed boats and solar (and lunar) symbolism are among the most common motifs in the rock art repertoire. Interestingly, the image of the sun is sometimes combined with an elk or a swan, as in the case of an elk at Peri Nos that has a 'globular device' rising from its back (Zhulnikov 2006, fig. 59). Also, in a few cases boats appear to be associated with the sun (Fig. 6.5). At the carving locale of Karetskyi Nos, the largest boat (in terms of crew-lines) of the entire Onega site is a possible candidate, as two of its altogether 21 'crew-lines' are in joined so that they form an arc in the central part of the boat. Ravdonikas (1936) thought it might represent a sail, but similar figures have sometimes been interpreted as solar vessels in Scandinavia (*e.g.* Kristiansen 2010, fig. 6.9). At the little island of Bolshoy Guri, Lake Onega, an elk-headed boat is depicted with a solar symbol 'hovering' just above it, and the prow of yet another elk-headed boat is depicted touching a large solar symbol on a newly discovered carved block from Peri Nos (Zhulnikov 2010). The situation with the large carving site of Kanozero on the Kola Peninsula is similar to that of Lake Onega: solar symbols (circular devices, often with spokes) are a common motif, as are elk-headed boats, but they are never combined into a single image (Kolpakov and Shumkin 2012).

Western Siberia

Formozov (1966) mentions a solar vessel depicted in the rock paintings of the Urals, but I was unable to confirm this claim in the published literature

Figure 6.5. Examples of the sun–boat–elk/deer theme in north Eurasian rock art: a) an elk-boat touching a large solar symbol from the Peri Nos panel, Lake Onega (according to Zhulnikov 2010); b) many-spoked wheels, elk, anthropomorphs and an elk-boat (upper right corner) from the Yelovyi-3 panel, Lake Kanozro (according to Kolpakov & Shumkin 2012); c) a boat with globular devices from Tomskaya Pisanicha (according to Okladnikov & Martynov 1972); d) elk with x-ray features, a circular design, and an elk-boat from Tomskaya Pisanicha (according to Okladnikov & Martynov 1972); e) two boat figures with globular extensions from Shalabolino (according to Pyatkin & Martynov 1985); f) wild reindeer, an elk-headed boat and a circular figure from Pegtymel (according to Devlet & Devlet 2005); a boat with circular features from Olguidakh (from Kulikova 2014). Different scales. Cf. also Fig. 6.6.

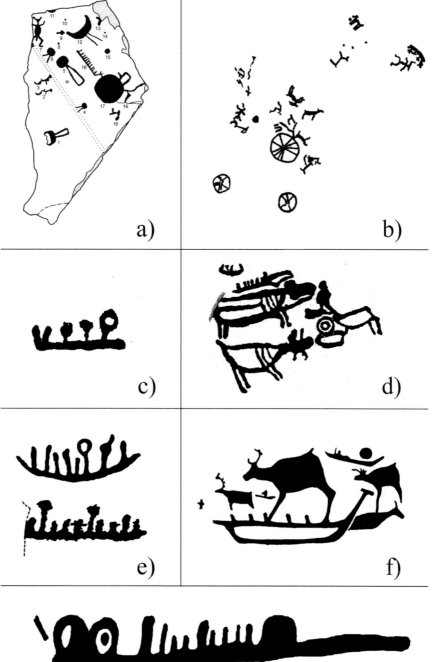

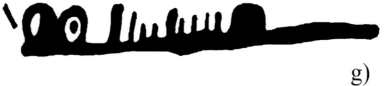

(*e.g.* Chernechov 1964; Shirokov *et al.* 2000; 2005), even if solar symbolism, a few ring-crosses and at least one elk-headed boat are certainly present. However, at the site of Tomskaya Pisanicha we finally find what appear to be a few genuine solar vessels. With around 280 carved figures, the site located on the River Tom (a tributary of the Ob) in western Siberia is one of the most important Siberian rock art sites, in terms of its number of images and its long history of research (O[k]ladnikov and Martynov 1972). In spite of the great distance, many of the motifs show clear affinities with Fennoscandian hunter-gatherer rock art. There are, for example, large boat figures with numerous crew-lines, and some of them feature an elk head in the prow. Elk are represented in X-ray style, human figures sometimes have horns on their heads, and humans and elk are sometimes combined into scenes that are highly similar to Fennoscandian rock art (*cf.* Lahelma 2007, fig. 5). Solar symbolism is represented by various circular motifs, including many-spoked wheels resembling those of Kanozero, as well as other types of circles. Given the presence of such wheels and circles at the site, the figures of boats with globular devices attached to them can reasonably be connected to solar symbolism.

Eastern Siberia

Further to the east, the site of Shalabolino in the Krasnoyarsk region features many typically circumpolar boat images, some of them equipped with exactly the same type of globular extensions as the ones at Tomskaya Pisanicha (Devlet and Devlet 2005: 216). Some of the boats, on the other hand, feature an elk head in the prow and horned anthropomorphs as part of the crew, bearing evidence of similar underlying themes to those found at several Fennoscandian rock sites. The images are located on a massive cliff rising on the bank of the River Tubes (a tributary of the Yenisei), and show both carvings and paintings, ranging from Stone Age imagery (boats, elk, aurochs, *etc.*) to battle scenes of the Iron Age and Medieval inscriptions (Pyatkin and Martynov 1985). This type of continuity from the Stone Age to the ethnographic present seems to be commonplace at the Siberian sites, and offers a promise of a 'direct historical' reading of the images – including any possible solar ships.

At the site of Shishkino on the Upper Lena River more than 2700 images (both carvings and paintings) have been made on dozens of different panels, showing for example aurochs, elk and deer in X-ray style, and boats occupied by horned anthropomorphs (Okladnikov 1977). In one of the panels there is a ring-cross above a wavy line that could be interpreted as a boat. This 'boat' differs from the other boats at the site in that the 'crew' is not depicted, making its identification uncertain, but the composition as a whole bears a resemblance to two similar figures cited by Devlet and Devlet (2005: 217) as possible evidence of 'Mediterranean influence' in north-eastern Eurasia. That depicted at Smolyanka, near Ust-Kamenogorsk in eastern Kazakhstan, is particularly similar. The presence of a circle-cross at these sites is noteworthy.

One of the most interesting cases of possible Siberian sun ships comes from the carved site of River Olekma (Okladnikov and Mazin 1976), where a remarkable scene shows elk, boats, human figures and solar symbols (Fig. 6.6). The boats give the impression of 'flying' among the heavenly

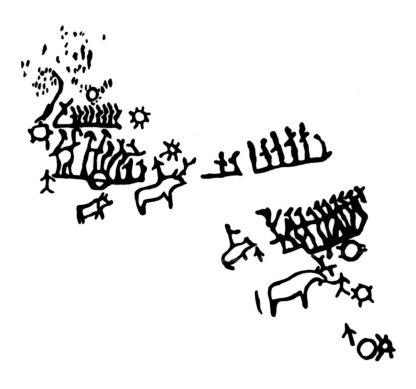

Figure 6.6. The rock painting of River Olekma, Eastern Siberia, showing boats, elk, anthropomorphs and solar symbols with projecting rays (according to Okladnikov & Mazin 1976).

bodies, and at least one boat is integrated with a circular figure. At the Olguidakh site (Kulikova 2014: 61), a boat figure has circular features among the more usual crew-lines. Finally, the rock art of Chukhotka (River Pegtymel) in the extreme east of Siberia includes a carved panel that seems significant to the present theme, because in it a 'classic' north Eurasian elk-headed boat is joined by several deer, a smaller boat and a circular figure (Devlet and Devlet 2005, fig. 4).

Northernmost North America

On the opposite side of the Bering Strait, the red ochre rock paintings of Alaska exhibit images of boats (de Laguna 1933) that are highly similar to north Eurasian ones, although they do not feature an animal head in the prow. Representations of the sun (*e.g.* at the Halleck Harbour site) are also present, but these two motifs do not seem to be combined into a single image. The same is essentially true of British Columbia, where boats of the same type are commonly depicted in red ochre pictographs (York *et al.* 1993) but not in petroglyphs, which differ stylistically from the paintings (Lundy 1974). The latter, it may be noted, provide a different type of evidence for inter-continental contacts in the form of elaborate human faces or 'masks' that have close parallels in the Amur region of the Russian Far East and elsewhere in northern Asia (Song 1998; Devlet 2014).

Still further east, the rock paintings of the Canadian Shield (Dewdney and Kidd 1967; Rajnovich 1994) are stylistically very similar to north Eurasian pictographs and feature the boat or canoe as one of the most common motifs, but as with Alaska and British Columbia, they never seem to occur in unambiguous association with solar symbols. Solar symbols in general are quite rare in Shield rock art, but seem to occur at sites like Cuttle Lake (Fig. 6.7) and Fairy Point in Ontario, and in some cases 'solar-headed' humans reminiscent of Peterborough are depicted (Dewdney and Kidd 1967: 89). Thus, even though both Peterborough carvings and the rock paintings of the Canadian Shield can be associated with Algonquian-speaking peoples, the solar boats of Peterborough discussed above remain, at least so far, a singular example.

This lack of exact parallels for the Peterborough boats in North America evidently puzzled Joan and Romas Vastokas, and has contributed to the

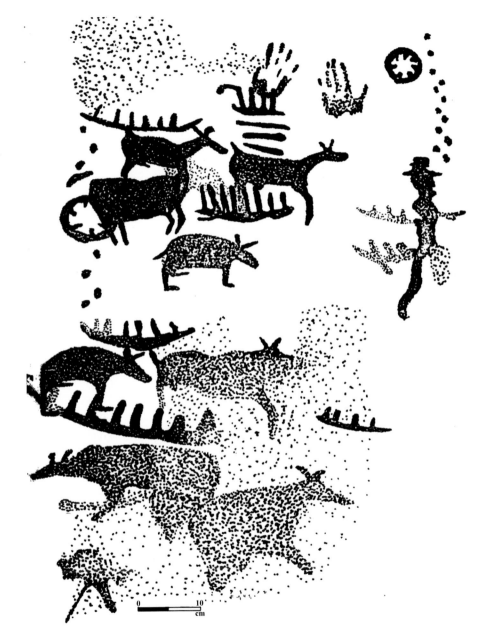

Figure 6.7. The rock painting of Cuttle Lake, western Ontario, Canada, showing boats, handprint, moose and possible solar symbols (according to Rajnovich 1980: 7).

eccentric theories surrounding the site. Yet, they demonstrate forcibly that Peterborough as a whole is not isolated: most of its motifs find clear parallels and indeed explanations in Algonquian materials such as Canadian Shield rock paintings, Ojibwa birch bark scrolls (Dewdney 1975) and traditional mythology. It is worth noting that, according to some Algonquian mythological sources, the creator-being *Kitchi-Manitou* 'lives in a golden boat, which we call the sun' (Vastokas and Vastokas 1973: 127). Also, some images of boats in Shield rock paintings feature human figures with uplifted arms, which according to some native informants represent shamans on a ritual voyage to the sky. On a general level, then, there appears to be an association between shamanism, boats and the sun in the Canadian Shield – even if its only clear manifestation in rock art is at Peterborough, Ontario.

Discussion

The evidence presented above is certainly sporadic and difficult to interpret. To begin with, I have not attempted to suggest an exact definition to what constitutes a 'sun ship'. I have generally taken it to mean an image where a physical connection – such as a line – exists between the boat and the solar device (which may be a wheel-cross, a plain circle, or a circle from which rays emanate). However, some writers (*e.g.* Kristiansen 2010) treat the category more loosely, and include images where the two motifs are spatially associated with each other. If images of sun ships are on some level linked to the celestial journeys of the shaman, scenes where a solar symbol is hovering over, adjacent to or otherwise associated with a boat may well belong to the same category. For this reason, I have included in my discussion also some sites and areas (such as Lake Onega), where the physical connection does not exist but the motifs are to some extent associated with each other.

Admittedly, there are huge geographic gaps in the distribution map, but this may in part be due to the fact that in most of European Russia between Lake Onega and the Ural Mountains, the bedrock is covered by loose sediments. The same goes for vast parts of Siberia – aside from perishable materials such as bone or wood, there is simply nowhere to carve or paint.

And of course, much of the circumpolar taiga is remote and difficult to access, and therefore only sporadic surveys have been carried out. Even so, the examples listed above are not mere curiosities, because they arise from a shared rock art repertoire that in some respects spans the entire circumpolar region. By contrast, there are to my knowledge no solar boats or indeed boats of any kind in Atlantic rock art (*e.g.* Bradley 1997), the rock art of the Alpine region (Arca and Fossati 1995), or anywhere else along the long north–south axis separating southern Scandinavia from Egypt. And although the solar barks of Ancient Egypt may seem thematically related to the South Scandinavian ones, they represent a completely different iconographic tradition. As noted in the introduction, the aim of this paper is not to dismiss a possible Egyptian connection, but I do believe that the Scandinavian sun-ship images arise from what is fundamentally a circumpolar iconographic tradition. They may have absorbed features from the Mediterranean world, and perhaps received new meanings and interpretations related to agricultural practices, but they are still essentially 'at home' in the north. This is nowhere more evident than at Alta, northern Norway, where the gradual transition from Stone Age elk-headed boats towards large ships of the South Scandinavian type can be seen within the carving sequence of a single rock art site (Helskog 2014a).

Likewise, the wheel-cross is not just a South Scandinavian and/ or Mediterranean symbol, but is found in a wide geographic region. Vastokas and Vastokas (1973: 61) claim that '[i]n agricultural societies the sun is most often rendered separately and abstractedly, rarely with naturalistic, projecting light rays. The [realistic] solar figure, therefore, is essentially a Siberian, North Pacific, and American Indian motif.' Although a sweeping generalisation, the observation holds some truth in the northern circumpolar region, where the sun is often represented with projecting rays. However, as noted already by Gjessing (1978), images of the sun as a four-spoked wheel do seem to occur throughout the region, even though they are not very common. At several sites, including Kanozero (Kolpakov and Shumkin 2012) and Tomskaya Pisanicha (Okladnikov and Martynov 1972), many-spoked wheels possibly representing the sun are depicted.

Sometimes, as at the rock paintings of Sinsk (Rozwadowski 2004: 102) near Yakutsk in eastern Siberia, it is clear that the 'wheel cross' in fact represents a shaman drum (see also Devlet 2001). But then, the shaman

drum also carries solar symbolism, as exemplified by Sámi drums that often show *Beaivi* or the divine sun in the centre, represented by a cross or a rhomboid with four rays that spread to the sides (Manker 1950). When the drum, moreover, can be understood as a 'boat' (Lahelma 2007: 127–128), we perhaps begin to get a sense of the logic behind the solar boat in a northern shamanistic context. It can be interpreted as arising from the same complex web of semantic associations that has given rise to such fantastic scenes as 'boat-antlered elk', 'elk-boats with legs', and humans riding elk, occasionally portrayed in northern hunter-gatherer rock art (Lahelma 2007).

Appearances can be deceptive and the temptation to assume direct contacts or diffusion based on outward similarity can be hard to resist. The history of rock art research certainly warns against careless inter-regional comparison. Perhaps the most notorious example of this is the 'White Lady of Brandberg', a San Bushman painting falsely identified by Abbé Breuil (1948) as evidence of Bronze Age Cretan or Egyptian immigrants in Namibia, but there are many others. Nielsen *et al.* (2009) examined similar claims based upon superficial similarity between the so-called 'maypole' depicted at the Swedish rock carving site of Gerum and certain scenes in Mesoamerican art. The Gerum scene (see also Almgren 1927; Fredell 2003; Ling 2008) appears to consist of the following elements, all of which correspond precisely to the Mexican 'volador' ritual which goes back to pre-Columbian times:

(1) a high pole, topped by a flat platform;
(2) a person standing or dancing on top of the platform;
(3) ropes reaching out from the platform, from which humans and/or animals are hanging and swinging around the pole.

Interestingly, the pole stands on the hull of a boat figure, and may thus be related to other 'devices' and figures associated with boats, such as the solar symbols, voltigeurs, men flaunting axes, etc. Although its naval association makes the Gerum maypole somewhat ambiguous, the similarity to Mesoamerican practices is indeed quite astonishing, and it is no wonder some have suggested that it provides evidence of transatlantic contact in the distant past. But as tempting as it would be to follow that line of argument, it is probably true that such similarities

> [do not] indicate either historical diffusion, the existence of transcendent archetypes, or orthogenetic stages of cultural

development. Rather, they may simply be the result of convergence in the sense of being cultural behaviour that evolves as a consequence of selective pressure on human ideas and behaviour that produce similar – though not identical – phenomena (Nielsen *et al.* 2009: 78).

This is likely to be the case with Gerum, not least because of the totally different cultural and environmental settings of Sweden and Mesoamerica, but the circumpolar region with its shared myths, ecology, material culture, and concrete evidence for long-distance contacts is a completely different story. An often-cited example of the latter is the discovery in Finland of artefacts like sled runners or spoons made of Siberian pine (*Pinus cembra* subsp. *sibirica*), a tree that only grows to the east of the Ural Mountains, about 2000 km from Finland (*e.g.* Carpelan 1977). Such evidence makes it perhaps a little bit easier to accept that places like Peterborough and Bohuslän, although separated by a staggering 14,000 kilometres (if you cross the Bering Strait), may in some sense have been part of the same exchange network of artefacts, images and ideas. They are located at the very extremes of this exchange area, but the vast distance between them is sparsely dotted with rock art evidence of contact and shared cosmological concepts – including, it seems, some representations of sun ships.

Conclusions

This paper has two main goals. On one hand, it is a simple review of published data on the geographic distribution of possible sun-ship imagery in the northern circumpolar region. Boats and solar symbols, either combined into a single image or spatially associated, were found to pop up in rock art throughout the whole vast region. That this is not a mere curiosity or coincidence is shown by other striking similarities in rock art, material culture and cosmological notions of the historical period. Some of this data is rather difficult to access, being found in obscure publications, many of them in Russian. As such, I hope the review is of some use, even if it is without doubt very incomplete and should be seen as an initial and rather feeble attempt to view northern rock art in a wider, inter-regional framework.

It has to be emphasised that there is nothing new about this approach, even though in the West rock art research has traditionally been narrowly focused on a specific region or tradition, such as South Scandinavian or Arctic rock art. In Russia (and before that, the Soviet Union), by contrast, wide geographic comparisons have been common – as exemplified by the book *Mify v kamne* ('Myths on the rock') by Ekaterina and Marianna Devlet (2005), an important work to which this paper is greatly indebted. While some of the culture-historical conclusions drawn in Russian comparative research may be questioned, to me the wide perspective seems essential to understanding the nature of northern rock art, which clearly bears evidence of a shared circumpolar background.

The second goal logically arises from the wide perspective adopted. My aim is to view South Scandinavian rock art from a somewhat unusual angle: one that emphasises its fundamentally *northern* cultural context, even if it acknowledges the strong influences from the Mediterranean world. From this northern point of view, the strict division between South Scandinavian farming rock art and northern hunter-gatherer rock art seems rather bizarre, as the two traditions overlap both temporally and geographically. When farming and metal-trading began in Scandinavia, rock art had been produced in the region for thousands of years. South Scandinavian rock art developed against this background. Like all expressions of mythology and worldview, it is layered, featuring both ancient and more recent elements – the former, I argue, having roots in the circumpolar north. If studies of Viking Age religion (*e.g.* Price 2002) have identified a circumpolar element underlying Scandinavian Iron Age practices, we should certainly expect to encounter it in the Bronze Age as well.

It is in fact difficult to escape the thought that the whole north–south dichotomy in Scandinavian rock art may in part be politically motivated and to some extent even racist. Ever since the first serious studies of South Scandinavian rock art, it has been viewed as 'our' tradition: Holmberg (1848) thought it portrayed Viking voyages, Almgren (1927) linked it to reflections of Classical/Mediterranean civilizations in the north, and Kristiansen and Larsson (2005) see it as representing Indo-European mythology. This overall 'Aryan' association of the art was not missed by Nazi ideologists, who took a keen interest in South Scandinavian rock art, arranged expeditions to Bohuslän, and viewed its rock art as evidence of the superiority of the

Nordic race (Pringle 2006). By contrast, northern hunter-gatherer rock art has always been associated with the primitive Other, usually identified – either explicitly or implicitly – as the Sámi (*e.g.* Olsson 1898). I suspect these associations are partly to blame for the emergence of two distinct research traditions that have sometimes been oblivious to each other, and which have fostered the notion of northern and southern rock art as two essentially independent phenomena. But whatever the history behind the divide, it is obvious to me that scholars working within both traditions will benefit from increased communication and a better awareness of each other's data.

Notes

1. It needs to be pointed out, though, that Kaul (2004) does not agree with some of the interpretations presented by Kristiansen and Larsson.
2. Formozov's examples included some sites of interest in Khakassia, Kazakhstan and Azerbaijan. I have decided to exclude them from this discussion, because their cultural context, style and natural setting are quite far removed from the rock art of the circumpolar taiga and tundra. However, the site of Gobustan in Azerbaijan should be mentioned here, as the sun ships depicted there have been compared to the Scandinavian ones – a link originally proposed by the Norwegian explorer Thor Heyerdahl. For a review of the discussion on its possible relation to Scandinavia, see Helskog 2014b.
3. An umbrella term for the Ojibwa, Odawa and Algonquin nations.
4. Here it may be noted that the most striking New World parallels to North Eurasian phenomena, whether related to material culture (snow shoes, pit-houses, pottery, red ochre graves, rock art) or mythology (bear cult, thunderbirds, shamanism), often appear to be found among the Algonquian-speaking peoples such as the Ojibwa. However, I am not aware of any serious attempts to address this fascinating parallelism.
5. Like the Anishinaabe, also an Algonquian-speaking people.

References

Almgren, O. 1927. *Hällristningar och kultbruk: Bidrag till belysning av de nordiska bronsåldersristningarnas innebörd.* Kungliga Vitterhets Historie och Antikvitets Akademien. Stockholm.

Arca, A. and A. Fossati (eds) 1995. *Sui sentieri dell'arte rupestre: Le rocce incise delle Alpi: Storia, ricerche, escursioni.* Edizioni CDA. Torino.

Arnzen, J. 2016. Sandvika in Northern Norway: The Northernmost 'Bronze Age' Settlement in Scandinavia. *Fennoscandia Archaeologica* XXXII: 3–34.

Ballard, C., R. Bradley, L. Nordenborg Myhre and M. Wilson 2003. The Ship as a Symbol in the Prehistory of Scandinavia and Southeast Asia. *World Archaeology* 35(3): 385–403.

Bednarik, R. 1995. Rock Art and Conservation in the Upper Lena Basin, Siberia. *Conservation and Management of Archaeological Sites* 1: 117–26.

Berezkin, Y. 2007. 'Earth-diver' and 'Emergence from under the Earth': Cosmogonic Tales as Evidence in Favor of the Heterogenic Origins of the American Indians. *Archaeology, Ethnology and Anthropology of Eurasia* 32(1): 110–123.

Berezkin, Y. 2010. The Pleiades as Openings, the Milky Way as the Path of Birds, and The Girl On the Moon: Cultural Links across Northern Eurasia. *Folklore: Electronic Journal of Folklore* 44: 7–34.

Bradley, R. 1997. *Rock Art and the Prehistory of Atlantic Europe.* Routledge. London.

Breuil, H. 1948. The White Lady of the Brandberg: Her Companions and Her Guards. *South African Archaeological Bulletin* III(9): 1–13.

Brøgger, A. W. 1909. *Den arktiske steinalder i Norge.* J. Dybwad. Christiania.

Carpelan, C. 1977. Älg- och björnhuvudföremål från Europas nordliga delar. *Finskt Museum* 85: 5–67.

Chernechov, V. N. 1964. *Naskalnye izobrazheniya Urala.* Svod Arkheologicheskikh Istochnikov. Moskva.

de Laguna, F. 1933. Peintures rupestres eskimo. *Journal de la Société des Américanistes* 25(1): 17–30.

Devlet, E. 2001. Rock Art and the Material Culture of Siberian and Central Asian Shamanism. *The Archaeology of Shamanism* (N. Price, ed.): 43–55. Routledge. London.

Devlet, E. 2014. Transokeanskie analogii antropomorfnym izobrazheniyam Sibiri i Dalnego Vostoka. *Arkhaicheskoe i traditsionnoe iskusstvo: problemy nauchnoy i khudozhestvennoy interpretatsii* (kollektiv avtorov eds): 26–33. Izdatel'stvo instituta arkheologii i etnografii SO RAN. Novosibirsk.

Devlet, E. and Devlet, M. 2005. *Mify v kamne: Mir naskalnogo iskusstvo Rossii.* Aleteia. Moscow.

Dewdney, S. and Kidd, K. E. 1967. *Indian Rock Paintings of the Great Lakes.* University of Toronto Press. Toronto.

Dewdney, S. 1975. *The Sacred Scrolls of the Southern Ojibway.* University of Toronto Press. Toronto.

Dikov, N. N. 1999. *Mysteries in the Rocks of Ancient Chukotka: Petroglyphs of Pegtymel* (transl. R. L. Bland). U.S. Dept. of the Interior, National Park Service. Anchorage.

Ekholm, G. 1916. De skandinaviska hällristningarna och deras betydelse. *Ymer* 1916: 275–308.

Eliade, M. 1964. *Shamanism: Archaic Techniques of Ecstasy.* Princeton University Press. Princeton, NJ.

Formozov, A. A. 1966. *Pamyatniki pervobytnogo iskusstva na territorii SSSR.* Nauka. Moscow.

Formozov, A. A. 1969. *Ocherki po pervobytnomu iskusstvu: naskalnye izobrazheniya i kamennye izvaniya epokhy kamnya i bronzy na territorii SSSR.* Nauka. Moscow.

Fredell, Å. 2003. *Bildbroar: Figurativ bildkommunikation av ideologi och kosmologi under sydskandinavisk bronsålder och förromersk järnålder.* Institutionen för arkeologi. Göteborgs universitet. Gothenburg.

Gjessing, G. 1944. Circumpolar Stone Age. *Acta Arctica* II: 19–70.

Gjessing, G. 1978. Rock-pictures in Northern Fenno-Scandia and their Eastern Affinities. *Acts of the International Symposium on Rock Art at Hankø* (S. Marstrander, ed.): 14–30. Instituttet for sammenlignende kulturforskning. Oslo.

Hallowell, A. I. 1926. Bear Ceremonialism in the Northern Hemisphere. *American Anthropologist* 28(1): 1–175.

Hallström, G. 1960. *Monumental Art of Northern Sweden from the Stone Age.* Almqvist & Wiksell. Stockholm.

Hatt, G. 1916. Moccasins and their Relation to Arctic Footwear. *Memoirs of the American Anthropological Association* III: 3. The New Era Printing Company. Lancaster, PA.

Helskog, K. 2012. Bears and Meanings among Hunter-fisher-gatherers in Northern Fennoscandia 9000–2500 BC. *Cambridge Archaeological Journal* 22(2): 209–36.

Helskog, K. 2014a. *Communicating with the World of Beings: The World Heritage Rock Art Sites in Alta, Arctic Norway.* Oxbow Books. Oxford.

Helskog, K. 2014b. Petroglyphs of Boats as Evidence of Contact between the Caspian Sea and Scandinavia. *Thor Heyerdahl's Search for Odin: Ancient Links between Azerbaijan and Scandinavia?* (V. Roggen, ed.): 202–219. Novus AS. Oslo.

Holmberg, A. E. 1848. *Skandinaviens hällristningar.* P.G. Berg. Stockholm.

Hood, B. 2009. The Circumpolar Zone. *The Oxford Handbook of Archaeology* (B. Cunliffe, C. Gosden and R. A. Joyce, eds): 812–840. Oxford University Press. Oxford.

Jordan, P. and M. Zvelebil (eds) 2009. *Ceramics before Farming: The Dispersal of Pottery among Prehistoric Eurasian Hunter-gatherers.* Left Coast Press. Walnut Creek, CA.

Kaul, F. 1998. *Ships on Bronzes: A Study in Bronze Age Religion and Iconography.* National Museum. Copenhagen.

Kaul, F. 2004. *Bronzealderens religion: Studier af den nordiske bronzealders ikonografi.* Det kongelige nordiske oldskriftsselskab. Copenhagen.

Kelley, D. H. 1994. The Identification of Proto-Tifinagh script at Peterborough, Ontario. *New England Antiquities Research Association Journal* (NEARA) 28(3/4), 86–98.

Kivikäs, P. 1995. *Kalliomaalaukset - muinainen kuva-arkisto.* Atena. Jyväskylä.

Kivikäs, P. 1999. Suursaimaan, Puulan ja Muinais-Päijänteen alueen kalliomaalausten sijantipaikat ja korkeudet. *Kalliomaalausraportteja 1/1999,* 7–111. Kopijyvä kustannus. Jyväskylä.

Kolpakov, E. M. and Shumkin, V. Ya. 2012. *Petroglify Kanozera.* Iskusstvo Rossii. St Petersburg.

Kristiansen, K. 2010. Rock Art and Religion: The Sun Journey in Indo-European Mythology and Bronze Age Rock Art. *Representations and Communications: Creating an Archaeological Matrix of Late Prehistoric Rock Art* (Å. Fredell, K. Kristiansen and F. Criado Boado, eds): 93–115.

Kristiansen, K. and T. B. Larsson 2005. *The Rise of Bronze Age Society: Travels, Transmissions and Transformations.* Cambridge University Press. Cambridge.

Kulikova, A. S. 2014. Izobrazheniya lodok severnoi Evrazii. *Vestnik Kemerovskogo Gosudarstvennogo Universiteta* 58 (2): 58–69.

Lahelma, A. 2007. 'On the Back of a Blue Elk': Recent Ethnohistorical Sources and 'Ambiguous' Stone Age Rock Art at Pyhänpää, Central Finland. *Norwegian Archaeological Review* 40(2): 113–37.

Ling, J. 2008. *Elevated Rock Art: Towards a Maritime Understanding of Rock Art in Northern Bohuslän, Sweden.* Göteborgs universitet. Gothenburg.

Lundy, D. M. 1974. The Rock Art of the Northwest Coast. Master's thesis, Department of Archaeology, Simon Fraser University (BC, Canada).

Manker, E. 1965. *Nåidkonst: Trolltrummans bildvärld.* LT. Stockholm.

McNeil, L. D. 2005. Seasonal Revival Rites and Rock Art of the Minusinsk Basin Colonisers (Southern Siberia). *Rock Art Research* 22(1): 3–16.

Nielsen, J., T. Bjørnvig and T. Sellner Reunert 2009. Seductive Similarities: A Comment on Gerum, Trans-Atlantic Contacts, and Analogies. *Adoranten* 2009: 71–80.

Okladnikov, A. P. 1977. *Petroglify verkhney Leny.* Nauka. Leningrad.

Okladnikov, A. P. and A. I. Martynov. 1972. *Sokrovishcha tomskikh pisanits: Naskalnye risunki epokhi neolita i bronzy.* Izadel'testvo Iskusstvo. Moscow.

Okladnikov, A. P. and A. I. Mazin 1976. *Pisanitsy reki Olekmy i Verkhnego Priamuria.* Nauka. Novosibirsk.

Olsson, P. 1898. Om hällmålningar och hällristningar i Jämtland. *Jämtlands läns fornminnesförenings tidskrift* 1: 54–57.

Osborn, A. J. 2004. Poison Hunting Strategies and the Organization of Technology in the Circumpolar Region. *Processual Archaeology: Exploring Analytical Strategies, Frames of Reference, and Culture Process* (A. L. Johnson, ed.): 134–193. Praeger. Westport.

Price, N. 2002. *The Viking Way: Religion and War in Late Iron Age Scandinavia.* Department of Archaeology and Ancient History. University of Uppsala. Uppsala.

Pringle, H. 2006. *The Master Plan: Himmler's Scholars and the Holocaust.* Fourth Estate. London.

Pyatkin, B. N. and A. I. Martynov 1985. *Petroglify iz Shalabolino.* Krasnoyarsk University Press. Krasnoyarsk.

Rajnovich, G. 1980. Paired morphs at Cuttle Lake in northwestern Ontario. Arch Notes (Jan/Feb 1980): 6–9. Ontario Archaeological Society, Toronto.

Rajnovich, G. 1994. *Reading Rock Art: Interpreting the Indian Rock Paintings of the Canadian Shield.* Natural Heritage Books. Toronto.

Ravdonikas, V. 1936. *Naskalnye izobrazheniya Onezhskogo ozera i Belogo morya.* Izdatel'stvo Akademii Nauk. Moscow.

Reichel-Dolmatoff, G. 1978. *Beyond the Milky Way: Hallucinatory Imagery of the Tukano Indians.* UCLA Latin America Center. Los Angeles, CA.

Rozwadowski, A. 2014. In Search of Shamanic Themes in Eastern Siberian Rock Art (Sakha/Yakutia Republic). *Shaman* 22(1/2): 97–118.

Sarvas, P. 1969. Die Felsmalerei von Astuvansalmi. *Suomen Museo* 76: 5–33.

Schlesier, K. 1993. *The Wolves of Heaven: Cheyenne Shamanism, Ceremonies, and Prehistoric Origins.* University of Oklahoma Press. Norman, OK.

Shirokov, V. N., Chairikin, S. E. and Shirokova, N. A. 2005. *Uralskie pisanitsy: Reka Tagil.* Bank kulturnoi informatzii. Ekaterinburg.

Shirokov, V. N., Chairikin, S. E. and Chemyakin, P. Yu. 2000. *Uralskie pisanitsy: Reka Neiva.* Bank kulturnoi informatzii. Ekaterinburg.

Siikala, A.-L. and Hoppál, M. 1992. *Studies on Shamanism.* Akadémiai Kiadó and The Finnish Anthropological Society. Budapest/Helsinki.

Siikala, A.-L. 2002. *Mythic Images and Shamanism: A Perspective on Kalevala Poetry*. Suomalainen tiedeakatemia. Helsinki.

Song, Y. 1998. Prehistoric Human-Face Petroglyphs of the North Pacific Region. *Arctic Studies Center Newsletter* 6, Supplement 1: 1–4.

Vastokas, J. M. and Vastokas, R. K. 1973. *Sacred Art of the Algonkians: A Study of the Peterborough Petroglyphs*. Mansard Press. Peterborough, Ontario.

Vastokas, J. M. 2004. The Peterborough Petroglyphs: Native or Norse? *The Rock Art of Eastern North America: Capturing Images and Insight* (C. Diaz-Granados and J. R. Duncan, eds): 277–89. University of Alabama Press. Tuscaloosa, AL.

Wehlin, J. 2014. Navigatören, skeppet och solen: Ett maritimt perspektiv på bronsålderns skepps- och solsymbolism. *I skuggan av solen: Nya perspektiv på bronsåldersarkeologier och bronsålderns arkeologiska källmaterial* (M. Ljunge and A. Röst, eds): 87–115. Institutionen för arkeologi och antikens kultur. Stockholm.

Westerdahl, C. (ed.) 2010. A Circumpolar Reappraisal: The Legacy of Gutorm Gjessing (1906–1979). *BAR International Series* 2154. Archaeopress. Oxford.

Winter, L. 2002. Relationen mellan Medelhavsområdets och Sydskandinaviens bildvärldar. *Bilder av bronsåldern* (J. Goldhahn, ed.): 201–222. Almqvist & Wiksell International. Stockholm.

York, A., Daly, R. and Arnett, C. 1993. *They Write Their Dreams on the Rock Forever: Rock Writings in the Stein River Valley of British Columbia*. Talonbooks. Vancouver.

Zawadzka, D. 2011. Kinoomaagewaabkong/Peterborough Petroglyphs: Confining and Reclaiming the Spirit of Place. *Penser et pratiquer l'esprit du lieu/Reflecting on and Practicing the Spirit of Place* (C. Forget, ed.): 103–25. Les Presses de l'Université Laval. Québec.

Zhulnikov, A. 2006. *Petroflify Karelii: Obraz mira i miry obrazov*. Skandinaviya. Petrozavodsk.

Zhulnikov, A. 2010. New Rock Carvings from the Peri Nos VI Cape on Lake Onega. *Fennoscandia Archaeologica* XXVII: 89–96.

The *Xenia* Concept of Guest-friendship – Providing an Elucidatory Model for Bronze Age Communication

Flemming Kaul

Abstract: Even though the Bronze Age is rich in evidence of long-distance exchange and communication, we have only vague ideas of how trade and long journeys were secured and organized. The ancient Greek (and Homeric) concept of guest-friendship, *xenia*, may give us an idea of the social mechanisms that would make such voyages practically feasible. *Xenia* was a concept of hospitality and friendship of individuals of non-related groups, distinctly separated from the notions of friendship relations between members of the individual's own society, kinship and family. *Xenia* was seen as a moral and religious obligation of hospitality securing food and accommodation to travellers. *Xenia* was instituted by the gods, Zeus being the protector of the traveller. The *xenia* bond did not expire with the death of the (first) partners themselves but outlived them, and was passed on to their descendants, apparently in the male line.

Our recognition of the particularly close bonds between guest-friends, *xenoi*, living far away from each other, will give a plausible explanation of how both ideas and valuable objects could spread over long distances. The long-distance connections, which seem to be reflected by specific shapes or types of Late Bronze Age rock carving ships – from Alta in northernmost Norway to Bottna in central Bohuslän – could be understood in terms of the *xenia* concept. Here, well established guest-friendship connections would make long-distance maritime journeys possible.

Key words: Bronze Age, long-distance exchange, sea voyages, guest friendship, rock carvings, Alta Norway.

Introduction – ideas about travel

The Nordic Bronze Age was a time of connections and of opening connections: a period of globalisation, so to speak. The demands for metal created long-distance exchange systems. Every drop of copper was imported into Scandinavia from sources far away, from the Alps, from the Carpathians, and even from Cyprus (Vandkilde 1996; Ling *et al.* 2014). A very important source of tin was Cornwall. A commodity demonstrating the most distant connections seen from Scandinavia is the glass beads, turning up in rich burials during the Nordic period II and III (1400–1100 BC). Most recently,

chemical analyses of the glass beads from a number of Danish burials have demonstrated that the glass was produced in Egypt and Mesopotamia (Varberg *et al.* 2014; Varberg *et al.* 2015) (Fig. 7.1).

Figure 7.1. Two glass beads of Egyptian cobalt coloured glass, from Hesselager, Funen, and Ølby, Zealand, Denmark. Their chemical composition is similar to glass from Amarna and Malkata, Egypt, and from the Uluburun shipwreck on the Turkish west coast and from Mycenae, Greece (photo: A. Mikkelsen, the National Museum of Denmark).

North–south exchange was not a one-way phenomenon. Early in the research history, the wealth of the Nordic Bronze Age was noted. The sources of amber along the coasts of the Baltic Sea, including Scania in Sweden, some of the Danish islands and the North Sea coast of the Jutland Peninsula, could explain this remarkable wealth. In 1882, the leading Danish archaeologist of the time, J. J. A. Worsaae, emphasized the importance of amber trade as part of the explanation for the metal-rich Nordic Bronze Age: 'Undoubtedly it was with amber, which was constantly increasing in value in the south, that the inhabitants of the Danish lands purchased their bronze and gold' (Worsaae 1882: 46). In 1897, S. Müller, Worsaae's successor at the National Museum of Denmark, saw amber as being the most important medium of contacts: 'It was the amber trade that connected the north with the south; ... only the fact that Denmark possessed this highly-treasured commodity can explain the high cultural position of southern Scandinavia in this distant period' (Müller 1897, 285, translated here). In 1921, he continued: 'Elements of decorative art, and in particular the spiral patterns, were brought here in connection with travels for the sake of the amber trade and through personal connections. The introduction of the spiral patterns marks the emergence of the succeeding independent Danish decorative art of greatest value' (Müller 1921, 8, translated here).

Later in the 20th century a more critical or minimalist approach was adopted to the importance of the amber trade (Jensen 1965; Harding and Hughes Brock 1974). However, now the tide has changed, and the significance of the amber trade has yet again been stressed (Jensen 2002; Kristiansen and Larsson 2005; Goldhahn 2013; Kaul 2013a) – and with a much larger body of empirical material at hand than at the time of Worsaae and Müller.

As already hinted at by Müller (1897, 1921), it was more than just the exchange of metal and amber that took place. Alongside the exchange of material goods, decorative and iconographic elements were transferred

following the roads of trade. During the Early Nordic Bronze Age, a large number of ideas related to the appearance of new types of artefacts and iconographic motifs were seemingly introduced in the north from the eastern Mediterranean. As examples, the folding stool and the one-edged razor with the handle in the shape of a horse's head could be mentioned, both appearing in south Scandinavia around 1400 BC (Prangsgaard *et al.* 1999; Kaul 2013a; Kaul 2013b). The folding stools were not imported; it was the idea of the folding stool being a ruling symbol that travelled. Similarly, no razors imported from the Mediterranean have been found in Scandinavia. It was the idea behind the razor that was transmitted – and its shape – probably reflecting new ideals related to the shaven warrior. In the field of rock carvings, the renderings of two-wheeled chariots – some being in use, as seen on one of the slabs of the large stone cist of Bredarör at Kivik, Scania, south Sweden – should also be seen as evidence of the introduction of an idea rather than depictions of imported vehicles (Randsborg 1993; Winther Johannsen 2010; Goldhahn 2013).

When considering the rock carvings in particular, the introduction of the ship iconography into the north in Period I of the Early Bronze Age might be seen as an expression of influences – of ideas – ultimately stemming from faraway Egypt, the ship being the sun-ship. When the ships on the rocks of Scandinavia were equipped with horse-headed stems around 1400 BC (Ling 2008; Ling 2013), the introduction of this feature could reflect a transference and local transformation of ideas from the Minoan-Mycenaean world. In this case, the razors – with their handles in the shape of a horse's head – may be seen as a sort of medium of mediation (Kaul 2013a; Kaul 2013b).

In this connection, a particular rock carving ship type should be taken into account, namely, the so-called boats of type E as defined by material from Trøndelag, Norway, for instance the Røkke rock carvings (Sognnes 1987). Ship images of E boat shape are also represented on the slabs of the Mjeltehaugen stone cist, Møre og Romsdal, Norway (Linge 2005). The E boats are characterised by a rectangular hull and no double stems, no keel extensions. The straight stems often terminate in what seem to be very stylised animal heads. They have been considered as representing the oldest Bronze Age boats (or Late Neolithic boats). The morphological similarity to ships belonging to the 'Arctic tradition' has long since been noted, even though there are also differences between the E boats and the boats of the

'Arctic tradition'. Furthermore, in Trøndelag there does not seem to be any geographical or environmental association between those ships (Sognnes 1987: 76–79; Sognnes 1999a: 37). However, it should not be excluded that this relatively small fleet of Norwegian ships could represent a continuation into the Bronze Age of an earlier shipbuilding or rock carving tradition (Gjerde 2010: 400). As we shall see below, such evidence of local continuations of an older shipbuilding tradition should not alter the view that other types of ships – Bronze Age ships proper – represent an innovation, something distinctively new.

The boats or ships of the Arctic Mesolithic/Neolithic tradition with stems in the shape of an elk's head are worth considering. Those elk-headed boats could be seen as a sort of background or inspiration for the Bronze Age ships with stems in the shape of a horse's head. However, there seems to be a sizeable chronological gap between the elk-headed boats in the north-eastern parts of Fennoscandia (including north Norway, north Sweden, Finland and north-west Russia) and the horse-headed ships/boats in south and central Scandinavia. The elk-headed boats date back to the Late Stone Age (Helskog 2000; Gjerde 2010: 397–399). Recent research seems to push back the main period of the elk-headed boats even earlier, as demonstrated by evidence from Alta, Finnmark, Norway, to 4200–3000 BC (Gjerde 2010: 252).

Furthermore, the earliest type of the Bronze Age ship did not carry animal-headed stems, being characterized by high stems turning inwards. A curved sword from Rørby, Zealand, Denmark, Period Ib (1600–1500 BC), is decorated with a ship of this shape (Vandkilde 1996; Kaul 1998). Such ships as shown by the rock carving evidence seemingly spread over large areas of Denmark, Sweden and Norway within a relatively short span of time. They are known in numbers on rock carvings in Uppland and north Trøndelag. By means of shoreline dating, Bohuslän and Uppland, Sweden, the time of the appearance of this ship type has been confirmed (Ling 2008, 2013). The time of the introduction of the ships with the stems in the shape of a horse's head has likewise been placed by shoreline dating around 1400 BC, this in accordance with the first appearance of the horse-head motif in Nordic Bronze Age bronze art (Ling 2008, 2013; Kaul 2013a, 2013b). Consequently, from a chronological point of view it seems most unlikely, that any inspirations or amalgamations of ideas of stems in the

shape of animal heads, elks' heads and horses' heads came about. The Bronze Age ships of Rørby type represent a new breed of ships, probably plank-built, well suitable for transport and communication over longer distances and open water (Østmo 2005), and opening up for wider possibilities for guest-friendship connections. The horse-headed ship represents the next generation of Nordic Bronze Age ships.

Networks of exchange

Ideas do not travel by themselves; they have to be transmitted as some sort of knowledge by travellers, over longer or shorter distances. The dissemination of ideas should be related to the routes of exchange – of metal and other commodities such as amber. However, even though we can trace the outcome of travels and contacts, both physically and by the evidence of transmission of ideas, it is difficult to comprehend how journeys were organized. Kristiansen and Larsson (2005) have been working with the concepts of mobility and exchange in pre-state societies, including ethnographical parallels. In their view, exchange and interaction cannot be understood as a neutral flow of material goods. They were embedded in a complicated system of social and political exchange rituals. Neither goods nor ideas can travel independently of human interaction. Furthermore, journeys will generate knowledge of distant fashions and ideas, forming part of a corpus of esoteric knowledge controlled by chiefs, priests and artisans – wisdom of the world.

In a Bronze Age context, extensive political control could not be exercised, and there were no large policing institutions that could secure the traveller. There were no inns or hotels. What happened when travelling outside the local area? – There must have been some order, some agreements so that you were not immediately robbed when entering foreign areas. There must have been some commonly understood rules and regulations in order to secure continuously open lines of the exchange systems required for bringing, for instance, tin and cupper to the north from far away sources. A trade network depending on chiefly alliances has been suggested, linking south Scandinavia with central Europe – the Carpathian area and north Italy.

The basis was, according to Kristiansen and Larsson (2005) the establishment of marriage alliances and trading partnerships. Along the exchange alliances chiefly traders or warriors travelled to the north, bringing with them metal and technological knowledge, and vice versa. This exchange system was hinged on yet another system with connections further south, eventually the eastern Mediterranean trade system.

A regional network has been demonstrated by the distribution of the octagonal-hilted swords appearing shortly after 1400 BC. Even though there are some regional variants, the similarities of the hilt shape and its decoration are close, from Denmark to the Alpine regions, including the southern Italian and southern Swiss Alps. One of the southernmost finds of an octagonal hilted sword was deposited at Rovereto, in the stream of Leno leading to the Adige River (Peroni 1970: 101; Quillfeldt 1995). The sword has disappeared, and the drawings do not seem to be of an adequate standard. The sword seems to have carried spiral decoration. If this is the case, it could be closely related to the Nordic swords of this type.

The distribution of the octagonal hilted sword – and other objects – seems to evidence a contact network with close ties between the Alpine region and south Scandinavia (Fig. 7.2). Recently it has been proposed that the distribution could reflect some sort of community or alliances, where the octagonal-hilted sword can be regarded as a kind of 'passport' or social identification of a group of chiefly traders and specialists (Kristiansen and Larsson 2005: 233–234). Like a medieval pilgrim mark, such a sword might have ensured safe transport through larger parts of northern and central Europe and even free accommodation and food among members of the brotherhood of the sword.

Among the explanatory key factors considered by Kristiansen and Larsson (2005) in order to understand the mechanisms of establishing and maintaining such long-distance networks are marriage alliances and institutions related to foster-sons and foster-brothers. Thus, by creating close family bonds between the chiefly elites, the routes were kept open, and commodities as well as ideas flowed through larger parts of Europe. However, creating family bonds may just be one part of the explanation. Kristiansen and Larsson (2005: 234) also use terms with a wider meaning such as 'exchange alliances'. Here, I would like, once again, to quote S. Müller: 'Elements of decorative art, and in particular the spiral patterns,

Figure 7.2. Map showing the distribution of octagonal hilted swords and lines of contact reflected by this distribution (from Kristiansen & Larsson 2005).

were brought here in connection with travels for the sake of the amber trade and through personal connections' (Müller 1921: 8, translated here). I believe that when using the term 'personal connections' (in Danish: *Personlige Forbindelser*), Müller is referring to the ancient Greek

concept of guest-friendship, *xenia*, at a time when knowledge of ancient Greek concepts and ideas were more commonplace among academics than today.

The *xenia* concept of guest-friendship

Naturally, a Bronze Age traveller (or a group of travellers) would not be able to go through larger parts of Europe solely depending on marriage alliances and family bonds. Furthermore, we should not suppose that the traveller was just sleeping underneath a tree or a rock shelter without any protection, without having some sort of relationship with people along the route. Access to food and accommodation as well as some measures of protection would have been crucial for the traveller. In pre-state societies without permanent policing institutions to create security, we should expect some agreements on regulations and customs concerning hospitality for the traveller, providing both security and night accommodation.

The ancient Greek concept of guest-friendship, *xenia*, may give us an idea of those social mechanisms that would make such voyages practically feasible. *Xenia* was a concept of hospitality and friendship of individuals of non-related groups – city states, ethnic groups – distinctly separated from the notions of friendship relations between members of the individual's own society, kinship and family. *Xenia* was generally seen as a moral and religious obligation of hospitality securing food and accommodation to travellers – *xenia* ensured that a traveller would not be turned away from any house. *Xenia* was instituted by the gods, Zeus being the protector of the traveller, and those who did not obey the rules of guest-friendship would call down divine wrath. Even a humble traveller could be a god in disguise, testing the host (Felher *et al.* 1998; Herman 2002). It seems possible that the word *xenia* can be traced back to linear B inscriptions in the form *ke-se-nu-wo*. (Hiltbrunner 2005: 18).

In more specific terms, *xenia* was an institution of mutual guest-friendship relations of individual partners, including rituals of gift exchange. *Xenia* could promote the exchange of goods and services, even though the transactions were supposed to be in a non-mercantile spirit. There was

always an insider-outsider dichotomy with respect to the partners' own social units. *Xenia* relationships could exist between members of Greek cities, between Greeks and non-Greeks, such as Persians, Lydians, Egyptians, Phoenicians and Romans, and between non-Greeks. Thus, there is no reason to believe that *xenia* should be regarded as an essentially Greek institution. The more formal guest-host relationships could also include friends of the partner. A friend of Socrates, Crito, made this suggestion to Socrates: 'If you wish to go to Thessaly, I have there *xenoi* who will make much of you and protect you, so that no one in Thessaly shall annoy you' (Herman 2002: 10–12). Escort through foreign land could also be provided by means of *xenia* connections (*ibid.*: 119).

The *xenia* bond did not expire with the death of the partners themselves but outlived them and was passed on to their descendants, apparently in the male line. Even in death *xenia* seems to have been of importance, since it could be the duty of a guest-friend to look after the earthly remains of a dead partner and celebrate his memory (Herman 2002: 16–26, 69–70). The great importance of *xenia* relationships, even for generations, is demonstrated by an episode described in the *Iliad*. Two heroes, Diomedes and Glaukas, were about to engage in fierce combat when they suddenly realized that their grandfathers were bound by *xenia*. Diomedes, pleasantly surprised at the revelation, drove his spear into the earth and spoke to his former rival in a friendly tone: 'Therefore I am your friend and host in the heart of Argos; you are mine in Lykia, when I come to your country. Let us avoid each other's spears, even in close fighting. There are plenty of Trojans and famed companions in the battle for me to kill ... But let us exchange our armour [= equipment, weapons], so that these others may know how to be guests and friends from the days of our fathers' (*Iliad* 6.224ff; Herman 2002: 1).

It is important to note that the bonds between Diomedes and Glaukas are personal, and related to ties between their grandfathers. Their revealed connections of guest-friendship were more important than where they served as soldiers. Thus, such bonds should not be described as chiefly alliances, even though there may have been occasions of more politically toned *xenia* bonds, for instance between a leader and a whole foreign people (*Odyssey* 9.18; Herman 2002: 135). In certain cases, *xenia* should not be seen as something in conflict with marriage alliances between noble families,

'political' marriages being an outcome of already established *xenia* bonds (Hiltbrunner 2005: 27).

At first glance, the behaviour of the two heroes, Diomedes and Glaukas, might seem to be disloyal. On the other hand, the text demonstrates that their conduct was regarded as being morally appropriate, the ideas of the God-given guest-friendship for a time overruling the decided progress of battle. Anyway, there were other warriors to kill for the two guest-friends. In a Bronze Age society, even in northern Europe, such personal guest-friend connections – in this case of formerly opposed heroes – could indeed be very practical. In times of war and hostilities between the chiefdoms, such more personal guest-friendship relations would ensure that the routes of exchange would remain open, not being disrupted. Or, after a conflict, the connection networks would be easily re-opened, not being weakened and destabilized by the effects of hatred and revenge, as the *xenia* bonds enhanced friendly connections.

This episode in the *Iliad* reveals what may be understood as a Bronze Age situation. Here, the hero could see the guest-friendship as his own private obligation. Such notions of the guest-friendship of the heroic Homeric age were in conflict with the notions of loyalty to the Greek city state. Two competing moral systems were involved, one archaic and pre-political, another steaming from the ideas of the *polis* structure. There are many references where army leaders or political leaders seemingly were forced to abandon their *xenia* friendships in order to uphold their loyalty to their state and people (Herman 2002: 2 and 156ff). When armies of hoplite structure met under firm command, there was limited room left for personal guest-friendship discussions on the battlefield. Nevertheless, discussions related to the conflicting obligations as to the objective of the army command, versus the *xenia* bonds, still occurred, creating virtually rebellious situations (*ibid.*: 119–120).

Special tokens were not necessarily required for marking or identifying *xenia* relations. When initializing such a friendship, feasting, declaration and gift exchange were indispensable for its validity. The gifts could include drinking gear (Felher *et al.* 1998: 798). When referring to relations with royals or leaders, gifts of value not only served as marks of prestige for the owner, but also as proofs of being under the king's protection (Herman 2002: 60–67).

The patterns of social relationship of *xenia* outlined above, including the exchange of gifts, are not peculiar to the ancient Greek world. Institutions displaying similar features have – naturally – been observed in many other societies (Service 1971; Morris 1986; Mauss 1993; Felher *et al.* 1998; Hiltbrunner 2005). Instead of finding a model framework among societies far away in time and space from the European Bronze Age, it would seem more straightforward to utilise the contextually closer evidence of *xenia* to gain an impression of the organization of long-distance connections and exchange. We should not forget that Nordic amber did reach Mycenae, and that the episode from the *Iliad* discloses the ideal behaviour of Homeric heroes.

Thus, the God-given obligations of the guest-friendship of *xenia* can provide us with an elucidatory model for Bronze Age communication. Even though the notions of guest-friendship can give us a better understanding of the social mechanisms lying behind the networks of exchange, we have only vague ideas as to how the journeys and transport of valuable commodities were organized.

How many travelled together? – what about escorts or guides, local or translocal? – caravans? Was it possible to celebrate smaller or larger banquets at the places of accommodation? There were no hotels or guesthouses in our modern sense (Felher *et al.* 1998) and in principle, any farm on the routes could be a place of guest-friendship. Perhaps there were places where guest-friendship was employed on a larger scale, where many friends related to a wealthy and famed host were well treated, and where people from different regions could meet, establishing further *xenia* connections. It is tempting to consider sites such as Monkodonja, Istria, Croatia (Terzan *et al.* 1999; Hänsel 2007) (Fig. 7.3) and certain (lightly defended) middle Bronze Age villages in the Alps, such as Sotciastel and Albanbühel (Tecchiati 1998; Tecchiati 2011) in Südtirol/Alto Adige, and Padnal, Graubünden, Switzerland (Rageth 1986) as places where guest-friends – travellers belonging to the highest echelons of the Bronze Age societies – could meet. Furthermore, a number of palafitte villages in the area of Lago di Garda (where Nordic amber has been found) should be included (Kaul 2013a; 2014a).

The *xenia*-like bonds would make possible not only the exchange of goods over long distances, but also of gift exchange, including valuable drinking (feasting) gear. Furthermore, close bonds between *xenoi* living far away from

Figure 7.3. One of the gates of the fortified site at Monkodonja, Istria, Croatia, at Caput Adria. The site was occupied c. 1600–1300 BC. Monkodonja is regarded as an imitation of Mycenaean palace architecture. Amber has been found at Monkodonja. Here, along the amber routes, guest-friendship was probably observed and enjoyed (photo: F. Kaul).

each other could provide us with an explanatory model of how ideas could spread over long distances.

The introduction of the single-edged razor in the north, and the idea of the appearance of the shaven warrior, could easily be understood as an outcome of meetings of guest-friends. On such occasions when guest-friends came close to each other, an atmosphere could be created that was well suited for imitating distant habits. The curious distribution of the octagonal hilted swords could excellently be understood within the contextual framework of the *xenia* concept. The occurrence of foreign swords might in some cases reflect the exchange of weapons as an act of sealing the guest-friendship.

Xenia in the north

Seen in the light of the *xenia* guest-friend concept, we can look at so-called imported objects – objects of prestige – in a new and hopefully more enlightened manner. For instance, imported bronze drinking gear, like the drinking set from Simons Mose, east Jutland (Thrane 1962; Frost 2011), or the Hajduböszerménu buckets from Siem, north Jutland (Thrane 1966),

Figure 7.4. Large drinking gear from Simons Mose, east Jutland, Denmark, 1300–1100 BC (photo: National Museum of Denmark).

should not alone be seen as prestigious imports. Taking the *xenia* concept into account, then, a biography of the objects can be included. Drinking gear such as that from Simons Mose (period III, 1300–1100 BC) (Fig. 7.4) would have been used at feasts initiating and reinforcing personal guest-friendship bonds. They may show that a person from Jutland has been in Hungary, or a person from Hungary has been in Denmark, or both – and has been well treated.

Thus, such objects were not merely rare and valuable. Before eventually being deposited in a wetland area, they would have served as tokens of guest-friendship. They would tell that the owner (or/and persons closely related to the owner) had specific relations to friends in distant areas. We can introduce personal friendship as an institution of great importance.

The feasting equipment would tell that the owner had a sort of passport for travelling to Hungary – that, if he went to Hungary, he would be under the protection of a chief there. When considering such objects as reflect long-distance contacts (including the octagonal-hilted swords) then the employment of the *xenia* concept provides new ways of understanding the social mechanisms behind the patterns of exchange and communication that we can observe.

In addition, when considering the Scandinavian rock carvings, *xenia* could keep lines of contact open making possible the swift spread of ideas related to art and religion. The seemingly quick expanse of the Early Bronze Age ship images on the rocks (and on the Rørby sword) with low keel extensions fore, and high in-turned stems from Denmark in the south to Trøndelag, Norway, and Uppland, Sweden, in the north may be due to already well established *xenia* and family connections. The spread of ideas and of the related imagery was of course also dependent on better means of transport – ships – and on skills of seafaring and shipbuilding (Kaul 1998; Østmo 2005; Ling 2008, 2013).

From Alta to Bohuslän

From the latest part of the Bronze Age, rock carving ships also seem to evidence some long-distance connections. At Alta in Finnmark, almost as far north as you can get, a number of rock carving ships of the Nordic Bronze Age tradition have come to light. In 1973, the first rock carvings were found at Hjemmeluft/Jiepmaluokta, Alta, Finnmark. Since then hundreds of rock carvings have come to light. Most of the rock carvings belong to the Arctic tradition (also named 'hunters' carvings').

However, slightly separated from the other rock carvings, at Apana Gård, on the east side of the Alta Fjord, more than 12 ships distinguish themselves by belonging to the Nordic Bronze Age tradition (also named farmers' carvings). The remarkable similarities to ship images of the Nordic Bronze Age were noted soon after the discovery of the ship renderings, and K. Helskog (1988: 94) mentions that one of the ships belongs to a type where you have to go to the southernmost parts of Scandinavia to find its equals.

In some cases, these ships have been dated to the Late Bronze Age (Helskog 1988: 33; Sveen 1996: 59), in other cases they have been dated to the Pre-Roman Iron Age (shoreline dating) (Helskog 2000). Recently, other shoreline dating studies seem to place these ships from 1100 BC and the following centuries (Gjerde 2010: 246–252). Most of the ships in question are asymmetrical, with a highly protruding keel extension fore and a short keel extension aft. In some cases, the stems fore and aft terminate in stylized animals' heads, probably horses' heads, ending in short spiral curls. This scheme of ship shape with a high keel extension at the prow fore is typical of the Late Bronze Age (Kaul 1998). At a number of the ships from Hjemmeluft, the keel extension and the gunwale extension meet, creating a pointed loop-shaped or rather contour-drawn stem, and there can be horse-headed stem-like decoration behind or on that (Fig. 7.5). Such loop-shaped stems are seen

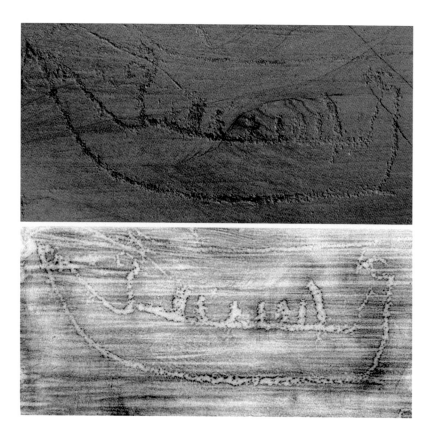

Figure 7.5. Ship image, rock carving, Hjemmeluft, Alta, Finnmark, Norway. Note the asymmetrical shape of the ship with a high extension or stem fore, and a low horizontal stabilizer aft. Upper: photo; lower: rubbing (photo: F. Kaul; rubbing: Alta Museum).

on ships belonging to the Pre-Roman Iron Age, but the loop-shaped stem in itself does not determine the age. By analogy with a number of razors seemingly of ship shape, the introduction of the loop shaped stem may have taken place during Period V of the Nordic Bronze Age (900–700 BC) (Kaul 1998: 140–141; Kaul and Rønne 2013).

Of great importance for the date is the asymmetrical ship shape which is to be considered as a typical Bronze Age feature (Østmo 1991; Kaul 2003; Sognnes 2006), even though some of the Alta ship features perhaps point towards an early part of the Pre-Roman Iron Age. With the incipient tendency on some of the ships from Hjemmeluft towards a more symmetrical shape, at date close to the end of the Bronze Age, period VI (700–500), seems most likely. Two of the ships seem to be equipped with steering oars, a feature best known from the Pre-Roman Iron Age. Other ships from Hjemmeluft, of basically the same design, carry a more pronounced high, almost tower-like stem construction. On this ship and other ships, the stem carries what seems to be a stylised horse's head with spiral curls (Fig. 7.6).

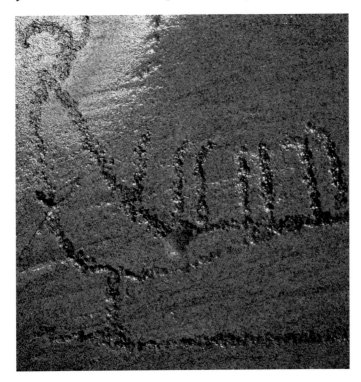

Figure 7.6. Detail, stern, carrying a stylized, spiralling head, Hjemmeluft, Alta, Finnmark, Norway (photo: F. Kaul).

In Bohuslän, west Sweden, parallels to the Hjemmeluft ships could be pointed out, in particular in Bottna parish, central Bohuslän, around 1500 km from Hjemmeluft as the crow flies (Fredsjö *et al.* 1975: 148; Strömberg and Strömberg 1983: 17) (Fig. 7.7). It is not just one or two ships which share their characteristics with the ships from Alta, including the pointed loop-shaped stems and spiralling horse's heads or spirals on contour-drawn tower-like projections, but a concentration of such ships (Fredsjö *et al.* 1975: 33–36, 49, 130–133 and 137). A little break or elbow of the carved line at the base of the spiral or horse's head towering over the stem is a peculiar shared detail (Fig. 7.8; Fig. 7.9). Ships of a similar design has also been found in northern Bohuslän, for instance at Hamn at Kville (Coles 2005: 16).

Ships that can be compared with the ships at Alta are also found on a number of rock carvings in southern and western parts of Norway. For instance, the high, almost tower-like stem construction is seen on the rock carvings at Åmøy near Stavanger (Fett and Fett 1941: pls 11, 14, 20 and 22). Here in Rogaland, there is a concentration of ships with closed, loop-shaped stems, not only at the rock carving sites on Åmøy, but also at other sites in the district such as Harastad, Rudio and Bru I

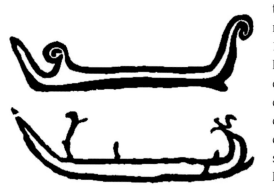

Figure 7.7. Ship images from Gisslegärde and Bottna, Bottna Parish, Bohuslän, Sweden (drawing: T. Bredsdorff after Fredsjø et al. 1975).

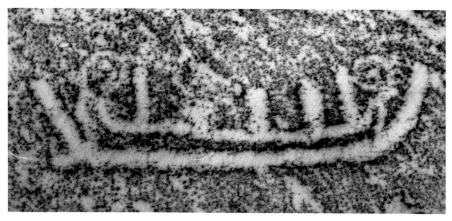

Figure 7.8. Ship image, rock carving, Bottna, Bohuslän, Sweden (rubbing: G. Milstreu).

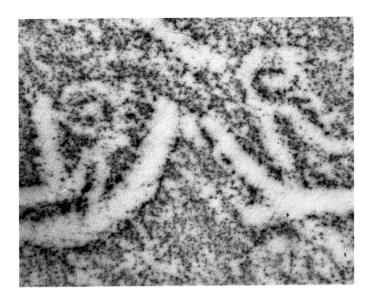

Figure 7.9. Details of prow and stern, two ships, Bottna, Bohuslän, Sweden (rubbing: G. Milstreu).

(Høgestøl *et al.* 2006: 54, 65 and 74). Similar ships are known from Utbjoa, Ølen, Hordaland (Mandt Larsen 1972: pl. 26), and some belonging to the same 'family' from Begby, Bilet and Borge Lille in Østfold (Vogt 2012: 105–122).

Very close to the ships of Nordic Late Bronze Age design, two snake figures are seen. When looking closer at one of the heads it becomes apparent that it is not a 'normal' snake's head, but a horse's head (Fig. 7.10). In the most elegant way the attributes of a horse, the ears and the mane, were created by very few hammerings. Even though there are only two 'dots' for each ear and four 'dots' for the mane, the 'horseness' of the head seems obvious. The mouth is a bit open. The artist knew exactly how to accentuate the character of a horse – intentionally and skilfully. We are obviously dealing with a snake with a horse's head, the *snake-horse* (Kaul 2014b). The other snake figure also has a 'snout' different from that of a snake, even though it may be difficult to identify it as a head of a horse (pers. comm., Christian Søborg, Alta Museum).

The snake is a well-known motif in the iconography of the south Scandinavian Late Bronze Age. It is also identified on the rock carvings of north Trøndelag, Norway, Leirfall, Stjørdal (Sognnes 1999b: 44). The fantastic animal, the mixed creature, the snake-horse occurs regularly in south Scandinavia, on rock carvings and on bronze objects (Kaul 1998, 2004, 2009,

Figure 7.10. Snake figure or rather snake horse, rock carving, Hjemmeluft, Alta, Finnmark, Norway. Upper: The full snake figure; lower: Detail, the snake's head seems to be a horse's head with open mouth, and ears and mane clearly marked (photo: F. Kaul).

2012, 2014b). Snakes with what seem to be a horse's head with marked ears, Late Bronze Age, is known from the rock carvings at Bro, at Tegneby and at Slänge, all Tanum Parish, north Bohuslän, Sweden (Högberg 1995: 103; Kaul 1998: 230–231). A most distinct snake with a horse's head is seen over a ship on the Lökeberg rock carving, central Bohuslän (Andersson and Toreld 2012: 9, Foss 6.1 yta B). Thus, the snake-horse or the snake-horses from Alta support the evidence of the ships as testimony to long-distance connections between Finnmark and south Scandinavia.

The presence of the ship images from Alta, Finnmark, related to the Scandinavian Bronze Age tradition, poses some challenging questions about our understanding of long-distance communication and contacts during the Late Bronze Age. They are found in an area where there are virtually no other finds belonging to the Nordic Bronze Age, though a few objects could be mentioned (Kaul and Rønne 2014). The observations of similarity between the ship images from Alta and ship images from south Scandinavia could be viewed in different ways. A population with roots in the circumpolar culture groups could have seen ships belonging to bearers of the Scandinavian Bronze Age culture, or they could have imitated the fashion of the stems of such ships. However, the ships in question seem to have been shaped so formally and technically correctly in Nordic Bronze Age style that this possibility could be ruled

out. This is also supported by the presence of the snake-horse at Alta, which should be considered as a distinctive iconographical feature of the Nordic Bronze Age culture. There seems also to be chronological problems with a possible overlap in time of the 'hunters' tradition' and the 'farmers' tradition'. Another possibility is that the ship images from Alta could reflect occasional visits of travellers – long-distance contacts or expeditions, setting out from south Troms or even ultimately from south-western Norway or Bohuslän.

However, we should not rule out the possibilities of a small Late Bronze Age and Early Pre-Roman Iron farming and pasture population. In that case, we might allow ourselves to reverse the communication scenario: It was from Alta that people from time to time went south, paddling for a month or more (Kaul 2012). The places where the best parallels to the ship images from Alta are found could be the goal of their journey. Another reason for such a long journey could be the wish to join pan-Nordic cult festivals that (probably) took place at regular intervals in Bohuslän, particularly around 800 BC, in period V (and period VI), when we see a peak of rock carving activity here. Bohuslän may have functioned as a central 'holy place' or place of pilgrimage for the surrounding regions, if not for the whole of Scandinavia (Kaul 2004: 103; Kaul 2012). By such cult festivals, where people from all over Scandinavia – even the most distant parts – met, a common ideology and religion related to farming was upheld.

We need to consider such scenarios seriously as possibilities if we want to explain the evidence of Nordic Bronze Age rock carvings demonstrating a common iconography covering huge areas (Kaul 1998: 274; Kaul 2004: 409). It should be emphasized that the Bronze Age rock carvings panels of Scandinavia, including Bohuslän, were predominantly created in a coastal or maritime location, and since many rock carvings include depictions of rituals on board ships we can easily speak about maritime rituals and ceremonies (Ling 2008).

The rock carvings, such as those in Bohuslän, reflect more than just long-distance journeys related to paramount cult festivals. Other sub-scenarios should be considered, including events connected to long-distance exchange, meetings, also of relatively local kind, initiation rites, launching of expeditions, perhaps even related to non-peaceful interaction. Some rock art may have been created in agreement with maritime rites of initiation into

skills and (religious) knowledge. When considering such skills particularly related to sea ventures, it has been suggested that a sea voyage in itself was perceived as an initiation rite (Ling 2008: 219), and as something sacred. Similar views are expressed concerning the Late Bronze Age stone ships of the Baltic Sea area: The monumental ship settings were much more than just visible monuments containing the earthly remains of the deceased. They seem also to represent meeting places related to voyages and exchange. It is proposed that activities related to the Bronze Age stone ships should be linked to the maritime sphere in society, and probably rituals and ceremonies in connection with departure and/or arrival from long-distance journeys. Notions about death cult and voyages were seemingly combined, the stone ships marking places of transition: from life to death and from home to faraway shores (Wehlin 2013).

When sea voyages in their own respect were understood as rituals of elevated social and religious significance, then the notions of guest-friendship, *xenia*, obviously related to travelling, would unavoidably have attained a prominent status in Bronze Age mentality.

Back to Alta

Today, at some places at the Alta Fjord, a particularly mild climate enables barley to ripen in good summers. Probably climate conditions for cereal cultivation were even better in the Bronze Age. In sheltered inland areas a few kilometres from Hjemmeluft, farms with byres for cattle can be seen today, surrounded by large grass fields. It is possible to speak of arctic agriculture, almost as far north as you can get, hundreds of kilometres north of the Arctic Circle, at 70 degrees north.

It should be admitted that the distances are large between the Alta area and the nearest area with an agricultural potential and Late Bronze Age finds such as the Harstad/Kvæfjord area in south Troms. But when considering the test sailings with a replica of the Pre-Roman Iron Age Hjortspring boat, probably sharing the same qualities at sea as the Bronze Age ships, where it could be demonstrated that in good conditions – fair weather in the summer – a well-trained crew can cover 100 kilometres in a day's voyage

(Kaul 2003: 201) then regular contacts between, for instance, the Harstad area and Alta would not have been impossible. Even much longer distances should not be seen as unrealistic.

It should be noted that the northernmost bronzes belonging to the Nordic Bronze Age culture also demonstrate that north Norway was integrated into a larger contact system, even though the finds are not numerous. Thus, the crescent-shaped necklaces from Trondenes and Tennevik, south Troms, can be related to finds from north Germany, Poland and west Denmark, and a flanged hilted sword from Vinje, Vesterålen, north Nordland, can be best compared with swords from north Germany (Kaul and Rønne 2013).

The maintenance of regular connections was probably a decisive point in order to uphold a relatively small population at Alta, Finnmark, with a certain agricultural basis and closely related to Nordic Bronze Age culture. If contacts for some reason faded away then such a population would gradually lose its connected identity, or if agriculture failed, people simply moved back to areas further south (Mahler 2012). Here at the border of agriculture even small climate changes could have been crucial. Consequently, we should not imagine a stable population of long duration of Bronze Age farmers at Alta but rather talk about one or some episodes of some generations where the conditions for farming and pasture were most favourable. Furthermore, a certain surplus, both here and further south, was needed for the ability of maintaining frequent (long-distance) contacts.

Concluding remarks

The long-distance connections, which seem to be reflected in specific types of Late Bronze Age rock carving ships – from Alta, in northernmost Norway to Bottna, in central Bohuslän – could likewise be understood in terms of the *xenia* concept. Here, well-established guest-friendship connections would enable long-distance maritime journeys, along the coast, regularly finding landing places, shelter, accommodation and food supply, probably also including a certain measure of feasting.

The concept of *xenia* and its manifestation as close bonds between *xenoi* living far away from each other could provide an explanatory model of how

ideas could spread over long distances, and how the lines of contact could remain open, even in times of hostilities. When utilizing the elucidatory potential of *xenia* we would hopefully be able to gain a better understanding of some of the social mechanisms that made Bronze Age exchange of goods and ideas possible. By means of the *xenia* concept we may be able to comprehend some seemingly odd distribution patterns of objects and art motifs – from octagonal-hilted swords and razors to certain motifs in rock art.

The introduction of the single-edged razor in the north, and the idea of the appearance of the shaven warrior, could be understood as an outcome of meetings of guest-friends. On such occasions where guest-friends came close to each other, an atmosphere could be created that was well suited for imitating distant habits. The diffusion of the razor and the ideas behind just before 1400 BC should not be seen as part of a 'wave' that overwhelmed the passive receivers in the north. Terms like 'influence' or 'diffusion' do not seem sufficiently explanatory. We could perhaps talk about active 'diffusion', where leading members of the societies having knowledge of the world of the south – probably after long journeys – deliberately picked up certain elements that could be used in self-promotion in a dynamic time of change.

References

Andersson, T. and Toreld, A. 2012. *Hällristningarna på Lökeberg/The Rock Carvings at Lökeberg*. Arkeologisk Rapport 8. Stiftelsen för dokumentation av Bohusläns hällristningar. Vitlycke Museum. Vitlycke.

Coles, J. 2005. *Shadows of a Northern Past: Rock Carvings of Bohuslän and Østfold*. Oxbow Books. Oxford.

Felher, H., B. W. Wiesehöfer and B. W.-H. Wagner-Hassel 1998. Gastfreundschaft. *Der neue Pauli Enzyklopädie der Antike, Band 4* (H. Concik and H. Schneider, eds): 793–798. Verlag J.B. Metzler. Stuttgart/Weimar.

Fett, E. and P. Fett 1941. *Sydvestnorske Helleristninger, Rogaland og Lista*. Stavanger Museum. Stavanger.

Fredsjö, Å., J. Nordbladh and J. Rosvall 1975. *Hällristningar Kville Härad i Bohuslän, Bottna socken*. Fornminnesföreningen i Göteborg. Gothenburg.

Frost, L. 2011. Depotfund fra yngre bronzealder i et lokalt, landskabsarkæologisk lys. *Depotfund i yngre bronzealders lokale kulturlandskab* (S. Boddum, M. Mikkelsen, M. and N. Terkildsen, eds): 63–73. Viborg & Holstebro Museum. Viborg.

Gjerde, J. M. 2010. *Rock Art and Landscapes: Studies of Stone Age Rock Art from Northern Fennoscandia*. University of Tromsø, UIT. Tromsø. Available at http://hdl.handle.net/10037/2741.

Goldhahn, J. 2013. *Bredarör på Kivik - en arkeologisk odyssé*. Linnéuniversitetet, Artes Liberales. Kalmar.

Hänsel, B. 2007. Ägäische Siedlungsstrukturen in Monkodonja/Istrien? *Between the Aegean and the Baltic Seas: Prehistory across Borders. Proceedings of the International Conference Bronze and Early Iron Age Interconnections and Contemporary Developments between the Aegean and the Regions of the Balkan Peninsula, Central and Northern Europe, University of Zagreb, 11-14 April 2005* (I. Galanari, H. Tomas, Y. Galanakis and R. Laffineur, eds): 149–154. Aegaeum 27. Annales d'archéologie égéenne de l'Université de Liège. Liège.

Harding, A. F. and Hughes-Brock, H. 1974. Amber in the Mycenaean World. *Annual of the British School at Athens* 69: 145–172.

Helskog, K. 1988. *Helleristningene i Alta*. Finnmarks Fylkeskomune, Icomos. Alta.

Helskog, K. 2000. Changing Rock Carvings – Changing Societies. *Adoranten* 2000: 5–16.

Herman, G. 2002. *Ritualized Friendship and the Greek City*. Cambridge University Press. Cambridge.

Hiltbrunner, O. 2005. *Gastfreundschaft in der Antike und im frühen Christentum*. Wissenschaftliche Buchgesellschaft Darmstadt. Darmstadt.

Högberg, S. 1995. *Arkeologisk rapport 1 från Vitlyckemuseet, Hällristningar från Litsleby, Tegneby & Bro i Tanums Socken*. Bohusläns Museum. Uddevalla.

Høgestøl, M., L. Prøsch-Danielsen, B. Bakke, S. Bakkevig, C. Borgarp, G. Kjeldsen, A. Meeks, M. Nitter and O. Walderhaug 2006. *Helleristningslokaliteter i stavangerområdet, Rogaland*. AmS-Rapport 19, Arkeologisk Museum i Stavanger. Stavanger.

Jensen, J. 1965. Bernsteinfunde und Bernsteinhandel der jüngeren Bronzezeit Dänemarks. *Acta Archaeologica* XXXVI, 1965: 43–86.

Jensen, J. 2002. *Danmarks Oldtid. Bronzealder 2.000–500 f.Kr.* Gyldendal. Copenhagen.

Kaul, F. 1998. *Ships on Bronzes: A Study in Bronze Age Religion and Iconography*. The National Museum of Denmark. Copenhagen.

Kaul, F. 2003. The Hjortspring Boat and Ship Iconography of the Bronze Age and Early Pre-Roman Iron Age. *Hjortspring - a Pre-Roman Iron Age Warship in Context* (O. Crumlin Pedersen and A. Trakadas, eds): 187–208. The Viking Ship Museum in Roskilde. Roskilde.

Kaul, F. 2004. *Bronzealderens religion: Studier af den nordiske bronzealders ikonografi*. The National Museum of Denmark. Copenhagen.

Kaul, F. 2009. Slangen i bronzealderens mytologi: Orden og kaos. *Det 10. nordiske bronzealdersymposium, Trondheim 5.-8. okt. 2006* (T. Brattli, ed.): 80–97. Vitark 6, Acta Archaologica Nidrosiensa. Trondheim.

Kaul, F. 2012. The Northernmost Rock-carvings of the Nordic Bronze Age Tradition in Norway: Context and Landscape. *Image, Memory and Monumentality - Archaeological Engagements with the Material World: A Celebration of the Academic Achievements of Professor Richard Bradley* (A. M. Jones, J. Pollard, M. J. Allen and J. Gardiner, eds): 233–240. Oxbow Books. Oxford.

Kaul, F. 2013a. The Nordic Razor and the Mycenaean Lifestyle. *Antiquity* 87: 461–472.

Kaul, F. 2013b. The One-edged Razor – Northernmost and Southernmost. *The Border of Farming Shetland and Scandinavia: Papers from the Symposium in Copenhagen September 19th to the 21st 2012* (D. L. Mahler, ed.): 156–176. The National Museum of Denmark. Copenhagen.

Kaul, F. 2014a. Idéer på vandring. *Skalk* 2014, no. 2: 14–23.

Kaul, F. 2014b: The Northernmost Rock Carvings Belonging to the Scandinavian Bronze Age Tradition. *Northern Worlds – Landscapes, Interactions and Dynamics: Proceedings of the Northern Worlds Conference Copenhagen 28-30 November 2012* (H. C. Gulløv ed.): 115–128. The National Museum of Denmark Copenhagen.

Kaul, F. and Rønne, P. 2013: Bronzes, Farms and Rock Art: The Agrarian Expansion of North Norway. *Adoranten* 2013: 25–56.

Kristiansen, K. and Larsson, T. B. 2005. *The Rise of Bronze Age Society.* Cambridge University Press. Cambridge.

Ling, J. 2008. *Elevated Rock Art: Towards a Maritime Understanding of Rock Art in Northern Bohuslän, Sweden.* Göteborgs universitet. Gothenburg.

Ling, J. 2013. *Rock Art and Seascapes in Uppland.* Oxford. Oxbow Books.

Ling, J., Z. Stos-Gale, L. Grandin, K. Billström, E. Hjärtner-Holdar and P.-O. Persson 2014. Moving Metals II. *Journal of Archaeological Science* 41: 106–132.

Linge, T. E. 2005. Kammeranlegget i Mjeltehaugen – eit rekonstruksjonsforslag. *Mellan sten och järn: Rapport från det 9:e nordiska bronsålderssymposiet, Göteborg 2003-10-09/12* (J. Goldhahn ed.): 537–559. Göteborgs universitet. Gothenburg.

Mahler, D. L. 2012. Øer langt ude i det blanke hav. Shetlandsøerne: Landbrug på grænsen 4000–3000 f.v.t. Et forskningsprojekt i Nordlige Verdener. *Agrarsamfundenes ekspansion i nord: Symposium på Tanums Hällristningsmuseum, Bohuslän, d. 25.–.29. maj 2011* (F. Kaul and L. Sørensen eds): 102–114. The National Museum of Denmark. Copenhagen.

Mandt Larsen, G. 1972. *Bergbilder i Hordaland.* Norwegian University Press. Bergen.

Mauss, M. 1993. *The Gift: The Form and Reason for Exchange in Archaic Societies.* Routledge. London.

Morris, I. 1986. Gifts and Commodity in Archaic Greece. *Man* (New Series) 21:1, 1986: 1–17.

Müller, S. 1897. *Vor Oldtid.* Det nordiske Forlag. Copenhagen.

Müller, S. 1921. *Bronzealderens Kunst i Danmark.* C.A. Reitzel. Copenhagen.

Østmo, E. 1991. A Local Picture Tradition of the Bronze and Early Iron Age in Southeast Norway: New Evidence from Rock Carvings at Dalbo. *World Archaeology* 23: 220–232.

Østmo, E. 2005: Over Skagerak i steinalderen: Noen refleksjoner om oppfinnelsen av havgående fartøyer i Norden. *Viking* LXVIII: 55–82.

Peroni, V. B. 1970. *Die Schwerter in Italien/Le spade nell'Italia continentale.* Prähistorische Bronzefunde, Abteilung IV, Band 1. C. H. Beck. Munich.

Prangsgaard, K., Andersen, S.T., Breuning-Madsen, H., Holst, M., Malmros, C. and Robinson, D. 1999. Gravhøje ved Lejrskov: Undersøgelse af fem høje. *Kuml* 1999: 53–97.

Quillfeldt, von, I. 1995. *Die Vollgriffschwerter in Süddeutschland.* Prähistorische Bronzefunde, Abteilung IV, Band 11. Franz Steiner Verlag. Stuttgart.

Rageth, J. 1986. Die wichtigsten Resultate der Ausgrabungen in der bronzezeitlichen Siedlung auf dem Padnal bei Savognin. *Jahrbuch der Schweizerischen Gesellschaft für Ur- und Frühgeschichte* 69, 1986: 63–108.

Randsborg, K. 1993. Kivik: Archaeology and Iconography. *Acta Archaeologica* 64(1): 1–147.

Service, E. R. 1971. *Primitive Social Organization*. Random House. New York.

Sognnes, K. 1987: *Bergkunsten i Stjørdal 2. Typologi og kronologi i Nedre Stjørdal*. Gunneria 56. Universiteten i Trondheim. Trondheim.

Sognnes, K., 1999a. *Det levende berget*. Tapir Forlag. Trondheim.

Sognnes, K. 1999b. *Helleristninger i Stjørdal*. Stjørdal Museum. Stjørdal.

Sognnes, K. 2006. Derom tier berget: Omkring slutten på den nordiske bergkunsten. *Historien i forhistorien: Festskrift til Einar Østmo på 60-års dagen* (H. Glørstad, B. Skar and D. Skree, eds): 173–182. Kulturhistorisk Museum, Universitetet i Oslo Skrifter 4. Oslo.

Strömberg, H. and M. Strömberg 1983. Båttyper på hällristningar i Kville. *Bohusläns Årsbok* 1983: 1–31.

Sveen, A. 1996. *Helleristninger Jiepmaluokta Hjemmeluft, Alta*. Utgitt i samarbeid med Alta Museum. Alta.

Tecchiati, U. 1998. *Sotciastel: Un abitato fortificato dell'età del bronzo in Val Badia*. Istitut Cultural Ladin 'Micurà de Rü', Soprintendenza ai Beni Culturali di Bolzano – Alto Adige. Bolzano.

Tecchiati, U. 2011. Albanbühel, Bolzano (Italia). *Enigma: Un antico processo di interazione europea: le Tavolette Enigmatiche/An Ancient European Interaction: The Enigmatic Tablets* (A. Piccoli and R. Laffranchini, eds): 94–98. Supplemento al n. XIV di 'Annali Benacensi'. Cavriana.

Terzan, B., K. Mihovilic and B. Hänsel 1999. Eine protourbane Siedlung der älteren Bronzezeit im istrischen Karst. *Praehistorische Zeitschrift* 74: 154–193.

Thrane, H. 1962. The Earliest Bronze Vessels in Denmark's Bronze Age. *Acta Archaeologica* XXXIII: 109–163.

Thrane, H. 1966. Dänische Funde fremder Bronzegefässe der jüngeren Bronzezeit (Periode IV). *Acta Archaeologica* XXXVI: 157–207.

Vandkilde, H. 1996. *From Stone to Bronze: The Metalwork of the Late Neolithic and Earliest Bronze Age in Denmark*. Aarhus University Press. Aarhus.

Varberg, J., B. Gratuze and F. Kaul 2014. Glasvejen. *Skalk* 2014:5: 20–30.

Varberg, J., B. Gratuze and F. Kaul 2015. Between Egypt, Mesopotamia and Scandinavia: Late Bronze Age Glass Beads Found in Denmark. *Journal of Archaeological Science* 64: 168–181.

Vogt, D. 2012. *Østfolds helleristninger*. Universitetsforlaget. Oslo.

Wehlin, J. 2013. *Östersjöns Skeppssättningar. Monument och mötesplatser under yngre bronsålder*. Göteborgs Universitet, Gothenburg.

Winther Johannsen, J. 2010. The Wheeled Vehicles of the Bronze Age on Scandinavian Rock-carvings. *Acta Archaeologica* 81: 150–250.

Worsaae, J. J. A. 1882. *The Industrial Arts of Denmark: From the Earliest Times to the Danish Conquest of England*. Chapman and Hall Limited. London.

Chapter 8

Axes and Long-distance Trade – Scania and Wessex in the Early Second Millennium BC

Peter Skoglund

Abstract: This paper discusses the occurrence of a number of axe images at Simrishamn in Scania and at Stonehenge in Wessex, all of which can be dated to the Arreton phase/Montelius' period 1, 1750/1700–1500 BC. These two concentrations are the only major clusters of axe images in northern Europe dating to this time. In order to understand this situation a model is discussed, which implies that these two areas were linked by a network of

people who traded in metal and amber. Amber collected along the coasts of the Baltic Sea went westwards, ending up as prestigious amber objects in Wessex; in return metal was traded from England to south Scandinavia. The function and value of amber and metal was thus different in the two areas. It is argued that differences in the conceptualisation of metal are reflected in the ways axe images are arranged and displayed in Wessex and in Scania.

Key words: Bronze Age, rock art, axes, Scania, Wessex.

South Scandinavia holds the largest concentration of rock art in northern Europe, and the origin of this tradition is set by most scholars at the transition between the Neolithic and the Bronze Age, *c.* 1700 BC (Ling 2008; Goldhahn and Ling 2013).

The rise in the number of images raises questions concerning the sources and inspiration behind the rock art tradition. For many years, there has been a focus on contacts between Scandinavia and the Mediterranean where similarities in motifs between the two regions have been taken as an indication of long-distance contacts (Winther 2002; Kristiansen and Larsson 2005).

Recently, another aspect of Scandinavian ship images has been brought into the discussion by scholars pointing out that the oldest ship images in Scandinavia are in the very north of the peninsula; where they are related to the northern hunter-gatherer tradition (Goldhahn and Ling 2013). Thus, we may also assume that inspiration for the south Scandinavian rock art tradition also came from the north.

There are good arguments for influences from both the south and the north, but it is not a complete model for understanding the complexity of the earliest south Scandinavian rock art tradition. When it comes to the axe images we should also consider influences from the west – *i.e.* the British Isles and France.

The notion of influences from the west, especially in the earliest Scanian rock art, is not a new one, but has been discussed earlier by scholars like Oscar Montelius (1900), Bertil Almgren (1987) and Göran Burenhult (1980). Montelius and Almgren pointed out the similarities

between certain axe images in the Scanian corpus and axes of a presumed English origin (the Pile type of axe). These ideas were elaborated by Göran Burenhult in his thesis from 1980. In contrast to the influences from the south and the north, this western link has not attracted interest in recent years. Today, there is new evidence calling for a fresh look at this western connection.

One strand of evidence concerns our understanding of the origin of copper and tin in the Scandinavian Bronze Age and how the metal trade was organised. Recently, the interpretation of lead isotope and chemical data of 71 Swedish metals conducted by Johan Ling and his team give a far more complicated picture of the origin of metals than hitherto assumed. There are no clear indications of local copper extraction; all metal seems to have come from abroad. The analysis points in different directions and the origin of metal varies over time. Central Europe is well represented but a high proportion of the analysed metals also originated in the western Mediterranean, for example, the Iberian Peninsula and Sardinia (Ling *et al.* 2013, 2014). Even though the analysis themselves do not inform us of how the metal came to Scandinavia, they put a new focus on the British Isles as a possible nodal place in the distribution of metals from the western Mediterranean to south Scandinavia.

Another strand of evidence is the outcome of a research project organised by the present author on rock art in south-east Scania (Skoglund 2016). In the project, which also involved documentation of a selected number of rock art panels, a find of two hitherto unknown axe images came to light at the site Simrishamn 16. Interestingly, the axes are unhafted, which corresponds to Early Bronze Age Axe images in Wessex, England. One of the axe images has a parallel in axes belonging to the Arreton phase (Figs 8.1 and 8.2). An analysis of nearby sites has revealed further examples of (hafted) axe images resembling British axes dating to the Arreton phase, *c.* 1750–1500 BC.

Against this background there is a need again to discuss the influences from the British Isles in the earliest phase of the Scandinavian rock art tradition. The aim of this paper is to discuss the axe images in Scania and Wessex and relate them to the idea of a trade in metal and amber between these two regions in Montelius period 1/Arreton phase, *c.* 1750/1700–1500 BC.

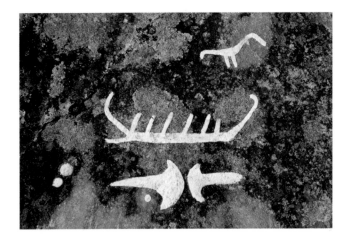

Figure 8.1. Two newly discovered axe images at Simrishamn 16; especially the one to the right resembles English axes of the Arreton type. Documentation by Sven-Gunnar Broström and Kenneth Ihrestam. From Broström and Ihrestam 2014 (photo: Peter Skoglund).

Figure 8.2. Photo of the panel at Simrishamn 16 demonstrating its location close to the shore (photo: Peter Skoglund).

The earliest Scanian axe images – dating and context

The beginning of the Scanian rock art tradition is defined by the occurrence of axes resembling types that were in use during Late Neolithic II and Montelius period 1 of the Bronze Age, *c.* 1950–1500 BC (Vandkilde 1996). These kinds of axes occur on four nearby sites, namely Simrishamn 15, 16,

Figure 8.3. Axe motifs from the Simrishamn 23 site. The image is composed of various documentations that are not directly related. Not to scale. Documentation by Dietrich Evers (source: SHFA).

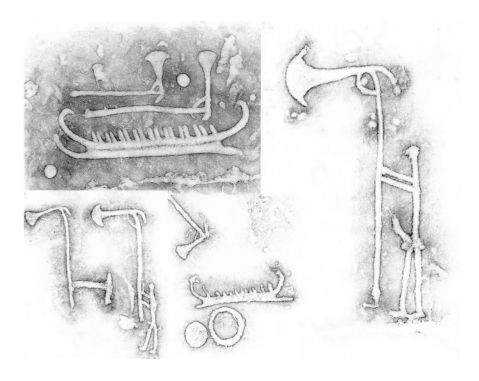

18 and 23, and the largest concentration is to be found on the last of these sites (Althin 1945: Taf. 1). (Fig. 8.3).

Bertil Almgren divided these axes into two groups: one with extended pointed edges at either side of the blade, often hafted in a slightly bent shaft (the Beddinge type) and another type with less pronounced blade, often hafted in a straight shaft (the Pile type) (1987: 38).

It is only the Beddinge type of axe with pronounced edges that can be dated more accurately. Oscar Montelius dated the Beddinge type of axes to period I, but the chronology of the earliest Bronze Age has been revised, and many types of axes previously thought of as belonging to Bronze Age period I are today placed in Late Neolithic II (Vandkilde 1996).

Axes with slightly pointed edges occur in the Fjälkinge hoard in northeast Scania, which are defined by Helle Vandkilde as axes of a pseudo-Irish type. This axe resembles contemporary Irish axes (Megaw and Hardy 1938: pls LV, LIV), which were in use during the Arreton-phase (Vandkilde type A8; Vandkilde 1996: 83ff). The Fjälkinge find also includes an unusual

low-flanged axe with a counterpart in the central German hoard of Kläden. Based on this particular axe Vandkilde date the Fjälkinge hoard very late in the sequence of Late Neolithic II hoards (Vandkilde 1996: 148–149). Late Neolithic II covers the time span 1950–1700 BC. From this a dating of the Fjälkinge hoard, and thus the axe images with pointed edges, to *c.* 1700 BC seems reasonable. The dating of the Beddinge type of axes to this timespan is further indicated by the similarities between some of these axes and axes found on either side of the English Channel, dating the Arreton phase to 1750–1500 BC (Megaw and Hardy 1938; Harbison 1968; Blanchet 1984).

The context of these axe images is rather special as the four panels holding these kinds of images are situated close together: three out of four sites are situated about 100 metres from the shore with a maximum distance of 800 metres in between. The last panel is situated only 500 metres inland, overlooking the other panels with axe images and the sea. In the Early Bronze Age these sites were even closer to the sea as the water level was 1–2 metres higher than today (Fig. 8.4).

From this perspective, we should consider these early axe images as reflecting a maritime logic rather than a land-based practice. In the following, I will try to understand what seems to be a western influence on the earliest Scanian rock art, by discussing a possible trade route linking Scania and Wessex in the period 1700–1500 BC.

The Wessex–Scanian link

Axes made at the British Isles, or inspired by Irish/British types, occasionally occur outside this region, and the greatest concentration is to be found in present-day Denmark and Scania. The distribution pattern, with a concentration in south Scandinavia, favours an idea of direct contact between the two regions during the Late Neolithic and the earliest Bronze Age (Megaw and Hardy 1938: 279–282; Harbison 1968: 180–183).

According to Butler, the distribution pattern indicates the existence of a direct overseas route between south Scandinavian and Britain and Ireland (Butler 1963: 210). Furthermore, it has been suggested that these contacts were well organised, and may have involved the movement of itinerant

Figure 8.4. The distribution of panels holding axe images dating to the time span 1700–1400 BC (image: Peter Skoglund).

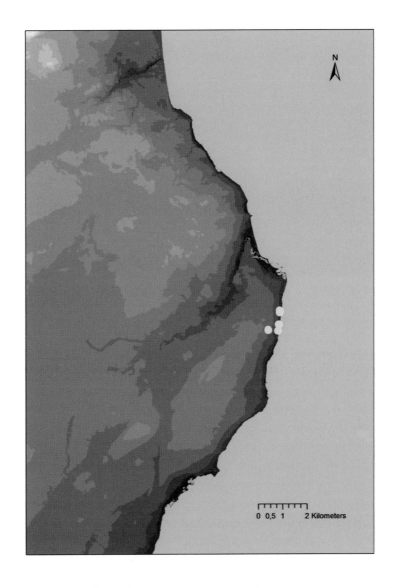

smiths (Megaw and Hardy 1938: 291–292; Butler 1963: 207–208; Harbison 1968: 180–181).

There is yet another set of evidence pointing towards contacts between primarily Wessex and south Scandinavia and that is the distribution of amber objects. There is a distinct concentration of amber objects in Wessex in the timespan 1950–1500 BC, including spacer plates, amber beads and

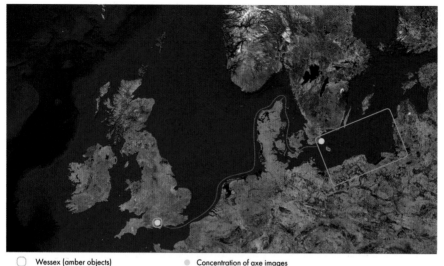

Figure 8.5. Map demonstrating the spatial relationships between Baltic amber sources, the concentration of amber objects in Wessex, the occurrence of axe images in northern Europe c. 1700–1500 BC and a possible sea route. (image: Peter Skoglund).

○ Wessex (amber objects)

○ South-east Baltic amber (raw amber)

● Concentration of axe images

— Sailing route

amber cups (Beck and Shennan 1991; Needham 2006: 77). As demonstrated by Beck and Shennan, the raw material used to make these objects came from abroad and originated from Jutish/Baltic sources, while the items themselves were produced in Britain and Armorica (1991).

The larger concentration of amber objects is found in the inland area of Wessex with Stonehenge as the centre (Fig. 8.5). Even though the amber must have reached this area with the help of ships crossing the North Sea, there are relatively few amber objects in the coastal zone of southern England. However, the area is not totally deprived of objects, and interestingly the two largest objects (amber cups) – requiring substantial pieces of raw material are found close to the coast; giving support to the idea that the amber trade was controlled by the coastal communities (Needham 2006).

This has led the Stuart Needham to argue that the amber was filtered through the coastal communities which kept the larger pieces for themselves to make the amber cups. In contrast to the inland area around Stonehenge these areas are characterised by hoards of the Arreton type, 1750–1500 BC. The concentration of these kinds of hoards is especially marked along the coastal zone of southern England where they often are accompanied by spearheads. The inclusion of spearheads in most of these

southern hoards is interesting, as it is a rare phenomenon in other parts of England, but has parallels on the Continent and in south Scandinavia (Needham 2006, 2009).

The amber ending up in Wessex was probably collected in one of two principal areas: either along the shores of the North Sea in western Jutland or along the shores of Scania, northern Poland or the Baltic states. Given the comparatively short distance between England and west Jutland it would only be natural if the Wessex amber was collected in this area. However, we should acknowledge a complex picture of different kinds of exchange networks, and some of the amber found in Wessex may have come from even further away, for instance the Baltic. Considering the latter region, it is tempting to view the Simrishamn area as a nodal point in a Baltic network focused on the collection and distribution of amber.

Amber is not evenly distributed in the Baltic Sea area; it occurs on the shores in many parts of Scania, though the Simrishamn area is not known for any large amounts of amber. Amber is found further north along Hanöbukten and south of Simrishamn along the southern shores of Scania (Goldhahn 2013: 387).

By far the largest concentration of amber, however, is found on the southern shores of the Baltic and especially around the area of present-day Kaliningrad in the Russian enclave between Poland and Lithuania – the Samland Peninsula (Gimbutas 1965: 48; Kristiansen 1998: 233–234; Bliujiene 2011). From the Samland Peninsula there are two sailing routes westwards: either following the Polish/German/Danish coastline towards the North Sea, or from the Bay of Danzig crossing the Baltic using the island of Bornholm as a landmark and from here straight to the Swedish coast, ending up at Simrishamn. This latter route equals about 400 kilometres, and is the shortest distance between the Scandinavian mainland and the Samland Peninsula, if crossing the sea with Bronze Age technology (Fig. 8.5). There are examples of bronze objects dating to Montelius 1 and 2 in the Baltic States, having their closest parallels in south Scandinavia/northern Germany which indicate contacts westwards during this period (Lang and Kriiska 2007; Vasks 2010).

Given this geographical position, the Simrishamn area could have operated as a gateway to the southern Baltic Sea shores, where amber was collected and distributed further west. At Simrishamn, expeditions from

various part of the southern Baltic could have gathered, after having crossed the Baltic Sea, and before following the Swedish coastline westwards.

Scania and Wessex should thus be regarded as two opposing poles on an east-west axis where amber was collected in one region and consumed in another region. Interestingly, Scania and Wessex are the only two regions in northern Europe that has a substantial number of axe images from the period 1750/1700–1500 BC. Moreover, the axe images in Wessex are exclusively found at the Stonehenge monument, which is located at the very centre of the distribution of amber objects.

Different contexts – different values?

As early as 1953, a dozen axe images at Stonehenge were reported by Richard Atkinson, and over the year's new images have been sporadically recorded, so that in 2011 altogether 44 images were known at Stonehenge. This situation changed dramatically this year when English Heritage undertook a laser scanning of all the stones; thanks to this new method another 71 axe images were recorded, and altogether 115 axe images are today known from Stonehenge, and in addition there are three images of daggers. The axes are not hafted; only the axe heads are displayed (Fig. 8.6) (Abbott and Anderson-Whymark 2012: 26–35).

The motifs are not randomly distributed, but occur on four key panels: the exterior E faces of stones 3, 4 and 5, and the north-west interior face of stone 53, and only four motifs are found elsewhere. The position of a majority of the motifs on the E exterior faces of stones 3–5 is interesting, as this direction had no specific significance in the Neolithic, which indicates that the carvings were done later. The axe heads are identifiable as a form of flanged axe with distinctively splayed edges (Arreton phase) which were in use c. 1750–1500 BC and the dagger style would also fit this range (Abbott and Anderson-Whymark 2012: 53–54).

The rock art postdates the major building phase at Stonehenge and there is very little activity reported from the site, or other nearby henges or related monuments, after c. 1900 BC. Instead Stonehenge was the centre of a very large burial area known for its richly equipped graves (the Wessex culture).

Figure 8.6. Axe images on the exterior of stone 4 at Stonehenge; above example of offset image and below image compiled from all 75 offset images. Motifs discovered in 2012 are marked green (from Abbot and Andersson-Whymark 2012: 29).

Example greyscale offset image 7.5cm band

Rock Art

█ Discovered Pre 2003

█ Discovered in 2012

Visable Rock Art compiled from all 75 offset images

0 1 2

Metres

It has been supposed by Timothy Darvil that the 'power' of Stonehenge in the early second millennium BC was not its use, but rather an ancestral memory of what it had been, and a desire to associate with its former glory in selecting a final resting place (Darvil 2005: 65). Even though the activities at the monument itself ceased, the area around Stonehenge continued to function as an important meeting place for people from a larger region.

The rock art discussed here is intriguing as there seems to be a link between the collection and consumption of amber and axe images. Accepting that amber went in an east-western direction we would presume metal to have moved in the opposite direction; as indicated by the results of the metal analysis carried out by Johan Ling and his team (Ling *et al.* 2013, 2014).

From this perspective, there is an interesting difference in the way the axe images in Wessex and Scania are displayed and arranged. At Stonehenge, the axes are unhafted and arranged in well-defined clusters, all with their edges oriented upwards. The rather deliberate display of the metal blades indicates that the images refer to the metal value itself, rather than the axe as a functional object. The display of a large and orderly assemblage of similar axes has parallels in the way axes would have been arranged if they had been a commodity and part of a cargo (Fig. 8.6).

A parallel to such a situation is the marine find from Langdon Bay in Kent dating to the 13th century BC which is usually interpreted as representing the remains of a cargo aboard a ship. Among the 361 metal objects extracted from the sea there is a large amount of similar kinds of palstaves and winged axes, numbering 50 and 61 items respectively (Needham *et al.* 2013).

The axe images in south-east Scania display a very different pattern. Here the axe images are displayed in multiple ways ranging from a few examples of unhafted axes resembling the British situation, to axes situated atop a ship as if they were being transported across the sea, to axes being carried around by people; but the majority of the axes are not attached to humans or objects (Fig. 8.3) (Althin 1945).

The Scanian axe images do not conform to any strict rules, neither in the ways they are combined with other images nor in their orientation. The axe images lack an overall orientation but the blades are oriented in all directions, giving a very lively impression. The different kinds of compositions of which these axe images are part supports the idea that the images represent objects with extended biographies (Kopytoff 1986). The lively impression given by

these images further indicates that they might have had a secondary agency – *i.e.* that they could act on, or enchant the viewer, as discussed in Alfred Gell's influential book Art and Agency (Gell 1998).

Looking at the axe images in Wessex and Scania from the perspective of trade with amber and metal gives some clues to understanding the differences in the ways axe images are displayed and arranged in the two regions.

In the Stonehenge area amber was an exotic object, and though axes of the Arreton type were in circulation, these were not deposited in hoards. As suggested by Needham (2006), when it reached England the amber was controlled by the coastal communities where we find a large number of hoards containing axes from the Arreton phase. To get hold of the amber the people living further inland may have given metal axes in return to the coastal zone, where some of these objects ended up in hoards. Other metal axes may have been given by the coastal communities to travelling maritime specialists of Scandinavian origin trading in amber. In Scandinavia, the circulation of the Arreton types of axes may have been restricted to a maritime sphere, as axes of English origin never entered the Scandinavian record in any large number.

Metal and amber thus held very different kinds of value in the two different regions. From a Scanian perspective amber was a raw material and a commodity; its prime value was that it could be exchanged for metal and prestigious metal objects. In Wessex, the situation was the opposite – here amber was prestigious and the value of metal axes lay primarily in the fact that they were valued by other groups of people and thus could be exchanged for amber (*cf.* Shennan 1982). These proposed differences in how metal axes were valued may help us to understand why the axe images at Stonehenge seem to highlight the metal value of the axes, while the axe images in Scania rather reflect a variety of meanings and values.

References

Abbott, M. and H. Anderson-Whymark 2012. *Stonehenge Laser Scan. Archaeological Analysis Report.* English Heritage Research Report Series No. 32. English Heritage. Wiltshire.

Almgren, B. 1987. *Die Datierung bronzezeitlicher Felszeichnungen in Westschweden.* Uppsala universitet. Uppsala.

Althin, C.-A. 1945. *Studien zu den bronzezeitlichen Felszeichnungen von Skåne 1–2.* Gleerup. Lund.

Beck, C. and S. Shennan 1991. *Amber in Prehistoric Britain.* Oxbow Books. Oxford.

Blanchet, J.-C. 1984. *Les premiers metallurgistes en Picardie et dans le nord de la France: Chalcolithique, âge du bronze et début du premier âge du fer.* Société préhistorique Française. Paris.

Bliujiene, A. 2011. *The Northern Gold: Amber in Lithuania (c. 100–c. 1200).* Brill. Leiden.

Broström, S.-G. and K. Ihrestam 2014. Hällristningar i Simrishamn 3. *Botarkrapport* 2014:06.

Burenhult, G. 1980. *Götalands hällristningar (utom Göteborgs och Bohus län samt Dalsland).* Stockholms universitet. Stockholm.

Butler, J. J. 1963. Bronze Age Connections across the North Sea: A Study in Prehistoric Trade and Industrial Relations between the British Isles, the Netherlands, North Germany and Scandinavia, *c.* 1700–700 BC. *Palaeohistoria* IX.

Darvil, T. 2005. (ed.) *Stonehenge World Heritage Site: An Archaeological Research Framework.* English Heritage. London.

Gell, A. 1998. *Art and Agency: An Anthropological Theory.* Clarendon Press. Oxford.

Gimbutas, M. 1965. *Bronze Age Cultures in Central and Eastern Europe.* Mouton de Gruyter. The Hague.

Goldhahn, J. 2013. *Bredarör på Kivik – en arkeologisk odyssé.* Artes liberales. Simrishamn.

Goldhahn, J. and J. Ling 2013. Bronze Age rock art in Northern Europe contexts and interpretations. (A. F. Harding and H. Fokkens, eds): 270–290. *The Oxford Handbook of the European Bronze Age.* Oxford University Press. Oxford.

Harbison, P. 1968. Irish Early Bronze Age Deposits Found on the Continent and Their Derivatives. *Palaeohistoria* XIV.

Kopytoff, I. 1986. The Cultural Biography of Things: Commoditization as Process. *The Social Life of Things: Commodities in Cultural Perspective* (A. Appadurai, ed.): 64–91. Cambridge University Press. Cambridge.

Kristiansen, K. 1998. *Europe before History.* Cambridge University Press. Cambridge.

Kristiansen, K. and T. B. Larsson 2005. *The Rise of Bronze Age Society: Travels, Transmissions and Transformations.* Cambridge University Press. Cambridge.

Lang, V and A. Kriiska 2007. The Final Neolithic and Early Bronze Age contacts between Estonia and Scandinavia. *Cultural Interaction between East and West: Archaeology, Artefacts and Human Contacts in Northern Europe* (U. Fransson, ed.): 107–112. Stockholm University. Stockholm.

Ling, J. 2008. *Elevated Rock Art: Towards a Maritime Understanding of Bronze Age Rock Art in Northern Bohuslän, Sweden.* Göteborgs universitet. Gothenburg.

Ling, J., Hjärthner-Holdar, E., Grandin, L., Billström, K. and Persson, P.-O. 2013. Moving metals or indigenous mining? Provenancing Scandinavian Bronze Age artefacts by lead isotopes and trace elements. *Journal of Archaeological Science* 40: 291–304.

Ling, J., E. Hjärthner-Holdar, L. Grandin, K. Billström and P.-O. Persson 2014. Moving metals II: Provenancing Scandinavian Bronze Age artefacts by lead isotope and elemental analyses. *Journal of Archaeological Science* 41: 106–132

Megaw, B. R. S. and E. M. Hardy 1938. British Decorated Axes and their Diffusion during the Earlier Part of the Bronze Age. *Proceedings of the Prehistoric Society* IV:2: 272–307.

Montelius, O. 1900. *Die Chronologie der ältesten Bronzezeit in Nord-Deutschland und Skandinavien*. Vieweg. Braunschweig.

Needham, S. 2006. Networks of Contact, Exchange and Meaning: The Beginning of the Channel Bronze Age. *The Ringlemere Cup: Precious Cups and the Beginning of the Channel Bronze Age* (S. Needham, K. Parfitt and G. Varndell, eds): 75–81. The British Museum. London.

Needham, S. 2009. Encompassing the Sea: 'Maritories' and Bronze Age Maritime Interactions. *Bronze Age Connections: Cultural Contact in Prehistoric Europe* (P. Clarke, ed.): 12–37. Oxbow Books. Oxford.

Needham, S., D. Parham, C. Frieman and M. Bates 2013. *Claimed by the Sea: Salcombe, Langdon Bay, and Other Marine Finds of the Bronze Age*. Council for British Archaeology. York.

Shennan, S. 1982. Exchange and Ranking: The Role of Amber in the Earlier Bronze Age of Europe. *Ranking, Resource and Exchange: Aspects of the Archaeology of Early European Society* (C. Renfrew and S. Shennan, eds). Cambridge University Press. Cambridge.

Skoglund, P. 2016. *Rock Art through Time: Scanian Rock Carvings in the Bronze Age and Earliest Iron Age*. Oxbow Books. Oxford.

Vandkilde, H. 1996. *From Stone to Bronze: The Metalwork of the Late Neolithic and Earliest Bronze Age in Denmark*. Aarhus University. Aarhus.

Vasks, A. 2010. Latvia as Part of a Sphere of Contacts in the Bronze Age. *Archaeologica Baltica* 13: 153–161.

Winter, L. 2002. Relationen mellan Medelhavsområdets och Sydskandinaviens bildvärldar. *Bilder av bronsålder: Ett seminarium om förhistorisk kommunikation: Rapport från ett seminarium på Vitlycke museum 19.e–22.e oktober 2000* (J. Goldhahn, ed.): 201–220. Almqvist & Wiksell International. Stockholm.